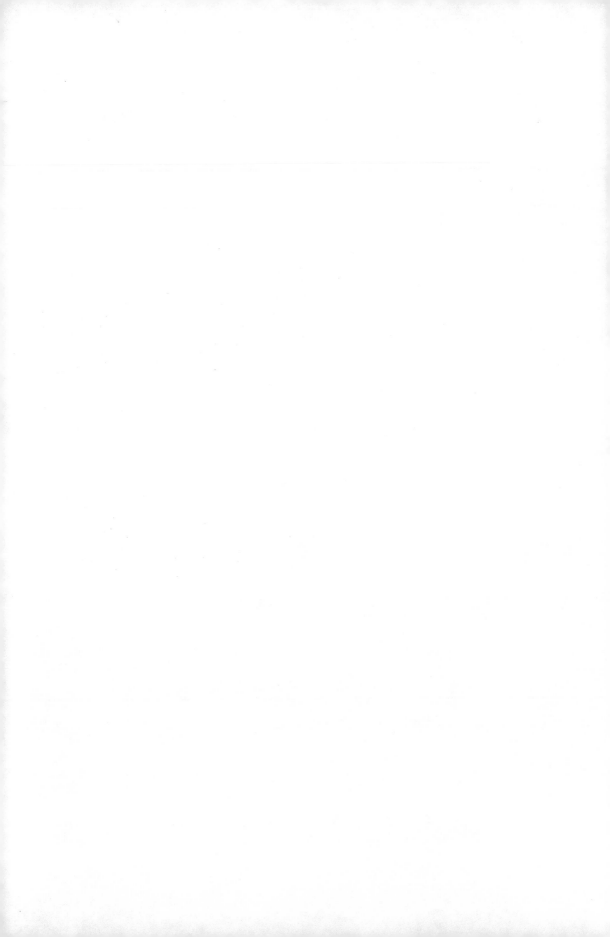

THE CLASH OF GODS

THOMAS F. MATHEWS

The Clash of Gods
A Reinterpretation of
Early Christian Art

REVISED EDITION

PRINCETON UNIVERSITY PRESS

PRINCETON · NEW JERSEY

Published by Princeton University Press, 41 William Street,
Princeton, New Jersey 08540
In the United Kingdom: Princeton University Press, Chichester, West Sussex

This book has been composed in Bembo with Weiss Roman display

Library of Congress Cataloging-in-Publication Data
Mathews, Thomas F.
The clash of gods : a reinterpretation of early Christian art /
Thomas F. Mathews. — [Rev. and expanded ed.]
p. cm. — (Princeton paperbacks)
Includes index.
ISBN 0-691-00939-2 (pbk. : alk. paper)
1. Art, Early Christian. I. Title.
N7832.M36 1999
709'.02'12—dc21 98–51583

First printing of the revised paperback edition, 1999

The paper used in this publication meets the minimum requirements of
ANSI/NISO Z39.48-1992 (R1997) (*Permanence of Paper*)

http://pup.princeton.edu

Second printing, and first paperback printing, 1995

Printed in the United States of America

5 7 9 10 8 6 4

Designer Laury A. Egan

To A.-C.D.

CONTENTS

ACKNOWLEDGMENTS

THIS IS A STUDY of that critical period of art when a new Christian pantheon replaced the Greco-Roman panoply of pagan gods. It is much too large a subject for a small book; it embraces three centuries and I have not spent more than three years in the writing. I would never have been so rash had not the National Endowment for the Humanities and the J. Paul Getty Trust offered liberal support for the project, allowing me to devote all my energies to it during my sabbatical leave in 1989–90, and providing me with funds for assistants. I am most grateful to those institutions and to my diligent assistants: Helen C. Evans, now of the Metropolitan Museum of Art, and Erik Inglis and Kathryn Smith, doctoral candidates at the Institute of Fine Arts, New York University. The N. E. H. grant also allowed me to enlist photographer John Dean of Baltimore to provide new views of some old works of art.

My research and writing had several venues, and it gives me pleasure to recall how helpful colleagues were everywhere. I spent the fall of 1989 in Rome where curators were most generous in allowing me access to material under their jurisdiction: Paolo Liverani of the Musei Vaticani; Vincenzo Fiocchi-Nicolai of the Pontificia Commissione di Archeologia Sacra; Suor Francesca, O.S.B., of the Archivio Fotografico of the same Pontificia Commissione; Marina Sapelli of the Museo Nazionale delle Terme; Giuliano Sacchi of the Soprintendenza per i Beni Ambientali e Architettonici del Lazio; Ioannes Deckers of the Deutsches Archäologisches Institut. My residence in Rome was made both more profitable and more enjoyable by frequent conversations with art historians Maria Andaloro, Marina Falla Castelfranchi, and Valentino Pace. M. Thomas Martone generously lent me his computer.

In my visits to Arles, I must thank Claude Santis of the Musée Réattu for allowing me to study his collection of Early Christian sarcophagi. In Berlin, Theun-Mathias Schmidt graciously guided me through the collection of the Bode Museum. The riches of the Coptic Museum in Cairo were put at my disposition by Gawdet Gabra. In Istanbul, I have Mehmet I. Tunay to thank for information and photographs. Raffaela Farioli Campanati and Franca Pierpaoli Fantini of Ravenna were most obliging during my visit to their city. In Thessalonica, Ioulia Vokotopoulou kindly let me photograph material in the Archae-

ological Museum and Eutychia Nicolaidou facilitated my work in buildings under the jurisdiction of the Ephoria of Byzantine Monuments. Moreover, many of Thessalonica's archaeologists came to my assistance: George Lavas, Euterpe Marke, Despina Markopoulou, Thanasis Papazotas, Dimitri Pandermalis, Sappho Tambaki, and Tasula Turta, all of whom made me most welcome.

As a member of the Institute for Advanced Study in Princeton, in the spring of 1990, I enjoyed the stimulation of seminars and meals with Glen Bowersock, Giles Constable, and Ernst Kitzinger, and I am most indebted to Glen Bowersock for a critical reading of the completed manuscript.

But my largest debt is certainly to my academic family at the Institute of Fine Arts, New York University. I am grateful to director James R. McCredie for arranging my year and a half of leave and to Frances B. Goodwin for working out my budget. Members of the community helped in assorted ways with counsel, cheer, photographs, and pointers on obscure iconography: Jonathan J.G. Alexander, Joseph D. Alchermes, Jonathan Brown, Hugo H. Buchthal, Ellen N. Davis, Evelyn B. Harrison, Richard Krautheimer, Lucy Freeman Sandler, Willibald Sauerländer, Roland R.R. Smith, Jane Timken, Marvin Trachtenberg, and Kathleen Weil-Garris Brandt.

In the final stages of the writing three close friends were especially important for their enthusiastic readings of the manuscript: Kathleen Lynch Baum, Michael Jacoff, and David Rattray. My warm thanks to them. The title of the book I owe to my wife Annie-Christine Daskalakis.

THOMAS F. MATHEWS
Institute of Fine Arts
New York University

PREFACE TO
THE REVISED EDITION

I WELCOME THIS opportunity to emend two serious shortcomings in the first edition of a book that has had its share of controversy. In the second chapter my obsolete dating of the Al-Mouâllaka lintel gave it undo prominence in my argument; it belongs to the eighth century not the fourth, and my attempt to correct this in a second printing of the book failed to clarify the issues involved. In the meanwhile the discovery of a new fourth-century piece from Palestine confirms my belief in the early popularity of the Entry into Jerusalem through-out the empire and prompts me to argue my Arian interpretation of the theme a little differently, and I hope more convincingly.

In addition, I have tried to make good an omission in the first edition that I was conscious of from the start but was unable to remedy within the sabbatical schedule of my writing, namely icons. The introduction of cultic panel paint-ings was certainly one of the major developments of the Early Christian period and one with long-lasting consequences for the history of art. In the interval since the appearance of the first edition, I have been pursuing research on the connection of icons to the religious panel paintings of Late Antiquity, and I am happy to be able now to present a summary of my findings. Here, too, past scholarship, I believe, has been excessively concerned with finding imperial sources.

For their attention in reading the new chapter on icons, I am especially grateful to Helen C. Evans of the Metropolitan Museum of Art and Thelma K. Thomas of the University of Michigan.

<div align="right">

THOMAS F. MATHEWS
The Institute of Fine Arts
New York University
September 14, 1998

</div>

THE CLASH OF GODS

CHAPTER ONE

The Mistake of
the Emperor Mystique

I N 322 Valerius Licinius was the last Roman emperor to put the image of Jupiter on his coins (308–24). Broad-shouldered and naked to the waist, the father of the gods lounges at ease on his throne with all the confidence of a king who has ruled unchallenged for a thousand years (fig. 1). While the eagle, symbol of heavenly rule, struts about at Jupiter's feet, the god holds the scepter of universal dominion in his left hand and on the palm of his right an exuberant little female figure of Victory does a dance and offers Jupiter a wreath. This was a sacred image of great antiquity immediately recognizable throughout the Greco-Roman world, for it was a replica of Phidias' masterpiece, his gold and ivory statue of Jupiter in the temple at Olympia.

The year was the fifteenth regnal anniversary of Licinius who governed the eastern half of the Roman Empire, and his decision to return to pagan imagery of such venerability tells us something about his estrangement from his Christian co-emperor and brother-in-law, Constantine. The two of them had co-authored the Edict of Milan (313) by which Christian churches were given legal status on a par with other religous institutions, but Licinius reneged on the agreement. Placing his trust in the ancient symbol of Jupiter, he tried to solidify his control of the administration by purging Christians from the ranks of government and army, a move that provided Constantine with the pretext for taking up arms against him.

At roughly the same time, a painter of the grave-diggers' union, working by lamplight in the underground cemetery of Domitilla in Rome, was tracing a rival god on the plaster (fig. 2).[1] Working with a limited palette in a sketchy

3

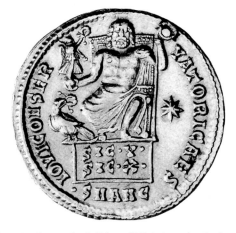

1. Jupiter Enthroned, *Solidus* of Licinius, Antioch, 321–322

style, he rendered a fragile and nervous Christ, beardless and adolescent, seated on a high-backed chair, with his apostles grouped around him on either side. An open book on his knee, Christ waves his right hand to emphasize a point in his lesson. He glances around at his companions with flashing eyes. They, like Christ, are dressed in the traditional purple-striped tunic of the Roman citizen of senatorial rank, but they appear even younger than Christ, hardly more than schoolboys with short haircuts, and they look at him stiffly as if hoping they won't be called upon to recite. Who commissioned this modest work and whose tomb it protected we do not know, but even in its anonymity it attests the community's firm faith in the power of this new divinity and his teaching to bring salvation, even in death.

Of these two images, unlikely as it may seem, the crude cemetery painting was proven by events to be the more powerful. Licinius' Jupiter was unable to confer victory on him in his final contest with Constantine, whose forces carried standards surmounted with the monogram of Christ.[2] Trapped in Byzantium (in present-day Istanbul), Licinius fled across the Bosphorus only to be captured in Nicomedia on the 18th of September, 324. Initially Constantine spared his life and put him under house arrest in Thessalonica, but soon changed his mind and had him executed on charges of conspiracy.

The modern historian may see in such a sequence evidence of the military genius of Constantine. But we could also read the events as a contest of the gods. Art historians have been slow to address the power of images, but the fourth century witnessed an unparalleled war of images and it was the strength and energy of the winning images that determined the outcome.[3] We are more

2. Christ Enthroned among His Apostles, Catacomb of Domitilla, Rome, c. 325

accustomed to narrating events the other way around, describing the winning images as a consequence of the political fortunes of one or another party. But this is to imagine that art is chiefly decoration and illustration, that it merely echoes decisions made in a higher court of activity without taking part in the events of world history. That is not the way things appeared in the fourth century. Constantine had learned in 312 the power of the sign of the cross in his contest with Maxentius at the Battle of the Milvian Bridge. It was Christ who, in a dream, directed him to fashion a Christian symbol on his standards. With his God's sign flying before him, Constantine caught Maxentius, who held Rome, in a defile on the west bank of the Tiber and drove him and his troops into the river.

In terms of its consequences for human history, the downfall of Jupiter was far more momentous than the downfall of either Maxentius or Licinius. Starting with Constantine's discontinuance of imperial worship at Jupiter's Cap-

itoline temple in Rome—the great "cathedral" of pagan Rome—the thunderer on high slipped into an irreversible decline. Not only was he banished from coinage but his great cult images were torn from their bases and evicted from their temples. Later in the century (perhaps even by Constantine's directive) Phidias' famous statue was unceremoniously carted off to Constantinople where it ended up a dust collector in the private museum of a court official named Lausos.[4]

The last recorded raising of a statue of Jupiter took place during the rebellion of the usurper Eugenius to whose cause the pagans of Italy rallied in 394. His general Flavian, defending a pass in the Alps at the River Frigidus, set up a great statue of Jupiter brandishing thunderbolts. The God of the Christian emperor Theodosius (379–95) proved stronger, however, sending a miraculous storm that was said to have turned back the javelins of the enemy; Eugenius' troops were overwhelmed and Eugenius himself decapitated. Down came the great statue of Jupiter, and as for his thunderbolts Theodosius made a present of them to some soldiers who had joked about their impotence.[5] The old gods did not die easily, but Theodosius' legislation against their cult was a heavy blow that opened the way to the violent destruction of pagan sanctuaries in the following century.[6] The undoing of paganism was not a process of gentle persuasion. The instruments of conversion were frequently axe and firebrand. In Gaza in 402 a rioting Christian minority burned down the ancient temple of Jupiter Marnas under the cover of Theodosius' legislation; in 426 the temple of Jupiter in Olympia, long empty, was torn down. Once deprived of his cult images and his temples, Jupiter was dead.[7]

Along with Jupiter, all the images of the ancient pantheon came tumbling down, and instead there appeared a strange collection of saints and angels that would rule the religious imagination of the West for at least the next millennium. The dimensions of this revolution are staggering. In effect, a highly nuanced visual language that had been developed over the course of a thousand years to express man's sense of cosmic order, to deal with the forces beyond his control, to carry his aspirations and frustrations, to organize the seasons of his life and the patterns of his social intercourse, was suddenly discarded. The gods and goddesses, nymphs and heroes were roughly thrown aside; their mutilated and decapitated statues were interred in the foundations of Christian churches.[8] Their battered remains still give us eloquent testimony of the violence of their downfall (figs. 3 & 4). In 401 Augustine stood by and cheered when a crowd

3. (*facing*) Mutilated Head of Mercury, from the foundations of what may have been a Christian chapel in Uley, Gloucestershire

4. Mutilated Torso of Aphrodite,
from Aphrodisias

assaulted a great statue of Hercules and "shaved" off his golden beard.[9] Great
quantities of ancient sculpture were melted down for their metal content and
those that survived for a while, like Phidias' Jupiter, were relegated to drab
gallery existence as relics of a story-book past.

In their place a new language of images was laboriously composed, se-
lected, assembled, rehearsed, and refined. The criteria of this process were
many, but the inherent strength of each new image must have been one of the
most decisive considerations in its eventual success. The new images should not
be thought of as simply filling up the voids left by the overthrow of the old, but
as actively competing with the old images. The lanky Good Shepherd of Early
Christian art wrestled with the muscular Hercules and won; we find him replac-
ing the mighty god on the funerary tables used for offerings to the dead
(figs. 5&6).[10]

Why at this point was the ancient pantheon found wanting? Gods, after all,
do not simply die of old age; indeed, the antiquity of a cult is often invoked as
the most convincing argument for its authenticity. Think of the pride with
which Catholics point to a line of popes stretching back to Peter. Nor do

5. Hercules Table Support, third century, Thessalonica Archaeological Museum

6. Good Shepherd Table Support, fourth century, Archaeological Museum, Alexandria

religions die because they can't adapt to changed conditions. Gods are flexible; they can accommodate all shades of politics and put up with all manner of adaptations, assimilations, and even dissimulations. Religions are nothing if not inconsistent.

The decline of the gods, I would like to suggest, had much to do with the bankruptcy of their images and the appearance of a more forceful set of divine images. As with politicians, nothing is more important to gods than image. If a god's image should fail, how long could he survive? Perhaps this is the secret of the longevity of the God of Israel, that he never allowed an image of himself. A god who appeared weak, a god who was seen to stumble when facing off with another divinity or who looked on helplessly while his image was defaced and dismembered, could never again expect a sea of heads bowed in worship before him. He must perforce follow the fate of his image.

The fourth century ushered in a war of images. What made the ill-knit Christian works of art, conceived in a haphazard, experimental fashion, executed at first in obscurity in graveyards by journeymen artists, more potent than works of a centuries-old tradition of the most sophisticated accomplishment? This is a question of some importance beyond its speculative intellectual interest. For at the point when Christian art graduated from its closed, private existence before the Edict of Milan to a more public existence, emblazoned in the apses and across the facades of churches, it suddenly became necessary to *imagine* Christ. The formulations arrived at in this effort not only affected the history of art but the history of Christianity itself. The images of Christ determined what people were to think of him not only in the early centuries of the current era, but ever after.

Modern historians have sifted and resifted the endless theological arguments concerning the reconciliation of two natures of Christ, his divinity and his humanity. This was an issue of such intense public preoccupation that Gregory of Nyssa, the champion of Nicaean orthodoxy, complained that he could not buy a loaf of bread or get his hair cut without people starting a discussion of how the Son shared the Father's nature. Arianism, the denial of the Son's full divinity, split the Christian church in two in the fourth century.

Yet historians never ask how *images* of Christ affected the way people conceptualized him. Not in an abstract sense, for images take us well beyond the world of ideas, but how they grasped him, how they felt about him, how they related to him, and what kind of a person they thought he was. And by "person" I mean not the subtle theological definition of person, but person in the more familiar sense of personality, temperament, or disposition, including the way he speaks or behaves, whether he seems warm and sympathetic or cold and re-

mote, direct and forceful or dreamy and nebulous. How did they imagine Christ? To what class of society did they assign him?

That Early Christians were intensely interested in how Christ carried himself, how he interacted with people, even how he wore his hair, is abundantly demonstrated by the vivid record of these details in the art of the period. But unlike many historical figures of Antiquity, Christ had no authentic portrait tradition. Of Socrates, for example, who like Christ accepted execution rather than betray his principles, portraits were made shortly after his death, and these became the prototypes for a very plentiful tradition of sculptures of the philosopher in Greek and Roman art.[11] Moreover, since the portraits correspond to contemporary descriptions of the man, they may be said to have a certain historical authenticity. No such tradition exists for portraits of Christ.[12] Images of him may therefore be said to be pure projections in the psychological sense; that is, inventions corresponding to what people needed or wanted from him. The enormous variability of images of Christ is one of the immediate consequences of this (figs. 12, 57, 74, 89, & 108).

But once they "imaged" Christ, he *became* what people pictured him to be. The translation of the Gospels from Greek into Latin altered their content only very marginally; the translation of the Gospels from literature into visual images profoundly affected their content. Images are not neutral; they are not just stories put into pictures. Nor are they mere documents in the history of fashion. Images are dangerous. Images, no matter how discreetly chosen, come freighted with conscious or subliminal memories; no matter how limited their projected use, they burn indelible outlines into the mind. Often images overwhelm the ideas they are supposed to be carrying, or dress up with respectability ideas that in themselves are too shoddy to carry intellectual weight. Images not only express convictions, they alter feelings and end up justifying convictions. Eventually, of course, they invite worship. One cannot write history without dealing with the history of images, and of no epoch is this more true than the fourth and fifth centuries of the current era.

ONE WAY to deal with the revolutionary changes of this period is to deny them, which is, in fact, what happens when Early Christian art is subsumed into a category called "Late Antique." This is the term that historians have now settled on to describe the history of Mediterranean lands from the third to the seventh century, in preference to the earlier terms of invasion and decline.[13] The term "Late Antique" emphasizes the strong lines of continuity in patterns of government, in social structures, and in culture that tie this period to the preceding age of Imperial Rome.

For the secular art of the period such an approach is, perhaps, adequate. In some categories, luxury silver plate, for example, mythological themes remained in vogue down to the seventh century.[14] In other categories, such as representations of the emperor and consuls in official imagery, the changes are more in fashion than in substance: a growing anonymity in portraiture, a preference for frontality, a disjointed space (figs. 17–19, 80).[15] But the same solemn officialdom still presides over the same old circus. The revolution is not in secular imagery but in the creation of a visual language to replace the imagery of the dethroned gods, and this is something substantially new which the term "Late Antique" cannot adequately embrace.

Another way to avoid dealing with the revolution in imagery is to look at the form rather than the content of the art. Following stylistic developments from the third century to the seventh, Ernst Kitzinger seeks to define meaning in the tensions between Hellenism and abstraction.[16] His formalistic approach examines less what the new Christian art introduced than what it managed to salvage from Classical art to pass on to succeeding generations. In effect, the artist is praised for his role as "re-cycler." One can imagine him picking through the trash heap of the old world to find a composition here or a figural motif there, worn thin from centuries of use; he dusts it off and adds a new coat of paint. The Christian character of the new art is hardly more than aberration, for it is one among many of the disintegrating factors in the decline of Roman art.

The discussion of Early Christian imagery hardly figures in these two approaches, and hence the question of its special energy and power in the competition with pagan imagery is not raised. But eventually, when the new imagery is finally confronted—generally under the term "iconography"—art historians have recourse to a theory that derives the images of Christ from images of the Roman emperor. Both the shape and the power of the images, according to this theory, come from reliance on imagery formerly used to present the emperor. I call this approach the "Emperor Mystique." It is a "mystique" in so far as it involves a reverence bordering on cult for everything belonging to the emperor. To such historians dropping the word "imperial" into a discussion represents an appeal to a kind of ultimate value beyond which one need never look.

We may summarize the Emperor Mystique in André Grabar's terms, since he developed it in its most coherent and all-embracing form.[17] Grabar saw two phases in the formulation of Christian imagery. The initial phase embraced the period before Constantine when Christianity existed under a cloud of intermittent persecution and Christian art was chiefly a private art restricted to house churches and cemeteries. In this phase Christian images consisted of one or two figures referring to some significant biblical event, such as Jonah emerging from

the sea monster, or a shepherd carrying a sheep, or Christ raising the paralytic (figs. 7, 48). Only the essentials are represented, with no attendant figures and no background, and no effort is made to connect one image to another to create a larger programmatic whole. To borrow a musical term, we might aptly call them "staccato" images, a word that refers both to the brevity of a note and its separation from other notes.[18]

7. Sarcophagus frontal with "staccato" biblical images including Daniel in the Lions' Den, Adam and Eve, Noah in the Ark, the Jonah Story, and the Multiplication of Loaves, c. 300, Museo Civico, Velletri

Constantine's conversion in 312, according to Grabar, changed the entire situation. Because the impoverished art of the catacombs and cemeteries was inadequate to express the grand claims Christians were making for their god, they now appropriated the grandest imagery they could lay hands on, namely that which had been developed in the service of imperial propaganda. Finding themselves with an emperor of their own faith, Christians boldly appropriated for their own religious purposes the entire vocabulary of imperial art, transforming motifs and compositions that had been used for imperial propaganda into propaganda for Christ. "The future of Christian iconography was profoundly modified, and what was created then has remained fundamental for Christian art. . . . All the 'vocabulary' of a triumphal or Imperial iconographic language was poured into the 'dictionary' which served Christian iconography, until then limited and poorly adapted to treat abstract ideas."[19] The term "imperial" is here used by Grabar not in the general sense of the "Empire" period of

Roman art, but in the restricted sense of art that is particularly concerned with presenting the person of the emperor, an autocrat who increasingly sought to advertise himself as a divinity dwelling among men. To put it crudely, one might imagine the early Christians running around Rome with magic markers defacing government posters by sketching in a bearded Christ over the emperor's face.

The scope of the Emperor Mystique is simply breathtaking. On the simplest level it has been invoked to explain certain formal, compositional traits in Early Christian art, such as frontality and symmetry. Thus the grand apse compositions of Christ, enthroned among his apostles and staring down the nave of the church over the heads of the faithful (figs.69–71) represent a takeover of images of the emperor who was similarly presented in the imagery of his propaganda, enthroned among his councillors or senate. Frontality and symmetry are considered an imperial mode of composition, and the images of Christ get their punch from evoking in the viewer latent memories of the emperor in the same pose.

Other kinds of specific compositions are said to carry similar evocations. Christ entering Jerusalem to the acclamation of the crowd (fig. 10) is seen as recalling images of the emperor being received at the gates of a city in a ceremony called the *adventus* (fig.8). Christ enveloped in an aureole of glory is supposed to have been copied from images of the emperor on shields (fig.88). In this manner, it is believed, the repertoire of Christian images was gradually constructed.[20] One would have to be not only brash but extremely patient to try to undo the countless connections that have been alleged.

But the Emperor Mystique involves much more than visual links between Christian and imperial art; it constitutes an "ideology." It involves what people have imagined to be a comprehensive theory of the period embracing virtually all cultural phenomena. In the largest scheme of things we meet the overarching philosophical justification of the autocrat's legitimacy. Within a few years of the conversion of Constantine, Bishop Eusebius of Caesarea in Palestine (c. 260–c. 340) was already busy formulating for the emperor a Christian theory of divine kingship that would give a new twist to late Hellenistic theories of kingship.[21] The emperor's governance of the Empire (which Romans were fond of calling the whole world) was likened to the Lord's governance of the universe; Eusebius called the emperor vicegerent of Christ, an apostle for the secular sector. Imperial overtones in representations of Christ, then, would harmonize neatly with the philosophical theory of the emperor's divine rule. Christ resembles the emperor because the emperor resembles Christ.

Beyond the philosophical realm, the Emperor Mystique has an important theatrical dimension. The emperor, we are reminded, presented his case to the

public not only in the static imagery of sculpture and painting but in the living imagery of court ceremonial, as the lead actor in a colorful drama of carefully staged processions, receptions, eulogies, enthronements, and hippodrome appearances. The splendid dress of the emperor and of his hierarchy of court officials and attendants, the gleam of the shields and banners of the military guard, the repetitious chant-like character of the greetings and acclamations offered to the emperor, must have made an enormous impression on the public. At the same time across the piazza from the hippodrome, in the cathedral, the public enjoyed a parallel ceremonial display in the Christian liturgy. The church might be described as the court of the heavenly king, and his representative and successor, the bishop, not to be outshone by secular pomp, practiced a pomp of his own. The church had its hierarchy of officials, as well, nicely distinguished by dress and insignia, and its own elaborate processions, receptions, its ritual chants, hymns, and sermons.[22]

All this ceremonial drama is currently described in metaphors of the Emperor Mystique. The church building is imagined to have been modelled on the imperial court; after all, etymologically, basilica means a "royal" hall.[23] Furthermore, the great arch over the sanctuary is described as the "triumphal arch" (figs. 70, 86, 120), positing a parallel with the grand, free-standing sculptural arches erected to commemorate conspicuous imperial triumphs, the arches of Titus or of Septimius Severus in the Roman Forum, for instance.[24] When Christian architects experimented with domed buildings, round and polygonal, these we are told are reflections of reception halls or *triclinia* within the sacred palace of the emperor (court language called everything imperial "sacred"). The central space under the dome is imagined to be reserved especially for the encounter between the emperor and the patriarch, while the faithful gathered in the surrounding aisles and ambulatories (fig. 111).[25] "It is hardly surprising," remarks Otto von Simson, "that an age which conceived the monarchical sphere as a reflection of the celestial one should have visualized the Epiphany of the Savior (as evoked by the liturgical drama) after the pattern of the epiphany of the emperor and that it should have designed the sacred stage on which the manifestation of the godhead took place after the model of the ceremonial court of the imperial palace."[26]

The Emperor Mystique then embraces the decoration of the entire church. The dominating apse composition of Christ among his saints is interpreted as Christ the King holding court or issuing his imperial proclamations; the deeds of Moses and Christ decorating the walls are read as parallels to the feats of the emperor set out in public Roman monuments; and when the church is topped with a dome, which is the case in a limited number of splendid Early Christian examples, the dome is interpreted as the extension of a "cosmic" canopy that

15

hung over the emperor's head. The imagery that decorates the dome makes it a symbol of universal dominion, formerly of the emperor, but now of Christ.[27] The Emperor Mystique explains all.

Perhaps it is precisely this all-encompassing character of the imperial interpretation of Early Christian art that makes art historians shrink from touching any piece of the grand jigsaw puzzle. So much seems to be explained by the Emperor Mystique that further progress can be imagined only through the fitting of ever smaller and more insignificant details into the already well-defined picture; it is unimaginable that the initial premise might be mistaken. In fact, the elaborate interlocking arguments about imperial precedents and imperial ideology have created a self-confirming system which pretends to accommodate all the evidence while actually practicing a radical exclusion. Where the evidence presents a gap, the persuasion of the argument posits the existence of evidence that has disappeared; on the other hand where the evidence conflicts with the argument it is dismissed as anomalous. The theory has become the screen for deciding the admissibility of evidence.

How THE EMPEROR MYSTIQUE came to be the controlling theory for explaining the development of Christian imagery makes an interesting chapter in twentieth-century intellectual history. Indeed the need to interpret Christ as an emperor tells more about the historians involved than it does about Early Christian art. The formulation of the theory can be traced to three very bold and original European scholars in the period between the wars: the medievalist Ernst Kantorowicz, a German Jew of a well-to-do merchant family; the Hungarian archaeologist Andreas Alföldi, son of a country doctor; and art historian André Grabar, a Russian emigré, whose senatorial family held important posts under the last Czars. Why three men of such varied backgrounds should have been preoccupied, on the eve of the Second World War, with the pomp and circumstance of the Roman emperor, and should have sought to find therein the explanation for the birth of Christian art, is a question not without bearing on the way the twentieth century has written the history of art.

The expectation that Germany ought to produce a modern emperor-savior underlay the thinking of the first great proponent of the Emperor Mystique, Ernst Kantorowicz (1895–1963).[28] From a wealthy family of Posen in East Prussia (now Posnan in Poland), he followed the curriculum in classics and history at the Kaiserin Augusta-Viktoria Gymnasium in Berlin, after which he started studies at Berlin University. With the outbreak of war, after barely a year at the university, he volunteered for service in a regiment of field artillery. Wounded in the infamous Battle of Verdun, Kantorowicz, like many patriotic Germans, was deeply distressed at the collapse of Kaiser Wilhelm II's govern-

ment in 1918. After the war, as a student at the University of Munich, he enlisted in the "White Battalion," a kind of vigilante anti-Marxist movement that gave momentum to the Hitler-Ludendorff Putsch of 1923. That his actions contributed to the rise of Nazism Kantorowicz was to admit with regret later in his life, when he took up the defense of academic freedom against the imposition of an oath of loyalty at the University of California in 1950.[29] But in Germany between the wars he was not privileged with foresight of what was to come.

At Heidelberg, where he finished his university training, Kantorowicz fell under the charm of the symbolist Stefan George. A major poet and a kind of heroic seer, George recruited an elite of gifted young men who, he hoped, would make come true his dream of the rebirth of a purified Germany.[30] It was in this spirit that Kantorowicz wrote his landmark study, a life of the great Holy Roman Emperor, Frederick II (1927). An idealized portrait of the medieval German monarch, it carried on its frontispiece the emblem of Stefan George's literary journal, *Blätter für die Kunst*, namely a swastika within a wreath, soon to become the emblem of National Socialism.[31] The book had an enormous success, running through three editions with a record-breaking 10,000 copies. Kantorowicz was an instant celebrity. He was appointed in 1930 as Honorarprofessor at the University of Frankfurt and in 1932 to a full professorship. The glory, however, was as brief as it was sudden. As a Jew he had to refuse the 1934 oath of allegiance to Hitler and resign his post. He lingered in Berlin until the horrors of Kristallnacht, the 9th of November, 1938, when he was forced to flee to England. After his tenure at the University of California he spent his last years at the Institute for Advanced Study in Princeton.

Though he disavowed art historical expertise, Kantorowicz constantly turned to artistic monuments for his historical evidence, and art historians in turn have relied heavily on his studies of medieval kingship.[32] A parallelism of Christ and emperor underlies all of Kantorowicz' discussions of kingship. A grand continuity in monarchic traditions was a basic assumption: medieval imperial practice and imagery were believed to be continuous with those of Late Antiquity, and Early Christian art was interpreted as the link between the two.

Equally fundamental for the development of the Emperor Mystique was the contribution of Andreas Alföldi. Born in Budapest in 1895, Alföldi had to go to work at age fifteen, after his father's death.[33] In World War I he served four long years in the Austro-Hungarian army on the eastern front. Wounded in combat with the Cossacks, he spent his convalescence writing his dissertation. After the war he held posts at the Hungarian National Museum and the University of Debrecen and was finally appointed to the chair of Ancient History and Archaeology of the Hungarian territory at the University of Budapest, where

he remained until 1947. Like Kantorowicz he spent the last phase of his career at the Institute for Advanced Study in Princeton, until his death in 1981.

An ardent patriot, Alföldi always deeply regretted the fall of the Hapsburg Empire. It is significant that, while the great nineteenth-century Classicist Theodor Mommsen was personally involved with the contemporary liberal democracy movement in Germany and focused his scholarship on Roman history of the period of the Republic, Alföldi focused rather on the period of the Empire, which he regarded as the culmination of Ancient History.[34] For Alföldi, Caesar was a benevolent monarch, a savior answering the yearnings of the masses too long oppressed by the aristocracy of the Republic. Coin imagery expressing the messianic expectations of Vergil's Fourth Eclogue is the theme of an article of 1930.[35] If Kantorowicz set the stage for the drama of the Emperor Mystique, Alföldi did the costumes. In a pair of brilliant studies of imperial ceremonial and imperial insignia Alföldi followed the growth of the external trappings that surrounded the sacred person of the emperor, tracing what he thought was a continuity from Roman practices through Byzantine.[36] These two articles are works of extraordinary thoroughness and are among the most cited in the entire literature on Early Christian art. However, in the world of German scholarship to which he belonged Alföldi's contributions had an unmistakable political ring. On the eve of the Second World War he was writing about "Germania" as a personification of military virtue in Roman art.[37]

The third scholar to share this grand vision became the most eloquent spokesman for the Emperor Mystique.[38] Born in Kiev in 1896, André Grabar's father was President of the High Tribunal in Kiev and then counsellor of the Court of Appeals in Petrograd (St. Petersburg), while his mother was daughter and granddaughter of generals who had served Czars Alexander I and II. In the First World War Grabar saw service as a medic in the Austrian campaign before being excused for reasons of health. Thereupon he resumed his studies in Petrograd, where the czar's government was rapidly disintegrating, until overtaken by the tumultuous Bolshevik Revolution. Fleeing to Odessa, he managed to complete his degree during the anarchy of Russia's civil war. In January of 1920 he and his mother were among the last to escape Odessa as the Red Army took control of that city.

After a brief residence in Sofia, Bulgaria, Grabar found a post at the University of Strasbourg where he prepared his decisive work on the emperor in Byzantine art, basically a continuation of the research of Alföldi, to be published in 1936.[39] The following year Grabar was chosen to succeed the distinguished art historian Gabriel Millet at the Ecole des Hautes Etudes in Paris. After the Second World War, in 1946, he was appointed to the prestigious chair of Byzantine art at the Collège de France, and during the next fifteen years

Grabar was invited nine times for prolonged stays at the Dumbarton Oaks Center for Byzantine Studies in Washington, D.C., where his international contacts multiplied his impact on the field. His study of the emperor laid down the basic premises of an approach that he pursued in a flood of subsequent books and articles, but his theory found its fullest expression in a set of lectures that he delivered at the National Gallery of Art in Washington in 1961, subsequently published as *Christian Iconography, A Study of Its Origins*.[40] This is a comprehensive study of the initial development of Christian imagery, and as such it stands alone in the field.

If there is a single common thread uniting the life and work of these three great scholars, it is nostalgia for lost empire. The three imperial states in which they were raised, and which they fought valiantly to defend, they saw crumble ignominiously in the horrible chaos of the First World War and its consequences. The glory of the czars, the might of the Prussian and Austro-Hungarian emperors, could never be restored. Accordingly Kantorowicz, Alföldi, and Grabar turned their scholarly energies to the great emperors of history—to Julius Caesar, Constantine, Frederick Hohenstaufen, or the emperors of Byzantium. These still remained, and to their defense one could devote one's loyal energies without fear of disappointment. When they undertook this theme, moreover, it held more than antiquarian interest. In the troubled years between the wars scholars of the political right felt they had something to say to their contemporaries. A call to greatness in the model of past imperial accomplishments is implicit in their scholarship. After the Second World War the political point of their message was somewhat less urgent, but the brutal and vulgar Communist alternative could be seen as demonstrating the basic correctness of their thinking.

Their voices were not alone. Around the three promulgators of the theory a second phalanx soon formed, developing other aspects of the Emperor Mystique. What is amazing is the close harmony of views among men of such diverse background. Sometimes expressly dependent on the work of the three, sometimes taking fresh intiative, they found agreement in their investigations concerning the imperial inspiration of Early Christian art.

The Norwegian classicist H.P. L'Orange looked at the evolution, or what he called the "devolution," of portraiture in Late Antiquity in which individual features were gradually lost and the emperor was made over into a stereotypical "saint."[41] On the other hand Friedrich Gerke, who exchanged a career as a Lutheran theologian for a professorship in art history and founded the Art History Institute of the University of Mainz, studied the image of Christ on sarcophagi and saw a gradual tendency to make Christ over into the likeness of the emperor.[42] Gerke made no secret of his allegiances: his work on Christ in

Late Antique sculpture bears a dedication to the professed Nazi art historian Hans G. Sedlmayr on the date of April 20, 1939—that is, the fiftieth birthday of Adolph Hitler. Meanwhile Catholic priest Johannes Kollwitz of the University of Freibourg im Breisgau was systematically collecting all the texts of Early Christian times that allude to the kingship of Christ, which he published in a Catholic theological periodical.[43]

While the preponderance of this work initially was done in Germany, or by German scholars, after the war the Emperor Mystique became an international intellectual phenomenon. Ease of communication allowed the three original promulgators to pool their energies, and in 1950, at the first symposium sponsored by Dumbarton Oaks, Grabar brought Alföldi and Kantorowicz together to share their research on the theme of the Byzantine emperor. Joining them in presenting papers were H.P. L'Orange, from the University of Oslo, Francis Dvornik, the historian of Byzantine kingship, and Paul A. Underwood, the director of Dumbarton Oaks. The program for April 27–29, 1950, was exclusively concerned with the Byzantine emperor: André Grabar, "The Emperor and the Palace: Introduction"; Francis Dvornik, "Origins of Byzantine Ideas on Kingship"; Ernst H. Kantorowicz, "Synthronos: God and King as Throne-sharers"; Hans P. L'Orange, "The Origin of Byzantine Imperial and Religious Portraiture"; Andreas Alföldi, "The Canopy over the Byzantine Imperial Throne and its Origins"; Kantorowicz, "Epiphany and Byzantine Coronation"; L'Orange, "Iconography of Cosmic Kingship in Persia, Rome and Byzantium"; Paul A. Underwood, "Problems in the Topography and Architecture of the Great Palace of the Emperors"; Grabar, "The Orientalization of the Byzantine Court and its Art." L'Orange's lectures presented the first stages of his work on "Cosmic Kingship," to appear in book form in 1953.[44] Catholic priest Dvornik offered a chapter from his life's magnum opus on Byzantine political thought.[45]

The Dumbarton Oaks symposium defined the direction American scholarship was taking. Unlike most Jewish refugees from Hitler, the aristocratic Otto von Simson, after spending the forties at the University of Chicago, eventually returned to Germany to take a position at the Freie Universität, Berlin. But it was during his stay in the United States that von Simson published his widely read *Sacred Fortress*, which frankly relied on the research of Grabar. This very provocative work attempted to explain the building and mosaic programs of Ravenna in the period of Justinian by appealing to a masterplan of imperial statecraft formulated in Constantinople.[46] On the other hand Karl Lehmann-Hartleben, who was one of Germany's leading Classical archaeologist when he fled Hitler's regime in 1933, seems to have worked independently

of the core group. Taking up his residence at New York University, he worked during the war on the cosmic and imperial implications of dome decoration, publishing his results in an article of 1945.[47] It was his only venture into Early Christian studies, but it was frequently cited, perhaps because it fit so neatly the expectations raised by the Emperor Mystique.

In this fashion the "Kaisermystik" was internationalized. It has remained unchallenged. As if by silent conspiracy, art historians have agreed not to question the theory formulated in the 1930s. The imperial structure of Christian imagery is a dogma too sacred to tamper with. Incorporated into handbooks of art history in English, French, and Italian, as well as German, it still represents the prevailing opinion on the rise of Christian art.[48]

It is my belief, however, that the whole of Early Christian art needs to be re-assessed in a most fundamental way. This is a task for an army of historians and well beyond the scope of this essay. It might be useful, however, to look at a select number of themes that pose critical test cases for the application of the Emperor Mystique. In one instance after another it seems to me that we have been calling motifs "imperial" where imperial insignia are in fact totally lacking.

This raises the question of what would happen if the superstructure of "Kaiser-kult" were removed. This is, to my mind, the real problem facing the study of Early Christian art. If Christ is not the emperor, who is he? In whose voice do these images speak? If their power is not a latent imperial authority, what is it? The question of power is critical during this war of images. One might put it in quasi-Darwinian terms of the survival of the fittest and most effective images. Why is it these images carried such assertive inner energy while other images—gods and goddesses galore—were failing like dinosaurs that had no more fight left in them?

If we were to see these early images of Christ with a fresh vision would we find them more benign or more sinister? More intimate or more strange? What do they really look like? The answer is not simple or univocal. Earlier in this century scriptural scholarship was tortured with the quest for the "historical" Jesus, an enterprise that verged on reducing him to the product of wishful thinking on the part of his first disciples. Since Christ wrote nothing himself, the historian is necessarily limited to sifting through the distorted impressions of a circle of people who were very deeply affected by their experience of him.[49] The Christ of Early Christian art is quite as elusive as the "historical" Jesus. As in the written sources, so in the visual monuments Christ has many guises, depending on who is visualizing him. We are faced, then, with the difficult task of understanding as far as possible the impression Christ made on people when

they, for the first time, were seeking to represent him. Hitherto he had existed only in the hearts of believers, in the visions of mystics, in the words of preachers; now he was to have a life in stone and paint. This period, from the mid-third century to the mid-sixth, was decisive; something radically new came into existence that had not been there before. It is important for the history of all subsequent Christian art that we read these beginnings carefully.

The Chariot and the Donkey

ONSTANTINE is one of a handful of figures who for better or worse have unalterably affected the course of human history.[1] Few rulers have had a parallel opportunity: the chance to see new possibilities in an aging, corrupt empire and make way for the emergence of a radically new social order. Constantine could hardly have foreseen what shape the new order would ultimately take; he could see, however, the structure of the Church that was already in place and quite visible, with its cohesive communities organized under bishops, priests, and deacons, its energetic societies for the upkeep of the poor, and its strong financial system. Historian Peter Brown has remarked how, after the barbarian raids of 254 and 256, the Christian communities of Rome and Carthage sent large sums of money to ransom captives, a responsibility that the Roman government was not able to assume; to be a Christian was already a better insurance policy than was Roman citizenship.[2]

Constantine's enlistment on the side of Christianity did not make the Church the "established" religion, nor did it undermine the entrenched position of the pagan aristocracy of the Empire. However, it did entail a sudden new prominence for the Church and the immediate involvement of skillful bishops in affairs of state. Constantine elevated bishops to the rank of praetors, or magistrates, creating an alternate juridical system in one stroke, and he gave them free transportation on the imperial post. Moreover, Constantine himself took an active interest in the building projects of the Church, erecting and endowing at imperial expense such grand monuments as the Lateran Cathedral and the "Old" St. Peter's in Rome and the Church of the Holy Sepulchre in Jerusalem. Constantine is even said to have decorated the sanctuary of the Lateran with images of Christ and the apostles, which unhappily have not survived. The impact of Constantine as a patron on the evolution of Christian

art was, therefore, quite considerable. How this affected the development of the image-language is another question.

In the early fourth century Christians were expanding their repertoire of succinct, unconnected images, adding new scenes of Christ's miraculous cures. Alongside these "staccato" images, however, several more ambitious images were now introduced, composed of larger groups of figures along with indications of the setting in which events took place. Generally these new images were placed side by side with the older staccato images, disregarding programmatic or chronological connections, although occasionally two or three images were purposefully linked together to make a more complex statement. Among the new subjects are the Adoration of the Magi (figs.61–63), the Entry of Christ into Jerusalem (fig.10), and Christ in an aureole of glory (figs. 88, 92).

This development marks the transition to which Grabar rightly attached so much importance; now Christian art was struggling to enunciate a more complex and nuanced message. The question is, what is the message? In all three of these images Grabar, and many subsequent art historians, have read imperial implications. Because these subjects seem to appear after Constantine's conversion (though the dating of the earliest such images is problematic), they are attributed to his influence. For the Entry of Christ into Jerusalem a very specific imperial connection has even been suggested, namely Constantine's own triumphant entrance into Rome in 312 immediately following his miraculous victory under the emblem of the cross-monogram of Christ. The German art historian Erich Dinkler imagined that in seeing Constantine enter the city, Christians would have associated his arrival with the arrival of the Christian faith; as a symbol for this novel experience they invented the new image of the Entry.[1] The Entry, then, is from many points of view a critical litmus for the Emperor Mystique theory.

The explosive reception of Christ only days before his trial and execution is a subject laden with dramatic possibilities, and its commemoration on Palm Sunday is still one of the most popular dates in the Christian calendar, perhaps because it gives people a rare chance for play-acting. In denominations closer to Catholic traditions people parade about the church carrying palm fronds and singing, welcoming their pastor as if receiving Christ into Jerusalem. Equally popular is the artistic theme of Christ's Entry, which since its introduction in the fourth century has been repeated thousands of times.

A long series of art historians have alleged a derivation from imperial imagery for the Entry.[2] Indeed, this notion is now so widely accepted that no one can refer to images of the Entry, whether in Early Christian or in any subsequent period of art, without buzzing the word *adventus*. Invoking this

technical term is like humming the first bars of Beethoven's *Eroica*, it carries such a load of triumphal associations.

The *adventus* is the imperial ceremonial "par excellence," as a recent author has called it, the ceremonial that more than any other involved the public presentation of the emperor to his subjects.[5] A parade ceremony in which the Roman emperor was received on state visits to the great cities of his empire, the *adventus* presents a superficial analogy, it must be admitted, with Christ's Entry. In both instances a person was being received at the gates of a city. The Emperor Mystique argument, however, cannot be sustained on so vague an analogy, for in fact any distinguished citizen could be accorded an honorary reception when arriving at a city; it is not a peculiarly *imperial* happening.

For example, the story is told that on approaching Antioch, Cato the Younger saw a great crowd lined up on either side of the road outside the gate, "in one group young men with military cloaks and in another boys with gala robes, while some had white raiment and crowns, being priests or magistrates." The sight upset him at first because, being a modest man, he had expressly forbidden any display in his reception. Then he realized the reception was for a freedman of Pompey, one Demetrius.[6] In Late Antiquity, moreover, the reception of the nobleman at his estate was represented with increased frequency in art. The mere fact that Christ is received with some ceremony is not enough to justify an imperial reading of the subject. We must ask precisely what elements in the representation of Christ's Entry were borrowed from images of the imperial *adventus*, a question art historians have failed to investigate.

The emperor's *adventus* is a well documented ceremony. Unlike the present pope, the emperor did not begin his visits by humbly and ostentatiously kissing the ground. The emperor presented himself as the indomitable, ever-victorious commander-in-chief of the armed forces. On a relief on the Arch of Galerius in Thessalonica erected in A.D. 300, the Emperor Galerius appears larger than life seated in his horse-drawn chariot (fig. 8). He wears military dress—the knee-length soldier's tunic for ease of movement, over which is thrown a semicircular cloak or chlamys fastened on his right shoulder, and boots. Banners fly overhead and the cavalry swirl around him carrying shields and spears. The parade is shown leaving one city on the left and arriving at another, Thessalonica, on the right, where the civilian population, issuing from the gate, cheer his arrival waving torches (barely visible due to the deterioration of the relief). Returning victorious from his Persian campaigns in 299, Galerius arranged that the city of his residence should celebrate his triumphant arrival and he had the celebration carved in stone so no one would forget it.

Emperors also commemorated their *adventus* by issuing gold coins to

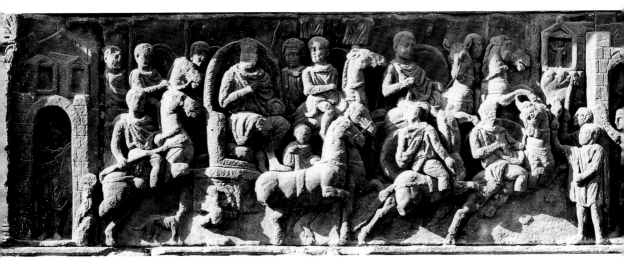

8. The Emperor's *Adventus,* Arch of Galerius, Thessalonica, 300

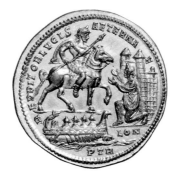

9. *Adventus* of Constantius Chlorus on gold coin, 296–298

which art historians often turn for *adventus* imagery (fig.9). The coins, however, make no attempt to represent the actual ceremony but offer various symbols of the emperor's arrival. Instead of riding in his parade chariot, the emperor appears simply as a warrior, on foot or riding a horse, with spear and shield in hand; instead of his army, a Victory might accompany him with a crown or a palm branch in hand; instead of the citizenry, a personification of the city might appear. This is a symbolic short-hand intended to commemorate but not to portray the historical event.[7]

Both the parade event itself and the art that represented it were products of a powerful propaganda machine that defined both the emperor's role and how people were to react to him. Galerius' *adventus* must have had some of the chilling effect of an old-fashioned missile parade in Red Square. This is the kind

of reaction Ammianus Marcellinus described when he witnessed Constantius II's *adventus* in Rome in 357.

The emperor, according to the contemporary historian, entered Rome in a battle array so ostentatious one might think he was trying to overawe the Persians with his show of arms. First came marching infantry, with shields and crested helmets; then came the cavalry "all masked, furnished with protecting breastplates and girt with armor belts, so that you might have supposed them statues polished by the hand of Praxiteles." Then there came standard-bearers on either side carrying banners stiffened with gold and dragons "woven out of purple thread and bound to the tops of spears, with wide mouths open to the breeze and hence hissing as if roused by anger, and leaving their tails winding in the wind." Finally the emperor himself appeared, seated in a golden chariot, clothed in a "resplendent blaze of shimmering precious stones." Although people shouted salutations that made the hills ring, the emperor never moved a finger to acknowledge them, but "as if his neck were in a vice, he kept the gaze of his eyes straight ahead, appearing like a statue rather than a man."[8] The *adventus* was a military parade designed to strike fear and awe into the hearts of the bystanders.

The imagery of Christ's Entry belongs to a totally different world, and there was not the slightest chance that contemporary spectators would have confused them. Two separate versions of the Entry appeared in the fourth century, a Roman and an eastern version. The first developed in the sculpture of Roman sarcophagi, the second in sculpture in Egypt and later in manuscript illumination in Palestine. The Roman version subsequently became the basis of representations of the Entry in the medieval West, while the eastern version became the standard format in Byzantine art. Each has something striking to say about how the Christians of the early centuries wanted to see their Savior.

At last count twenty-eight Roman sarcophagi were known to carry images of the Entry of Christ into Jerusalem.[9] A particulary fine example in the Museo Nazionale delle Terme, Rome, has recently been cleaned and may stand for the group (figs. 10–12). It belongs to the second quarter of the fourth century, immediately after Constantine's assumption of power. The action moves from left to right and it involves six figures, three of them apostles. The apostles are individualized by distinctions in hair, beard, and age: the one immediately behind Christ is given the receding hairline and beard characteristic of Paul, although historically Paul was not a witness to any of the events of the life of Christ; the one who precedes the party on the right has Peter's bushier hair, and like Paul carries the scroll of a man of learning.

Christ is distinguished from his apostles by his youth; he has smooth plump cheeks and a full mane of gentle curls falling forward over his forehead.

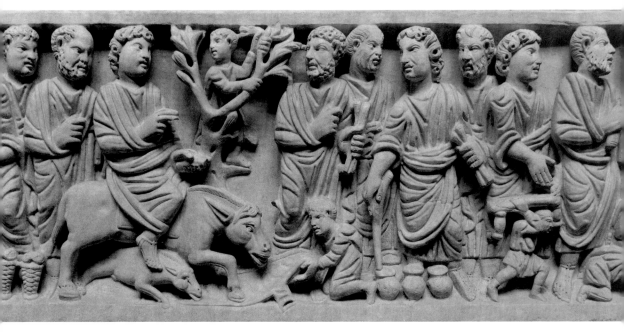

10. Sarcophagus with Entry of Christ into Jerusalem and Miracle Scenes (Cana; Cure of the Paralytic; Peter Striking Water), c. 325, Museo Nazionale delle Terme, Rome

Like his colleagues, Christ dresses in tunic and pallium, his right arm enclosed in the sling of the pallium the way a philosopher traditionally wore the garment, and his hand gestures in speech or blessing. In his left hand he holds not a scroll—the scroll is usually held erect—but a rod or wand that has been broken off; the break is visible where it touched the head of the ass (fig. 11). The humble beast of burden is shown at reduced scale, plodding along with head down and with her foal under her belly. Consistent with Mt. 21: 7, a garment covers the ass's back; a diminutive man spreads another in front of her and overhead another little man clambers in an olive tree, pulling at its branches. These two men, dressed in short tunics, represent the crowd of common people: "Most of the crowd spread their garments on the road, and others cut branches from the trees and spread them on the road" (Mt 21:8).[10] That's all there is to the image. Curiously enough, the portal of the city is not shown, though it would make a natural part of the story. Of the the twenty-eight sarcophagi with the Entry the gates of Jerusalem appear only on three, and then rather accidentally, in that the whole relief was given an arcaded background.[11]

One searches in vain for a single element that might have required the sculptor to have recourse to borrowings from imperial imagery. Neither char-

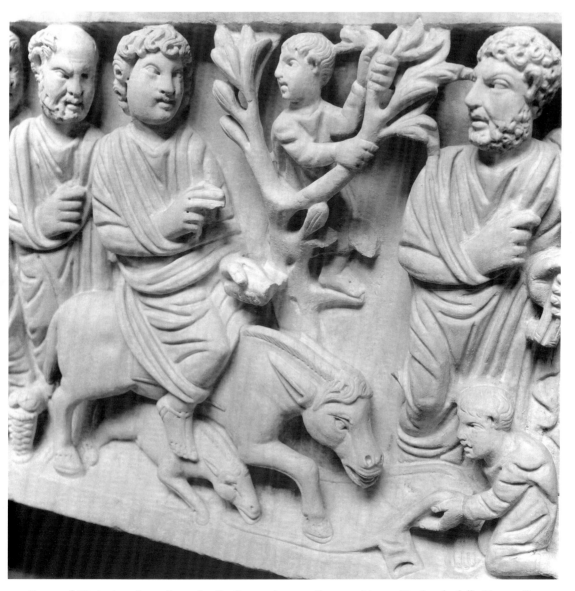

11. Entry of Christ into Jerusalem, detail of sarcophagus of c. 325, Museo Nazionale delle Terme, Rome

iots, nor horses, nor armor, nor weapons, nor banners, nor any of the trappings of the emperor's parade figure in the Entry into Jerusalem. In the stratified world of Late Antiquity, dress was a most important index of status, and the easiest way to make imperial claims for Christ would have been to give him some article of imperial dress; it is therefore significant that Christ and his

companions wear the civilian attire of tunic and pallium. The asinine nature of Christ's transport is emphasized in the images by the small stature, large head, and huge ears of the beast. Moreover, the trees and the figures in or beneath them, so prominent a part of the image, never occur in the *adventus* imagery.

Palm branches can be associated with imperial triumphs, but there were other more common uses. In the hippodrome, a palm branch was the prize of the victor, and in Greek worship the "carrying and waving of branches is found with great frequency at festivals of the gods."[12] Moreover, in the Jewish tradition, in which after all the story of the Entry is firmly embedded, branches were commonly used in religious rituals of purification. According to modern biblical scholarship the circumstances of Christ's Entry into Jerusalem, particularly the prophetic verses recited by the crowd (Mk 11:9), fit the celebration of the Jewish feasts of Tabernacles or of Dedication, at both of which ceremonies branches were carried in procession.[13] The fact that the Jewish crowd carried branches had nothing to do with the emperor cult.

Neither does the spreading of garments before Christ derive from Roman imperial traditions, but rather from oriental traditions of hospitality. Aeschylus was alluding to this when he made Agamemnon tread upon the purple that Clytemnestra had spread for him.[14] But the closest precedent for the Gospel story is the account of the hasty reception given Jehu (2 Kgs 9:13); when his men heard that the prophet had anointed him king and they spread their cloaks on the bare steps before him. It is an unusual and spontaneous gesture with no known precedent in imperial ceremonial.

If the Entry does not spring from imperial sources where does it come from? If Christ is not playing emperor, what role is he assuming in these images? The answer requires some understanding of the tradition of sarcophagus cutting in Rome.

Sarcophagus sculpture was a conservative art practiced within the parameters of an established repertory of subjects.[15] It was an art with a long pagan history under the Empire before Christian patrons began coming to the workshops and asking for subjects more consistent with their beliefs. Confronted with such novel demands, the sculptors at first reviewed the kinds of images with which they were familiar to find motifs that could be adapted to the new purpose with the least trouble. The result was often a certain stretching or twisting of the biblical subject as it was fitted to the pre-existing framework of imagery designed for Roman mythology.

The image of Jonah resting under his vine is an instructive example of this process, since it was pointed out almost a century ago that Jonah's languid, naked figure—hardly the picture of a dour and gloomy prophet—is an adaptation of Endymion waiting for the arrival of his lover Selene, the moon goddess

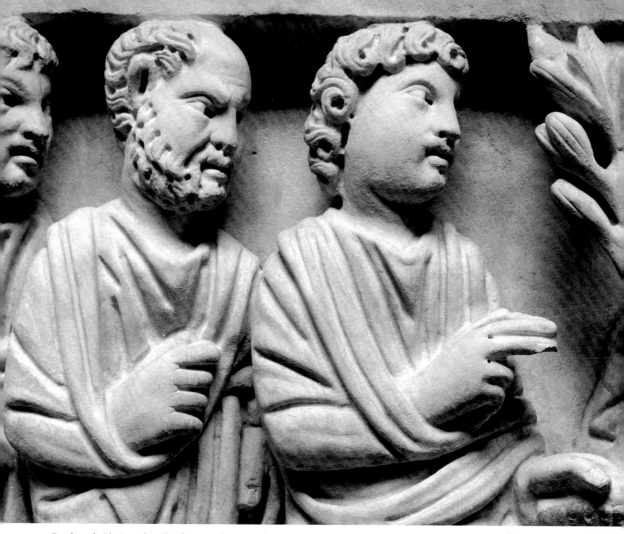

12. Paul and Christ, detail of sarcophagus of c. 325, Museo Nazionale delle Terme, Rome

(figs. 13&14).[16] Endymion was a favorite motif for Roman sarcophagi. The mythical youth, having been cursed with the mixed blessing of eternal youth and perpetual sleep, was visited nightly by Selene who made love with him and bore him forty children. Endymion was therefore a type of happy repose appropriate for sarcophagi, if you consider making love while asleep happiness.

When the figure of Endymion was re-employed to tell the Jonah story an interesting transformation took place, for the image could hardly shake off all of its original associations. In the biblical story Jonah's repose under his vine was scarcely happy; after he preached the imminent destruction of Nineveh, the Ninevites surprised him by repenting, and the Lord relented and spared their city. Feeling he had lost face, Jonah went off to sulk and curse his lot (Jon 4). Having chosen the figure of Endymion to represent Jonah in this moment, the

13. The Repose of Jonah, on a sarcophagus from Santa Maria Antiqua, Rome, end of third century

14. The Repose of Endymion, on a Roman sarcophagus, second century, The Metropolitan Museum of Art, New York

sculptor transformed the story and made the prophet's rest into a metaphor of the repose of the blessed. Suddenly the story of Jonah's frustration was turned into a story of full physical satisfaction, not necessarily implying that Christians should expect sex after death, but clearly implying the Christian belief in the resurrection of the body and its incorrupt beatitude after death. That, after all, was the Christians' reason for burying their dead intact instead of cremating them.

When he was required to introduce a new Christian subject, the pre-existing supply of images at the sculptor's disposal restricted his flexibility. The Christian subject had to be bent somewhat to fit what the artist was familiar with and this bending in turn suggested new ways of interpreting the new subject.

Something like this happened when Christian patrons began ordering sarcophagi bearing the Entry of Christ into Jerusalem. If the *adventus* of the Emperor had been part of his pagan sarcophagus repertory, perhaps the sculptor would have been tempted to rework it into the Entry; but in fact the *adventus* never occurred on Roman sarcophagi. The nearest motif the sculptor had was the image of the Roman nobleman going to the hunt, a common subject for sarcophagi with biographical themes. The Entry images contain a number of clues to this earlier history, and one of them is a little, dog-like animal that runs along between the legs of the ass. This, of course, is meant to be a foal, for Matthew said that the disciples had fetched an ass with a foal, and that Christ actually rode on both (Mt 21:2 and 7). But the creature on the sarcophagi is not a spindly-legged foal. Hardly rideable, his belly hugs the ground and he runs along sniffing in the dirt like a hunting dog, because in fact the composition of Christ on ass with foal beneath is derived from a composition of a hunter on horseback with his dog beneath (figs. 10 & 15).

The tree and its climber is another clue to the pre-existing imagery from which the Entry was formed. Strangely enough, although this motif is invariably a part of the Entry imagery, no one bothers asking about its origin. The exception is Erich Dinkler who suggested that the figure in the tree came from images of the nymph Daphne's transformation into a laurel tree.[17] But the Daphne story does not occur in the sarcophagus repertory of imagery, and besides the Entry shows a man, not a woman, in the tree.

On the other hand, men or putti climbing trees are commonplace in pagan Roman sarcophagi in scenes of the harvest, and this clearly is the image that the sculptor was re-working for the Christian scene. A lovely, albeit damaged, example in Berlin's Bode Museum presents a composition strikingly similar to the Entry (fig. 15).[18] The sarcophagus belongs to a biographical type, and it contains four vignettes reading from left to right. In the first the deceased

15. Gentleman's Homecoming, on a biographical sarcophagus, early fourth century, Berlin

appears as a philosopher reading from a scroll; in the second the harvest of grapes on his estate is shown; in the third the deceased appears again, now riding to or from the hunt, a dog beneath his horse; and in the last putti are seen climbing in trees to harvest olives. The olive tree is significant, for the Gospel identifies only palm trees in connection with the Entry (Jn 12:13), but the representations of the event on sarcophagi show only olives trees. This, like the doggy foal, is an accident of the source images, for men climbing palm trees is again a motif foreign to the sarcophagus vocabulary.[19] But working from images of the nobleman going hunting and the harvest of olives on his country estate, the sculptor had ready at hand the basic ingredients which with a little reworking could make a very presentable composition of the Entry of Christ into Jerusalem.

The Roman version of the Entry seems to owe its origins, then, not to images of the emperor and his military parade but to images of Roman aristocracy who saw Christ as one of their own; the associations were not imperial but gentlemanly. Indeed, someone ignorant of the Gospel story might at first glance read the image simply as a landed gentleman riding out to view his olive groves. It should be noted that the landed gentry of the Late Roman empire did in fact celebrate their own private *adventus* ceremonies; their happy homecomings with domestic staff to greet them became a relatively common subject in Late Antique art (fig. 16).[20]

The connection that emerges between representations of the Roman nobleman and the imagery of Christ suggests that Christians saw in Christ someone

quite different from their emperor. If we return to our question about the power of Early Christian images, we must entertain the possibility that the power of this particular image derives not from intimations of imperial *adventus*, but from associations much closer to the social group for whom the sarcophagi were made. After all, the patrons who commissioned these expensive, carved sarcophagi, and who paid the bill to ship so many tons of stone in which to be buried with their loved ones, were themselves members of the upper classes of society. They were aristocracy, rural landlords, and people tied to commerce.[21]

Their portraits speak eloquently of their social aspirations. In the early fourth century a gentleman named Eustorgios had his whole family represented in his painted tomb outside of Thessalonica (fig. 17).[22] His purple cloak, or *chlamys*, reaches his ankles and is decorated with *segmenta* (panels) of rich embroidery, a mark of rank in the civil aristocracy of the city; his wife in a full-sleeved tunic wears pearls both in her hair and around her neck. The mid-fourth-century couple on the sarcophagus from Arles appear in the dress of the leisure class, the wife wearing jewelry, the husband in the traditional toga, holding the scroll of a man of learning (fig. 18). On the "Traditio Legis" sarcophagus from Ravenna at the end of the century, the gentleman on the left wears a cloak over a knee-length tunic; his wife has a tunic that reaches the ground and a *paenula* (fig. 98).[23] In Constantinople in the middle of the fifth century another family portrait was recently found in a tomb of the Silivri Kapi

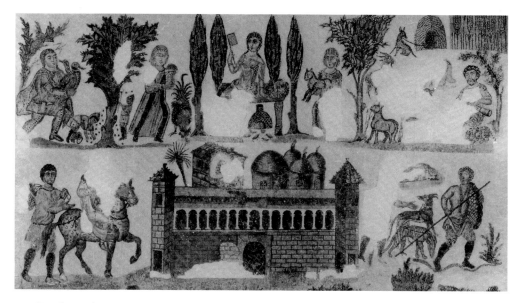

16. Gentleman's Homecoming, on a floor mosaic from the Villa of Dominus Iulius, Carthage, late fourth century

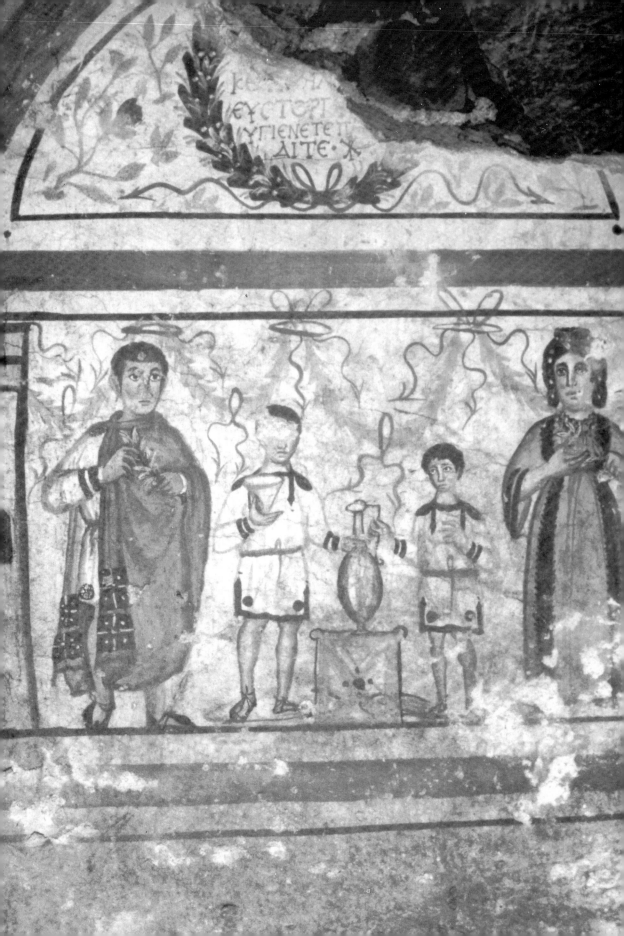

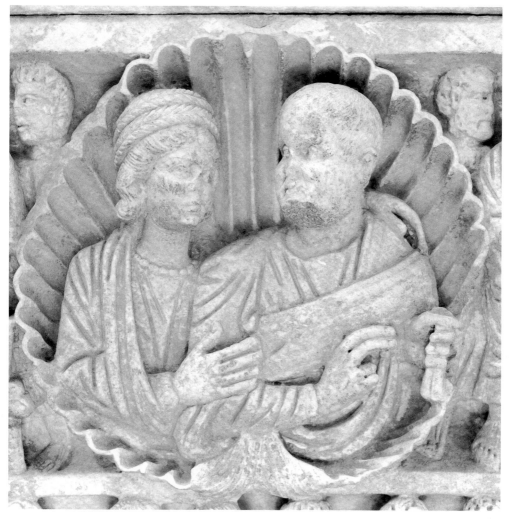

18. Portraits of the Deceased and Family, from a sarcophagus from Trinquetaille, c. 340, in the Musée Réattu, Arles

(fig. 19).[24] Why should we be surprised if people of this class imagined Christ to be one of their own?

Christ as gentleman, of course, is not strictly consonant with the Gospel picture of Christ, any more than the sensuous, nude Endymion image is faithful to the biblical story of the angry Jonah. The Christ of the Gospel was working class, a carpenter and the son of a carpenter, and the Gospels say that people who knew his family resented it strongly when they found an ordinary workman

17. (*facing*) Portraits of the Deceased and Family, in the Eustorgios Tomb, Thessalonica, fourth century

37

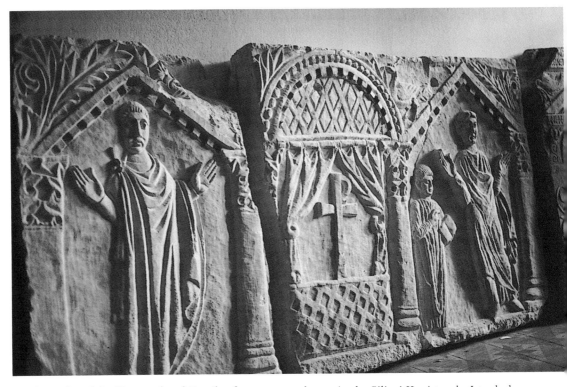

19. Portraits of the Deceased and Family, from a sarcophagus in the Silivri Kapi tomb, Istanbul, mid-fifth century

presuming to teach in synagogues (Mt 13:54–57; Mk 6:1–4). In the Entry, however, although Christ rides on working-class transport, the long tunics and palliums of Christ and his apostles distinguish them quite clearly from the ordinary working class people who come to greet the procession; the lower class wear short tunics without pallium (fig. 10).

To a Roman this all would have made perfect sense: Christ was a philosopher and philosophers were gentlemen.[25] Philosophers, moreover, wielded considerable power and influence in the late Roman Empire, enjoying a status very different from, say, the scruffy American professor whose political importance is generally marginal. In the Late Antique world the philosopher was committed to an "otherworldly" teaching, but he was a person whose wealth made it possible for him to pursue a life of renunciation marked by periods of retirement—on his country estates. He was "vested with an aura of authority" that allowed him to play an effective mentor role in the affairs of state in the fourth and fifth centuries.

Clearly it is in a pacific, non-imperial guise that Christ is presented to us on

the Terme sarcophagus. His garb of long tunic, with his arm caught in the sling of his pallium, identifies him as a philosopher, and indeed this is how the Early Christian apologists from Justin to Augustine regarded him. But the philosopher's role leaves other aspects of the image unexplained. The Late Antique philosopher cultivated a rugged, bearded look quite different from the soft, long-haired Christ on the sarcophagus. And while Christ often carries the philosopher's scroll of learning, on the Terme sarcophagus he carries a wand. These are details, but they cannot be safely bypassed in interpreting the image. Further, why the Entry should have been introduced at this point in the development of Christian art remains unanswered.

ANY ATTEMPT to address this last question must acknowledge the wide popularity of the Entry in the East besides its role in Roman art. In the third quarter of the fourth century a soldier from Thessalonica in Greece took with him to his grave in Pella of Palestine (now Jordan) a little bronze plaque of Christ's Entry.[26] On its reverse a summary representation of Jerusalem's shrine of the Holy Sepulchre tells us where he acquired this religious keepsake and hints at the interpretation intended: Christ's Entry into Jerusalem is employed as pendant to his resurrection. This reminds us that the most important use Christians made of the Entry story was in the liturgy of the eucharist in which, from at least the third century on, the verse of Mt. 21:9, "Blessed is he who comes in the name of the Lord," was applied to his "coming" in bread and wine.[27] The Entry functioned as an emblem of the epiphany of Christ eternal.

The cities of Syria, Palestine, and Egypt were once as rich in Christian art as Rome, but the Muslim conquest of the seventh century erased most evidence of this culture. Nevertheless, the remaining Eastern instances of the Entry emphasize the liturgical significance of the theme by giving prominence to the worshipping crowd. And quite unexpectedly, they commonly show Christ riding side-saddle on the ass.

In Constantinople enthusiastic young men encircle Christ, waving palm branches (fig. 21). To the right, in the missing third of this fifth-century relief, the inhabitants of Jerusalem issued from the city. Also from Constantinople are the ivory book covers now in Yerevan and Paris in which a personification of the city joins the crowd (fig. 23).[28] The sixth-century Rossano Gospel, perhaps from Palestine, enlarges the crowd further (fig. 24). A dense throng of men carry branches, children run after them in a group, and city dwellers lean from their windows to see what is happening. The philosopher-apostles of the Roman sarcophagi have given way to the adoring populace.

Very significantly, in a relief from Egypt, Christ's companions are transformed into angels, one holding the ass's bridle while another supports Christ's

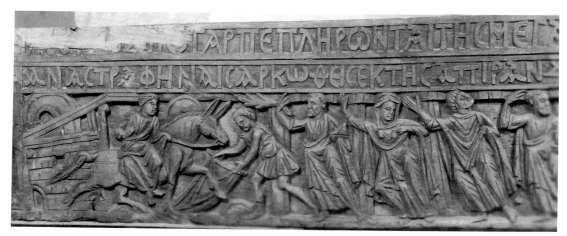

20. Entry of Christ into Jerusalem, from the wooden lintel of Church of the Virgin (Al–Mouâllaka), late fourth century, Coptic Museum, Cairo

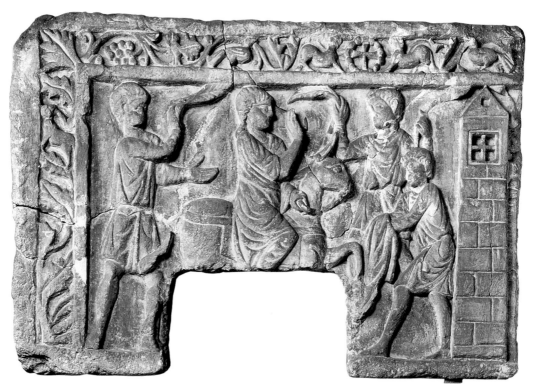

21. Entry of Christ into Jerusalem, limestone sarcophagus relief, fifth century. Istanbul Archaeological Museum, no. 2395

22. The Entry of Christ with Angels, relief of the sixth century, Berlin

blessing right arm (fig. 22). The liturgical intent is unmistakable. In the Cherubic Hymn the Eastern church greets the entrance of the Christ in the bread and wine by singing: "Let us who mystically represent the Cherubim . . . now lay aside all earthly cares that we may receive the King of All who comes invisibly upborne by the angelic hosts."[29] Christ's Entry with angels is his entrance in the divine liturgy.

At the same time these Eastern representations commonly show Christ riding side-saddle on the ass, a motif that became standard in subsequent Byzantine art (fig. 20). All scholars who study Entry imagery distinguish the Eastern from the Western type by this difference in how Christ rides.[30] Yet, however often it is noticed, the meaning of the side-saddle pose is unexplored, as if it were merely a detail of antiquarian lore without consequence for the message of the image. In fact, it is this motif that serves most effectively to advertise the anti-imperial role of Christ, for no emperor ever rode side-saddle. In antiquity, as in modern times, it is pre-eminently a woman's way of mounting a beast, called the "selle de femme" in French. Nor is it possible to wield a

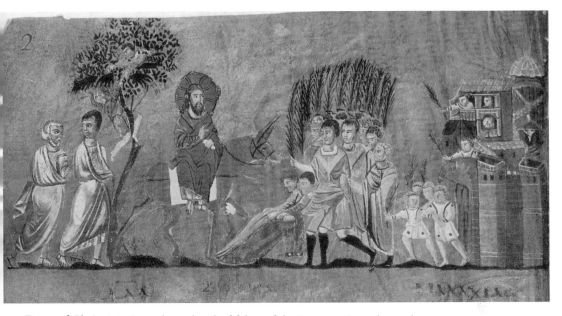

24. Entry of Christ into Jerusalem, detail of fol. 2 of the Rossano Gospels, sixth century

weapon riding side-saddle; it is the ultimate non-military pose. This is the way Jacob's wives ride in the sixth-century Vienna Genesis, also from Palestine, and this is the way Mary rides, whether on her way to Bethlehem, on the St. Lupcin ivory (fig.23), or on the Flight to Egypt on a sarcophagus fragment from Constantinople (fig.25).[31] Or to turn to Late Antique pagan precedents, the Gallic goddess of the horse, Epona, is habitually shown riding side-saddle.[32]

The connotations of this pose are significant. Besides the implication that Christ is assuming a feminine role, a very important observation in view of the way he is presented in some of the other images we shall discuss, the pose requires that we find an alternative to the Emperor Mystique interpretation. Christ does not imitate the emperor's *adventus* but celebrates an explicitly *anti-imperial* arrival ceremony, and this is exactly the way the Gospel interpreted Christ's action. Matthew cites Zechariah's ringing rebuke of the Jews of his day to tell them that arrows and horses are the last thing Jerusalem will need for its messianic triumph: "Rejoice greatly, O daughter of Zion! Shout aloud, O daughter of Jerusalem! Lo, your king comes to you; triumphant and victorious is he, humble in riding on an ass, on a colt the foal of an ass. I will cut off the chariot from Ephraim and the war horse from Jerusalem; and the battle bow

23. (*facing*) Ivory book cover with the Life of the Virgin and the Entry into Jerusalem (Saint-Lupicin Diptych), sixth century, Cabinet des medailles, Paris

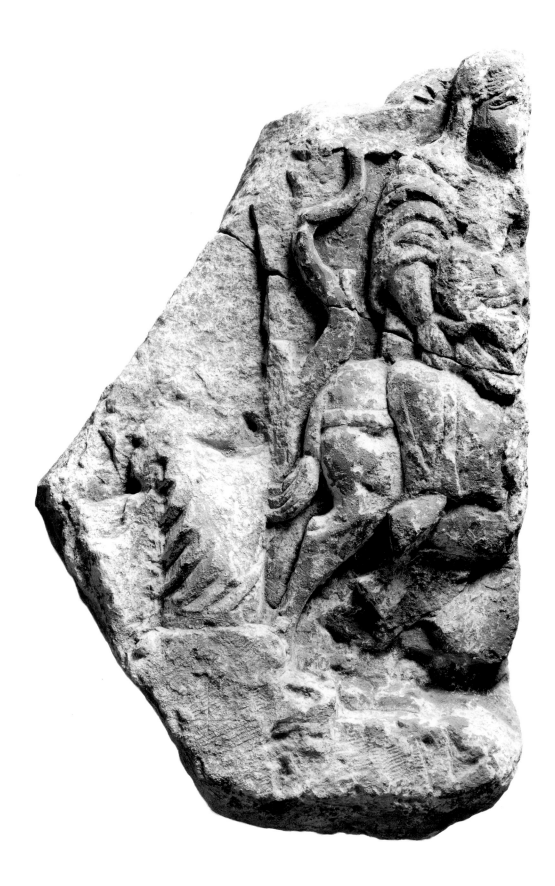

shall be cut off, and he shall command peace to the nations; his domination shall be from sea to sea, and from the River to the ends of the earth" (Zec 9:9–10; cf. Mt 21:5). The opposition between horse of warfare and the humble, agricultural ass is commonplace in biblical language.[33] From the point of view of the Gospel narrative, then, Christ demonstrates the uselessness of imperial parades by doing an anti-imperial *adventus* seated on the least military of all beasts, a farmer's ass.

The lesson was not lost on the early commentators. To John Chrysostom, ever the panegyrist of Christ's humility, the Entry offered a most congenial theme. Christ, he points out, was born of a poor woman in a shed, he chose ordinary men for his disciples, he sat on the grass to eat, he possessed no home, and he clothed himself in what was cheap. He contrasts Christ's behavior with that of the princes of this world; Christ makes his advent, he says, "not driving chariots, like the rest of the kings, not demanding tributes, not thrusting men off, and leading about guards, but displaying his great meekness even hereby. Ask then the Jew, what king came to Jerusalem borne on an ass? Nay, he could not mention but this alone."[34]

The image of a God riding on an ass is an image of extraordinary power. That power derives first from the Buddha-like pacifism of Christ's pose; in assuming the garb and teaching gesture of a Roman philosopher he asserts the adequacy of his philosophy to move kings and kingdoms without touching a weapon. The power of the Philosopher-God is a central theme of Early Christian art. But the power also derives from his insignificant and ridiculous mount, the ass.

The ass, besides its status as prosaic beast of burden, carries associations in classical art which could hardly have been avoided in its Christian use. In classical art the ass is common in Dionysiac processions, whether carrying Hephaistus, the divine smith, on his entry to Mt. Olympus, or Silenus, Dionysus' aged mentor. Both of these are drunk, and both might bear a remote comparison with Christ in that they are figures of wisdom, albeit of a very earthy kind.[35] In addition, a mule, offspring of an ass and a horse, is the common transport of Dionysus himself. Early Christian art is rich with Dionysiac associations whether in boisterous representations of *agape* feasting, in the miracle of water-into-wine at Cana (figs. 34, 37), in vine and wine motifs alluding to the Eucharist, and most markedly, as we will see, in the use of Dionysiac facial traits for representations of Christ.

In the realm of Christian art, moreover, the ass has a surprising prominence

25. (*facing*) The Flight into Egypt, from a sarcophagus frontal of the fifth century, Istanbul Arkeoloji Müzeleri

26. The Sacrifice of Abraham, from the Via Latina Catacomb, Rome, mid-fourth century

aside from its use in the Entry into Jerusalem.[36] This is most noticeable in the choice of Old Testament subjects in the frescoes of the catacomb of the Via Latina in Rome. Found in 1955, this is the most recently discovered of the Roman catacombs and therefore the best preserved.[37] In the Sacrifice of Abraham the ass, which carried the wood for the fire (presaging Christ's carrying of the wood of the cross for his own sacrifice), is accorded a register of its own, as if it were of equal importance with the scene of the sacrifice (fig.26).

Elsewhere in the Via Latina catacomb the scene of Balaam on his ass is used twice (fig.27). Balaam is the soothsayer of the Moabites who was called upon to curse Israël (Nm 22–23). A man of pagan magic, he carries a wand, the way Christ does in the Terme sarcophagus. Balaam's ass, endowed with the gift of speech, recognized the angel of the Lord that blocked his way before Balaam himself did, and Balaam was forced, against his will, to bless Israel and predict the coming of Christ. In an adjacent scene the ass figures still again (fig.28). Samson is shown slaying the Philistines with the primitive weapon of the

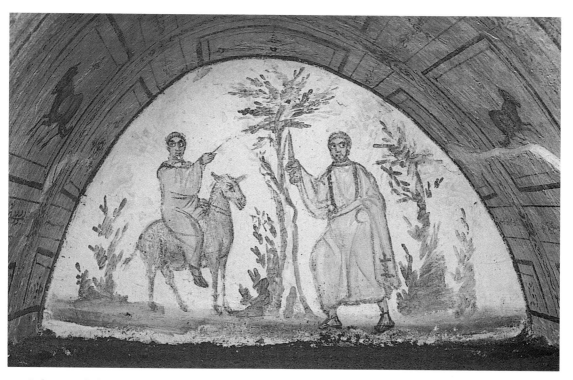

27. Balaam and the Ass, from the Via Latina Catacomb, Rome, mid-fourth century

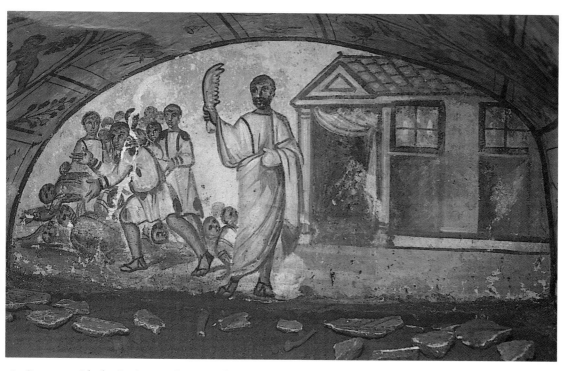

28. Samson with the Jawbone of an Ass, from the Via Latina Catacomb, Rome, mid-fourth century

jawbone of an ass to demonstrate that it is not the sophistication of weaponry but the power of the Lord that brings victory (Jgs 15:14–17).

The importance of the ass has not been properly acknowleged. The worship of the ox and the ass at the Birth of Christ is as common as the Adoration of the Magi in Early Christian art (fig. 29). Isaiah's verse, "The ox knows its owner and the ass its master's crib" (Is 1:3), was taken by Christians to refer to the birth of Christ. They are gifted with the same kind of intelligence as Balaam's ass. The ass, too, is Mary's means of travel, whether on her trip to Bethlehem or in the Flight into Egypt (fig. 25).

In all of these manifold appearances of the ass one detects something of the special pleasure that Christians took in believing that Christ had led them into a kind of looking-glass world in which all traditional values were turned inside-out and upside-down. "I will destroy the wisdom of the wise, and the cleverness of the clever I will thwart, the Lord says" (1 Cor 1:19; Is 29:14). The Virgin Mary announced that the Lord had "put down the mighty from their thrones and exalted those of low degree" (Lk 1:52); what more suitable image of this inversion than a plodding ass carrying the salvation of the world? Symbol of stubborn stupidity, the ass recognized the divine Logos; Balaam's ass was thought by Irenaeus to have recognized Christ, the Divine Word himself, in the angel that confronted him.[38] The ass that looks over the crib practically kisses the Christ child, so intimate has he become with the Word (fig. 29).

The importance of the ass in Early Christian art signals a new attitude toward the whole animal kingdom. While the classical world sometimes drew moral lessons from animal behavior and made them act out human dramas in Aesop's Fables, the Christian mind saw them as somehow collaborators in the human endeavor, both in revealing the depths of God's mysterious plans and in helping people along on the treacherous road to salvation. Thus the whole realm of beasts and birds entered into the religious sphere. Medieval man expected to encounter a vision of Christ in the horns of a stag as readily as in any sanctuary. On the other hand if one's faith in the unfathomable mystery of the Eucharist should falter, an ass might lead the way to the altar and kneel devoutly to venerate the Sacrament, as in Donatello's relief in Padua (fig. 30).[39]

But the story does not end here, for there is also evidence that Christians venerated the ass. Amulets and gold glass bowls of the Early Christian period survive carrying the ass alone, in emblematic fashion, sometimes simply labeled "asinus" but at other times labeled "Jesus Christ" (figs. 31 & 32).[40] And, most amazing, there are several representations of Christ with the head of an ass. A famous graffito of around the year 200 discovered on the Palatine in Rome shows a man worshipping a crucified, ass-headed Christ above an inscription saying that "Alexamenos worships his god" (fig. 33).[41] There is disagreement

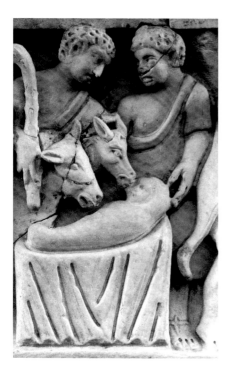

29. The Birth of Christ, from a sarcophagus in the Lateran, fourth century, Musei Vaticani, Rome

30. Ass Worshipping the Blessed Sacrament, from the High Altar of Saint Anthony, Padua, by Donatello, c. 1450

 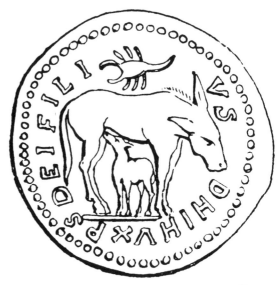

31. Gold glass with Ass, Museo Sacro Vaticano

32. Amulet with Ass and Foal (Inscription: "Dominus Noster Iesus Christus Dei Filius"), c. 400

whether this should be taken as Alexamenos's own profession of faith or as the taunt of a pagan observer; but even in the second alternative it is still good evidence of the central role of the ass, for the taunt would otherwise lose its barb. Part of the background of such images is the allegation that Jews, too, worshipped an ass.[42] Tacitus, Plutarch, and Apion all witness this belief, for which they offered various reasons such as the help wild asses gave in the desert by leading the Israelites to water. Ultimately, the Egyptians' identification of both Jahweh and Jesus with Seth, an ass-headed god, may form the basis of these associations, but this lies in a shadowy realm of speculation.[43]

What is clear is that the ass was not just incidental to the imagery but carried a heavy load of powerful associations, all of which have been washed out in the attempt to read the scene as if it were an imperial *adventus*. In the world of Late Antiquity the gods came mounted on magic beasts of extraordinary power: stags, eagles, bulls (figs. 134, 135, 138). The new rival God rides an unexpectedly wise donkey.

WHY, then, did Christians want to add the Entry of Christ into Jerusalem to their repertory of images at the beginning of the fourth century? The simul-

33. (*facing*) Ass-headed Christ Crucified, Palatine Graffito, c. 200 (Inscription: "Alexamenos worships his god"), Museo Nazionale delle Terme, Rome

taneous appearance of the subject in Rome and distant Jerusalem argues for a motivation that transcended local feelings. It had little to do with Constantine's momentary triumph in Rome in 312, but much to do with the principal intellectual task of the century, the struggle to define who Christ was. This was a problem that touched people all around the Mediterranean.

Arius, a priest in Alexandria, posed the problem c. 319 in most abstruse theological terms as a question of the eternal existence of the Son prior to his appearance on earth.[44] Arius identified the Son with the *logos* of the Neoplatonists, the created principle through which all other created things came into existence. Hence Arius' slogan, "there was when he was not." To make the Son eternal, he thought, threatened the oneness of the divinity. By 325 the question had so tormented the Church that Constantine convoked a universal council at Nicaea near Constantinople in an effort to preserve unity within the Empire.

Constantine's contribution, however, was itself deeply divisive. Though he endorsed the declaration of the un-created nature of the Son, "of one substance with the Father," within two years he had taken on the Arian bishop Eusebius of Nicomedia as his personal advisor in all matters religious. It was Eusebius who baptized the emperor on his death bed in 337 and became mentor to Constantine's son and successor, Constantius II. Moreover, it was Eusebius' disciple who was the apostle to the Goths, Ulfilas (c. 311-c. 383).[45] Largely through his efforts the Germanic peoples who poured into the Empire in the fourth and fifth centuries were enlisted on the Arian side—the Ostrogoths, Visigoths, Vandals, Burgundians, Suevi, Lombards. Henceforth the problem was ethnic and political as well as theological.

Constantius II (337–361) took a personal interest in promoting Arianism, and his twenty-five year reign gave him plenty of space to meddle in church affairs. Bishops who failed to conform to his theology were exiled from their sees and replaced with Arians. Athanasius, metropolitan of the powerful see of Alexandria, he exiled twice. Thinking himself a theologian, he convoked a double council that convened in 359 at Ariminum (Rimini in Italy) and Seleucia (Silifke in Turkey), at which he obtained a majority consent to an Arian creed. The resulting situation was aptly summed up by Jerome, "The whole world groaned and marvelled to find itself Arian."[46]

Emperor Julian (361–363), who abandoned Christianity entirely for a neoplatonic paganism, perversely tried to perpetuate the Christian schism by restoring some exiled bishops. But his Arian successor, Valens (363–378), banished them again. The orthodoxy of Nicaea did not find its political vindication until the Council of Constantinople was convoked under Emperor Theodosius the Great in 381, and the consequences of the schism rankled for another two centuries.

The images of the fourth century played an important role in this struggle to define who Christ was. Given the political situation, Christians were not apt to turn to the emperor for the imagery of their Lord. Rather, the Entry, like the Adoration of the Magi and the Christ in Glory, which were also introduced at this time, was part of a concerted effort to emphasize moments of Christ's glory in an anti-Arian context. The common liturgical association of the Entry with the coming of Christ in the eucharist strengthened this argument, for the Christ of the eucharist was the supra-temporal Christ, risen and eternal. The fact that the entrance of the as yet unconsecrated bread and wine was greeted with the triple chanting of the Cherubic Hymn, along with Psalm 24:7–10 calling Christ the "King of Glory," should not be read as a theological inaccuracy; rather it was a deliberate assertion of the eternal divinity of the Logos even prior to his incarnation in Christ. This was the popular answer to Arius' "there was when he was not."

Explanatory inscriptions are rare in association with Early Christian images, giving special importance to the few that we have. It is significant that the inscription of the wooden lintel from the Church of the Virgin in Cairo insists on the "fullness" of the divinity of Christ, identifying him with the Godhead manifest on Mount Sinai: "There dwells all the fullness of the Godhead on the peak of truly heavenly Sinai; the angels . . . ceaselessly honor him with thrice-holy voice. . . . You are invisible in the heavens amidst manifold powers, and you were content to dwell together with us mortals." While the inscription is firmly dated to 735, when it had special importance for its Coptic audience,[47] it repeats formulae first used in Athanasius' *Discourse against the Arians* in the early fourth century.[48] Alongside the Entry the wooden lintel shows Christ in an aureole of light in the scene of his Ascension. As we will notice below, the first occurrence of the Christ in an aureole was also accompanied by an explicitly anti-Arian inscription (fig. 92).

Art historians, intent on a political interpretation of Early Christian imagery, seem to have overlooked the obvious fact that the Council of Nicaea was not convoked to declare Christ emperor but to declare him God—"God of God, light of light, true God of true God, begotten not made, of one substance with the Father." The new thrust of Christian art in the fourth century was aimed at advertising this belief. Since most of the emperors of the fourth century, including Constantine himself, aligned themselves on the Arian side of the debate, the imagery of this anti-Arian art can be seen as anti-imperial on more than one level.

CHAPTER THREE

The Magician

O N THE SARCOPHAGUS RELIEF of the Terme Museum a Philosopher-God entered Jerusalem on a farmer's beast, carrying a wand (fig. 11). The wand is unusual in this context—in only one other Entry does Christ carry a wand[1]—but it is not at all atypical for Christ in other scenes. Again we are confronted with a daring re-write of scripture on the part of the artists. Nowhere in the Gospel is Christ said to make use of anything resembling a wand. But next to the scroll of his teaching, the wand is the most constant attribute of Christ in Early Christian art, introduced already in the third century.[2]

The more usual settings for Christ's use of a wand are his miracles. In the food miracles, the Multiplication of Loaves and the water-to-wine miracle of Cana, the wand is an invariable part of the picture; touching the baskets and the amphorae he fills them instantly with bread and wine (fig. 34). The Raising of Lazarus, too, is commonly effected with a wand; Christ revivifies his friend by touching the tomb or Lazarus himself with a wand (figs. 35 & 36). But he can be shown with the wand in other miracles as well. On a gold-glass bowl in The Metropolitan Museum of Art, New York, Christ appears three times with a wand: in the wine miracle of Cana, curing the paralytic, and defending Daniel's three companions in the fiery furnace from the flames that leap up about them (fig. 37).

From a Catholic apologetic stance one scholar proposed that the wand was a staff of authority.[3] But in compositions that would emphasize authority, for example seated between Peter and Paul, Christ never has a wand. The wand only occurs when he is actually performing his magic. Departures from the scriptural version of events are always significant; they are red flags signalling the intervention of some special concern beyond the obvious storytelling inter-

34. The Trees
Sarcophagus, c. 360,
Musée Réattu, Arles

35. The Raising
of Lazarus, on a
sarcophagus in the
Lateran, c. 340,
Musei Vaticani, Rome

55

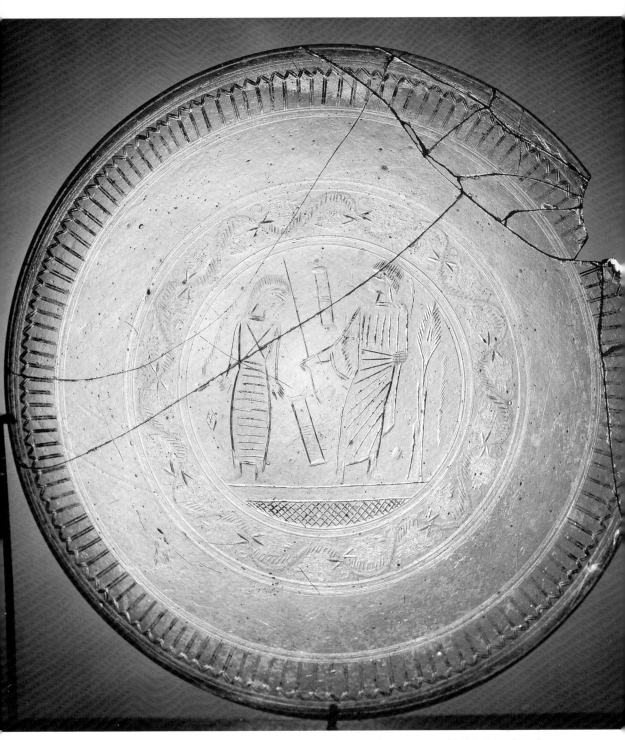

36. The Raising of Lazarus, on a glass bowl from Cologne, second half of the fourth century, The Metropolitan Museum of Art, New York

37. Gold glass bowl showing Christ with his miraculous wand in three scenes: with the Three Young Men in the Fiery Furnace, in the Wine Miracle, and in the Cure of the Paralytic, Rome(?), end fourth century, The Metropolitan Museum of Art, New York

est. The wand is not incidental but a standard and necessary feature in Early Christian art. Sometimes an effort is made to "Christianize" the wand by putting a little cross on the top of it (fig. 38); but it is still used as a wand to convey magic power by touch.[4]

In antiquity, as today, the wand (*rabdos* in Greek and *virga* in Latin) is the distinctive attribute of the magician. In classical literature, for example, Circe the witch wields a wand to transform people into pigs, and Mercury with a

golden wand leads the dead back to life.[5] By carrying a wand Jesus, too, has been made a magician. The implications of this are enormous and have never been examined.

In Early Christian art, in contrast with later periods, miracles were by far the largest group of subjects. They constituted the standard repertory into which the newer and more ambitious subjects like the Entry were being inserted in the fourth century. On the other hand, in the Middle Ages the tender moments of Christ's infancy and the heart-rending events of his passion became the principal subjects of pious meditation and artistic representation. Medieval illustrations of the life of Christ often omit the miracles and preaching of Christ altogether. In the Scrovegni Chapel, Giotto narrated the life of Christ in thirty-eight panels but allotted only two panels to miracles—that of Cana and the Raising of Lazarus.[6] The proportions are quite the reverse in Early Christian art. The miracles make up the bulk of the narrative while the infancy and passion stories are reduced to one or two subjects.

Around the year 400 a bishop of Pontus in present-day Turkey, one Asterius, spoke out against luxury in Christian life and left a vivid description of the imagery that decorated the clothes of the wealthy. "The more religious among rich men and women, having picked out the story of the Gospels, have handed it over to the weavers—I mean our Christ together with all His disciples, and each one of the miracles the way it is related. You may see the wedding of Galilee with the water jars, the paralytic carrying his bed on his shoulders, the blind man healed by means of clay, the woman with an issue of blood seizing Christ's hem, the sinful woman falling at the feet of Jesus, Lazarus coming back to life from his tomb. In doing this they consider themselves to be religious and to be wearing clothes that are agreeable to God."[7] To such Christians the life of Christ consisted simply of a series of miracles.

Moreover, representation of these miracles was ubiquitous. In general one may divide Early Christian art into three categories: objects for everyday life, ecclesiastical objects, and art connected with burial. To the confusion of the modern art historian who likes to search for meaning of art in its context, the miracle imagery was regarded as equally appropriate to all three situations. Most of the themes that we see packed in staccato fashion into the reliefs of the sarcophagi were thought equally appropriate decoration for altarplate or church walls. In addition, in everyday life you might use the same images on your dinner table, on vessels of glass and clay (fig. 39); or you could wear them on your tunic, as Bishop Asterius relates (fig. 40).[8]

38. (*facing*) Ivory diptych with miracle scenes, counterclockwise: Cure of the Blind Man, Cure of the Possessed, the Three Young Men in the Fiery Furnace, Cure of the Paralytic, and the Raising of Lazarus, sixth century, Ravenna, Museo Archeologico Nazionale

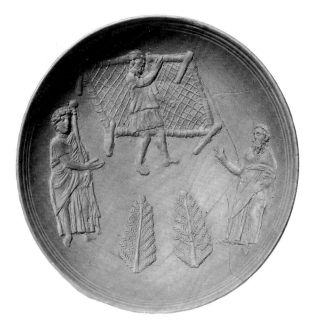

39. Cure of the Paralytic, on a red earthenware bowl of the fourth century, Mainz

40. Textile fragment showing Christ and Moses in the upper register, and below, the Cure of the Woman with Issue of Blood and the Raising of Lazarus, fifth century, Victoria & Albert Museum, London

41. Sarcophagus frontal with miracles: The Raising of Lazarus, the Cure of the Blind Man, and the Cure of the Woman with Issue of Blood, fifth century, Arkeoloji Müzeleri, Istanbul

Because the miracles often consist of just two figures—Christ and the blind man, for example—they fit conveniently into all sorts of compositional framings (figs. 36–41). This may have been one reason for their popularity. But formal concerns alone cannot account for the promiscuous proliferation of miracle scenes. Over and over Christ appears raising the dead, casting out demons, giving sight to the blind, curing women of arthritis or menstrual disorders, changing water to wine or multiplying loaves to feed the thousands. The insistent repetition of these images implies that people identified Christ most often as a miracle-man. Judging from the ubiquity of the miraculous Christ, the meaning of such images must have transcended specifically sepulchral connotations. These images must have been affirmations of faith in Christ's saving grace that were equally valid in life or in death.

Curiously enough, the commonest subjects in Early Christian art have excited the least interest. Though Morton Smith explored the historical framework of Christ's magic, there has never been a serious art historical study of Christ as miracle-man.[9] It is most significant that in André Grabar's study of Christian iconography—the sole attempt at a comprehensive examination of the subject—the miracles are simply omitted. Imperial imagery has no room for miracles.

Because these images seem so ordinary and "innocuous," they raise even more acutely the question of their hidden potency. In the relentless war of images of the fourth and fifth century, these most unassuming images played a

42. Coin with Hadrian restoring Judaea, Naples, Museo Nazionale

considerable role. What was the source of their power, that they were able to supplant the solemn, sacred imagery of the ancient pantheon? What was the urgency that a Christian should need to have them on the hem of her tunic, on the ring on her finger, on her husband's tomb? Frequency of use does not reflect a lack of imagination; miracles were repeated not because the artists ran out of things to say, but because these subjects said what they wanted to say, and said it perfectly.

The images of Christ's miracles are distinctively pacific, non-military, and non-imperial. Only one of these has ever been associated with imperial prototypes, the cure of the woman with the issue of blood, for which Erica Dinkler-von Schubert suggested an unlikely connection with the composition of the Emperor as "restitutor provinciae."[10] This invocation of the Emperor Mystique is instructive. The restoration of a province, usually following a military campaign and a large investment in rebuilding, was commemorated on coins symbolically with the standing emperor facing a kneeling female personification of the province. The gracious emperor reaches out his hand to raise her from her suppliant position (fig.42). The vague resemblance of the standing-man-kneeling-woman compositions suggested to the German art historian that the two must be connected. In fact, all the other details of the cure of the woman are inconsistent with such a connection.

43. Cure of the Woman with Issue of Blood,
Catacomb of Sts. Petrus and Marcellinus, Rome,
c. 340

There are two ways of representing the encounter between the woman and Christ. In the first, Christ is shown not facing the woman but walking *away* from her and looking back over his shoulder to notice her (fig.43). This is the way the story unfolds in the Gospel. The woman took the initiative by grabbing the hem of Christ's garment in the belief that just a touch would cure her persistent bleeding. Then, according to Mark 6:30, "Jesus, perceiving that power had gone forth from him, immediately turned about in the crowd, and said, 'Who touched my garments?'" And he pronounced her cured by her faith.

The second way of presenting the encounter departs significantly from the Gospel story by bringing Christ and the woman into close contact (fig.44). Instead of cure by the mere touch of his hem, Christ is pressing his hand on the kneeling woman's head. One must recall that menstruation carried a strong sense of uncleanness in the Jewish world, and Christians prohibited menstruating women from approaching the Eucharist.[11] Christ violated that taboo by touching the woman, and far from "catching" her uncleanness, he purified her. Neither of these compositions repeats the gesture of the emperor reaching out to take the hand of the kneeling province, and Christ wears no imperial insignia but is dressed, as usual, like a classical philosopher or man of letters.[12]

Far from evoking associations of emperor and offical imperial protocol, these images represent a warm, profoundly intimate encounter of the woman with her magical gynecologist. The power of these curing images does not

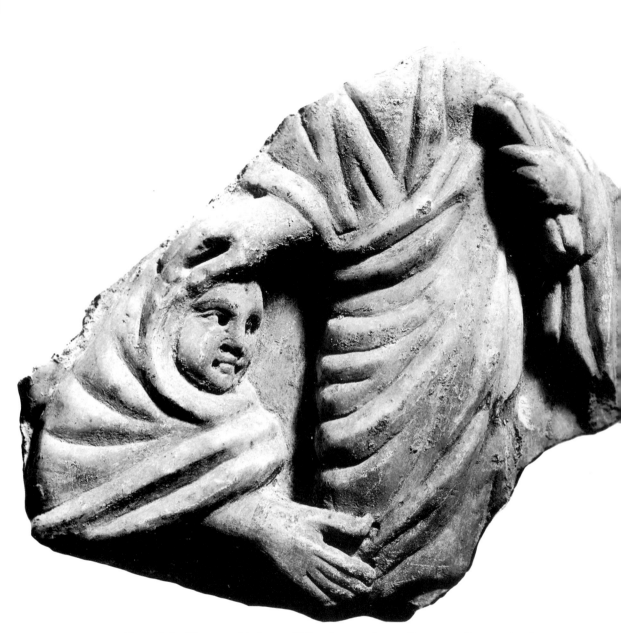

44. Cure of the Woman with Issue of Blood, sarcophagus fragment, Catacomb of
St. Callixtus, Rome

derive from reminiscences of imperial propaganda but from evocations of a
profound human vulnerability crying out for succor. The touch of Christ's
hand conveyed an electricity like the charge of his wand. Hand and wand are
presented as parallel instruments. This is strikingly evident in the six miracles
on the Sarcophagus of the Trees in Arles, where the gestures of hand and wand
are paralleled (fig. 34). The same point is made in the sarcophagus fragment in
Istanbul in which, instead of rapping the tomb of Lazarus with his wand, as he
usually does (fig. 35), Christ simply touches it with his fingers (fig. 45).[13]

64

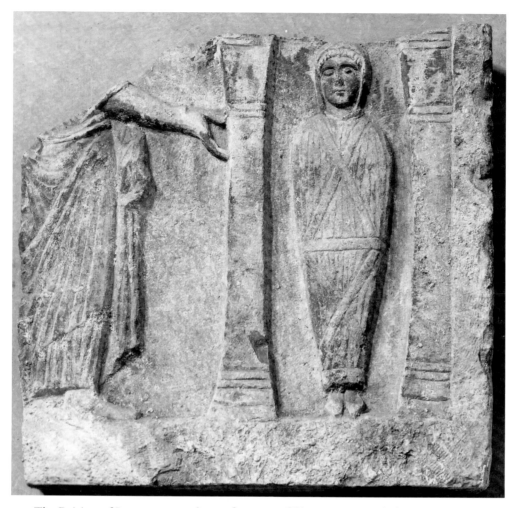

45. The Raising of Lazarus, sarcophagus fragment, fifth century, Istanbul

The tendency of scholars to turn to the Emperor Mystique, however, is not merely a misconstruction of the one image but a gross distortion involving the conspicuous neglect of all the miracles in studies of Early Christian art. Miracles are the core, the mainstay of Early Christian imagery; we cannot simply bypass this material because it fails to fit imperial categories.

The issue of magic in Early Christian art has generally been addressed only in the very limited sphere of charms, amulets, and rings: that is, objects that Christians used for specifically apotropaic and magical purposes.[14] But magic is far more central an issue than that. The images of Christ's miracles were part of an ongoing war against non-Christian magic. Fighting fire with fire, these images addressed a major preoccupation of Late Antiquity. Like advertising slogans, they repeated to the point of saturation the startling message that

Christ the Magician had out-tricked all the magicians of the pagans.[15] Indeed, it can be said that magic provides the first coherent theme of Christian art, the first theme that linked the otherwise disconnected, staccato images in a unified statement. The interest in magic explains both the predominance of the miracle scenes over other stories in the life of Christ and the selection of the Old Testament stories of Moses and Daniel to complement them. Moses and Daniel were introduced to fill out the ancient history of Jesus' magic. They in turn are linked with Jesus through the Magi, from whose name the very word "magic" derives.[16]

IT IS DIFFICULT to overestimate the importance of magic in the ancient world. Whether you wanted your crops to grow, your lover to yield, or your horse to win in the hippodrome, there were rituals and incantations to suit the purpose. However, it was especially in the area of health that people were most liable to invoke what we might call the "magical."[17] If you were suffering some bodily ailment a wide variety of choices were open to you, but none of them much resembled modern medicine.

For example, you might take your illness to Asclepius, the great god of healing (fig. 47). Asclepius managed to maintain his hold over the affections of the masses longer than any of the other traditional gods of antiquity, making him Christ's most formidable rival.[18] His shrines were "everywhere on earth," according to Julian the Apostate.[19] In Rome the Asclepieion was located on the Tiber Island, which became the site of a hospital in the Middle Ages.

The ancient shrines to Asclepius, however, were not hospitals. Treatment began by bathing and purifying oneself ritually, after which sacrifice was offered; a cock was the commonest victim. The cure itself was effected by the practice of incubation; that is, you spent the night sleeping in the temple in the hope that Asclepius would minister to you in a dream. Inscriptions of grateful devotees recount their experiences at the shrine. A blind soldier named Valerius Aper recorded that he recovered his sight by following the directions Asclepius gave in his dream, namely to mix the blood of a white cock with honey and apply it to his eyes for three days.[20] A paralytic named Diaetus of Cirrha dreamed that Asclepius drove a chariot over his legs, and so he recoverd use of them immediately.[21] At the conclusion of your cure you were expected to make a votive offering at the temple.

Going to Asclepius did not preclude your turning to a medical doctor for a remedy. We must always bear in mind, however, that while medical science in antiquity achieved considerable sophistication in theoretical learning, the ability to apply this in the day-to-day practice of medicine was extremely limited. The range of misinformation available in purportedly scientific treatises was absolutely staggering. Pliny's *Natural History* is full of remedies that can best be

classified as magic.[22] We must remember that the word *pharmakeia*, or pharmacy, signified not only drugs and medicines but potions, spells, and witchcraft. The two were quite inseparable. When trying to decide whether to submit to bloodletting for his migraine headaches and gout, Libanius the Sophist of Antioch, one of the best educated men of the fourth century, consulted a soothsayer and a doctor in that order. Fortunately on this occasion they both agreed and dissuaded him from that hazardous "treatment."[23]

Jewish magic, too, was an important ingredient of the Late Antique world. In 386, John Chrysostom, on the occasion of Rosh Hashanah, Yom Kippur, and Sukkoth, directed a series of eight virulent sermons against the Christian "Judaizers" of Antioch, that is, Christians who were celebrating these festivals with the Jews in their synagogues.[24] The Judaizers turned to Jewish practice for charms and spells as cures for diseases, and they frequented synagogues as holy places for the practice of incubation. Chrysostom, whose name means golden-mouthed, excoriated the Jews in the worst possible language as dogs, drunkards, gluttons, and ignoramuses. Better to die a martyr to one's illness, Chrysostom insisted, than to be cured by Jewish charms, admitting incidentally the efficacy of the Jewish magic.[25]

Against all such sorcery and witchcraft the new God had to be vindicated.[26] Curiously, the argument that was advanced did not try to distance Christ from ancient magicians. Rather it was proposed that he was a far better sorcerer, for his magic really worked.

Jesus had been repeatedly identified as a magician by his critics. Celsus, the author of the first comprehensive philosophical polemic against Christianity (c. A.D. 178), enunciated a persistent pagan characterization of Christ as nothing more than a common sorcerer. Christ's multiplication of loaves Celsus dismissed with the work of "sorcerers who profess to do wonderful miracles and those who are taught by the Egyptians, who for a few obols make known their sacred lore in the middle of the market-place and drive daemons out of men and blow away diseases and invoke the souls of heroes, displaying expensive banquets and dining-tables and cakes and dishes which are non-existent." Celsus challenges his Christian adversaries, "Since these men do these wonders, ought we to think them sons of God? Or ought we to say that they are the practices of wicked men possessed by an evil demon?"[27]

It was a difficult challenge to answer, for Christ's miracles do present countless parallels to the works of the magicians, and the terminology in which Christ's miracles are described does not differ from the terminology used to describe the works of the magicians. Fifty years after Celsus, Origen, the great biblical scholar and theologian of Alexandria, undertook to answer him in painstaking detail in eight books. The works of Christ, Origen had to concede, were in themselves very like those of magicians. The differences, he argued, lay

more in the circumstances. Christ took no money for his tricks; he did them not for entertainment but to lead his spectators to conversion; he needed no spells or incantations but performed them by his own name; and while magicians' tricks are illusions, Christ's were permanent and real.[28] But what this amounts to is not a denial that Christ was a magician, but an assertion that he was a better magician; he was the true magician compared to whom all the others were base pretenders, and his was a holy magic that led his followers to a better way of life. According to Origen, simply pronouncing the name of Jesus effected a holy magic, regardless of the speaker's way of life.[29]

The problem did not go away. At the beginning of the fourth century a high government official Sossianus Hierocles attacked Christianity by making an extended comparison between Christ and the magician Apollonius of Tyana. Apollonius, almost contemporary with Christ, studied magic in Babylon and India and was credited with miracles, prophecies, and exorcisms. After his death and rumored resurrection, a cult grew up around him in which even the emperors Caracalla and Alexander Severus allegedly took part. His continued popularity was attested by a new biography written by Nicomachus Flavianus in the late fourth century and revised in the fifth by the bishop of Clermont, Sidonius Apollinaris.[30] Both Lactantius and Eusebius felt the need to answer the slander, the former demonstrating the authenticity of Christ's miracles by Old Testament prophecies of them, the latter by their beneficent result in enlightening the whole human race.[31]

The force of the Early Christian miracle images is their radical novelty. Over and over again they show Christ in the very moment his magical power takes effect. He is touching his wand to Lazarus' tomb and calling him, "Lazarus, come out," and Lazarus is emerging from the little door, still wrapped in bandages, but with eyes open and very much alive (figs. 35, 45). The moment of the miracle is critical. Christ is pointing his wand at a row of baskets and already they have filled up with loaves of bread (fig. 34). He is pressing his hand on the sick woman's head and already she feels his healing power in her body (fig. 44). This was a new kind of imagery, for which, surprisingly enough, non-Christian art had no answer. Paganism had no images to compare with this propaganda.

Though magicians, astrologers, and sorcerers were available in every marketplace they never developed an imagery to advertise their services. Perhaps because this sort of street magic was illegal, magicians don't appear in Roman art. The most frequently represented good magicians were the semi-divine Orpheus and Apollonius of Tyana. It is significant that a fourth-century legend of what would have been the earliest image of Christ placed him in company with Orpheus and Apollonius, along with Alexander and Abraham, in a private cult shrine of Alexander Severus (A.D. 222–35).[32] According to literary sources, images of Apollonius tended to be cultic images—the standing figure in his

temple—and these were evidently so rare that none has been found.[33] Images of Orpheus, on the other hand, consistently show him singing his mystical message, charming the wild beasts into peace (fig.46). Art was not called upon to demonstrate the magic of these famous magicians on behalf of mankind.

Even Asclepius, whose epithet in Greek was the "epios," the gentle or kind one, and whose curing mission most closely resembled that of Christ, lacked an imagery of curing. Asclepius appeared in a static cultic pose, occasionally seated but generally standing, naked to the waist, with a pallium thrown over his left shoulder, and leaning on his staff (fig.47). But surprisingly in Roman art the great healing god was never shown in the act of healing.[34] It is significant that even grave reliefs showing medical doctors practicing their art usually show them diagnosing the patient—peering in a woman's eyes or feeling a man's bloated belly—but not curing them. A doctor's cure, of course, would not be effected by wand or by laying on of hands but by administration of medicines, bloodletting, surgery, and the like.[35]

The contest between Christ and Asclepius takes a most interesting turn in two relief fragments of the late third century in the Terme Museum, Rome

46. Orpheus Charming the Beasts, floor mosaic from the Villa Trinquetaille, fourth century, Musée Réattu, Arles

47. Statue of Asclepius, with Telesphorus
(a God of the Underworld), second century,
Borghese Museum, Rome

48. Sarcophagus fragment with Miracle scenes:
from left to right, the Cure of the Woman with
Issue of Blood, the Sermon on the Mount, Cure
of the Paralytic, and the Cure of the Leper, c.
300–310, Museo Nazionale delle Terme, Rome

49. (*facing*) The Cure of the Leper, detail of
sarcophagus fragment with Miracle scenes, c.
300–310, Museo Nazionale delle Terme, Rome

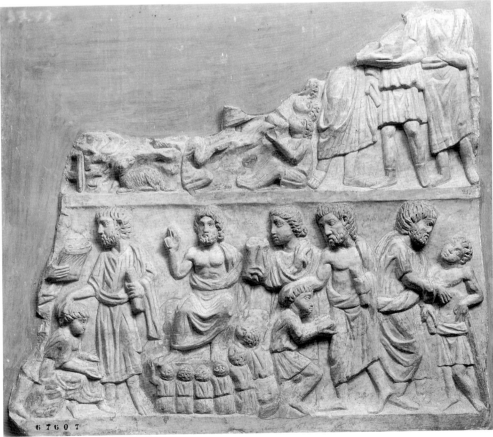

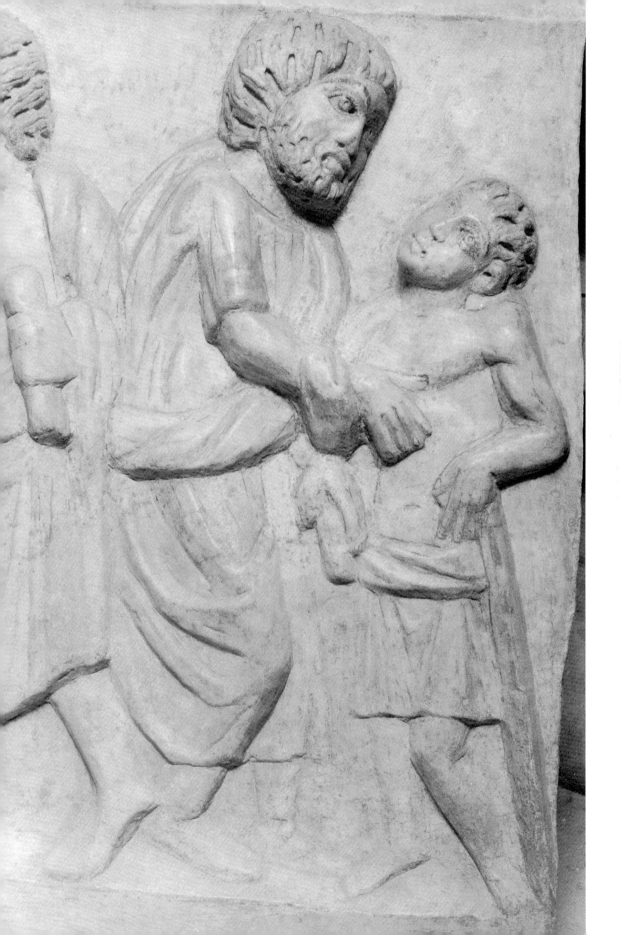

(fig. 48). Christ is shown in a most unusual guise, seated with a pallium draped around him so as to leave his chest and right shoulder bare, exactly in the manner of seated statues of Asclepius, while his broad forehead and full beard copy the traits of the god's face (fig. 49). Unlike Asclepius, however, Christ is shown actually working the miraculous cures that had been claimed for his pagan rival. On the left he places a compassionate hand on the head of a seated woman; on the right he places his hand on the head of a bent man, perhaps blind; and, most unusual, on the far right he places his hand on the chest of a pathetically misshapen leper. Christ has co-opted the fatherly looks and the gentle manner of Asclepius. But while the record of Asclepius' miracles was written on stone slabs in his shrines, Christ's were shown in tender detail in incessant replication on tombs, tableware, and clothing—wherever people would most often encounter them.

THE MAGIC of Christ was presented more effectively in art than the magic of his rivals. Beyond the repetition of his miracles, however, Early Christian art sought to vindicate Christ's magic by giving it an historical validity and authority. Not only was his magic effective, it had ancient roots in the two great traditions of magic—that of Egypt and that of the Chaldeans. Both of these dimensions of the subject were developed in considerable detail in Early Christian imagery—in the stories of Moses, Daniel, and the Magi. The imagery of each of these stories develops another dimension of Christ's magic, and in each case the imagery involves an explicitly anti-imperial ideology.

Moses was by far the best known figure of Jewish history, and the story of his contest with the magicians of the Pharaoh was familiar to several pagan authors.[36] For their part, Jews claimed that Moses antedated the sages of Greece and was the teacher of the pagan magician Orpheus, a thesis readily accepted by Christian authors to explain the monotheism of the Orphic Hymns.[37] Virtually the entire life of Moses was illustrated in Early Christian art, the most comprehensive treatment occurring in the mosaics of Sta. Maria Maggiore in Rome (432–40), but three subjects gained special popularity: Moses Receiving the Law (fig. 50), the Crossing of the Red Sea (figs. 52–54), and Moses Striking Water from the Rock (fig. 51). These subjects are ubiquitous in catacomb art and the latter two demonstrate Moses making use of his magic wand.

Historically the wand as a wizard's sign originated in Middle Kingdom Egypt.[38] According to Exodus it was Yahweh himself who taught Moses the use of his magic staff (*rabdos*), instructing him in how to make it turn into a serpent to impress the Pharaoh (Ex 4:2). A difficult man to impress, Pharaoh called his own magicians, who promptly duplicated Moses' trick, only to be out-tricked by Moses whose serpent gobbled up those of the rival magicians (Ex 7:8–13). The subsequent seven plagues are described as a magic competi-

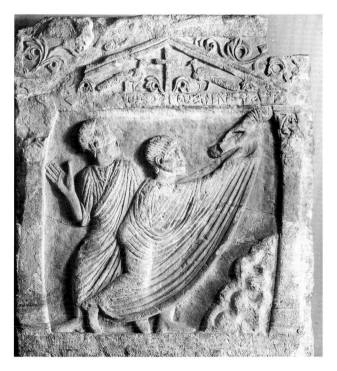

50. Moses Receiving the Law, sarcophagus fragment from Istanbul, fifth century, Staatliche Museum, Berlin

51. Moses Removing His Sandals and Striking Water from a Rock, Catacomb of St. Callixtus, Rome, fourth century

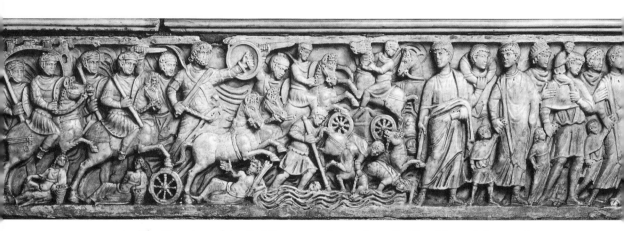

52. The Crossing of the Red Sea, sarcophagus from St. Trophîme, Arles, c. 380

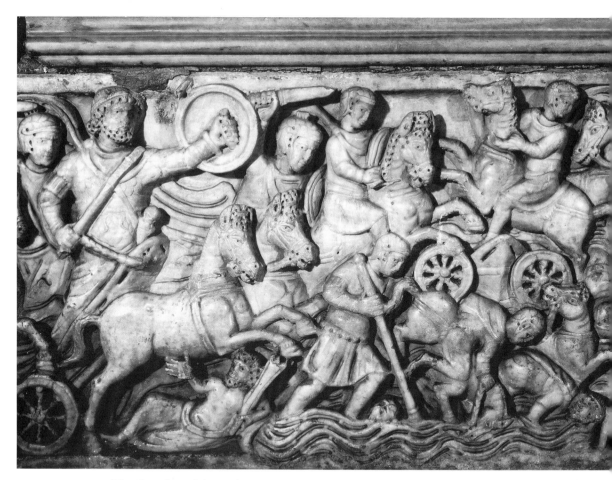

53. The Crossing of the Red Sea, detail from a sarcophagus at St. Trophîme, Arles, c. 380

54. The Crossing of the Red Sea, sarcophagus fragment of c. 325, Camposanto Teutonico, Rome

tion in which Moses' feats of blood and thunder continue to upstage the smoke and mirrors of Pharaoh's magicians (Ex 7:22; 8:7, 18; 9:11).

The Crossing of the Red Sea occurs in relief on twenty-nine sarcophagi, according to the latest count. Introduced in the early fourth century as a modest narrative theme sandwiched in among the many staccato scenes of Christ's miracles, by the end of the century it was expanded to an ambitious battle scene occupying the entire face of the sarcophagus, including as many as thirty human figures, in addition to horses and chariots (figs. 52&53).[39] It is an image of epic proportions. No other narrative subject occupies the entire face of any sarcophagus. Speculation on precedents for the composition in manuscripts or monumental mosaics are of little utility, since the supposed precedents are lost.[40] The real problem is the motivation behind the development of this extraordinary image.

In a curious anticipation of the Emperor Mystique theory, E. Becker argued as long ago as 1910 that the introduction and popularity of the Crossing of the Red Sea derived from association with Constantine's victory over Maxentius at the Battle of the Milvian bridge.[41] This explanation has been echoed by a number of historians since.[42] Because Eusebius of Ceasarea, the Emperor's personal historian and publicist, had compared the drowning of Maxentius' men in the Tiber with the drowning of Pharaoh's troops in the Red Sea, Becker seized upon this comparison as key to the imagery.[43] Constantine was another Moses. The sarcophagi were modelled, Becker proposed, on the representation

75

of the Battle of the Milvian Bridge on the Arch of Constantine, and he accordingly dated the sarcophagi to the Constantinian period.

The scenes, however, show little resemblance to the frieze on the Arch of Constantine.[44] Furthermore, the epic version of the subject, covering the entire sarcophagus front, is not Constantinian. Rather it belongs stylistically to the reign of Theodosius I (379–95), when an interest in the Battle of the Milvian Bridge would be difficult to explain.[45] After Eusebius no one ever takes up the comparison of Constantine to Moses. In Early Christian literature Moses is not a type of the emperor but of Christ.[46] Becker made an ideological muddle of the subject.

The politics of the image are well worth examining. Though commonly called the "Crossing of the Red Sea," the image actually shows the Israelites already well out of the sea safely on land. This is not a quibble; the imagery deserves to be read for precisely what it is saying. In Exodus 14:16–27, Moses used his wand on the Red Sea twice, once to part it and again to close it. Significantly, the moment chosen in the Early Christian art is not the parting but the closing of the Red Sea over the pursuing enemy after the Israelites had safely emerged on the other side. Also significant is the inclusion of Pharaoh riding his chariot to a watery grave. To give the action greater vividness, Pharaoh is actually shown twice—riding into the sea and then sinking with his chariot upturned at the very point of Moses' wand (fig. 53).

The scriptural account, however, says nothing of Pharaoh's death, and the pre-Christian version of the subject at the Synagogue of Dura Europos omits him entirely.[47] This insistence on a "face-off" between Moses and Pharaoh is the one constant in all of the Early Christian representations of the miracle. In the earliest examples this sense of confrontation is heightened by the sparse number of attendant figures.[48] On the relief in the Camposanto Teutonico, Rome, the two mortal enemies face one another across the abyss: Pharaoh raises his hand in despair as Moses' wand draws the waves over him and his horses (fig. 54).

Again it is important to insist that when an image departs from the text of Scripture it is a signal that the image is being purposely manipulated to express something outside the narrative. In this case it is the garb of Pharaoh that reveals the intention of the imagery, for he is dressed exactly like the Roman emperor. His military tunic and cuirass are covered by a chlamys, he wears the beard traditional to Roman emperors before Constantine, and his hair is bound with a diadem (figs. 53 & 59). The politics of the scene are extremely important and they could not have escaped the viewer of late Roman times. The salvation of mankind is represented as a deliverance from the power of the Roman emperor! Misled by the rhetoric of Constantine's toady Eusebius, Becker wanted to

equate Moses with the emperor, but it is Pharaoh who is cast as emperor; Moses is always dressed in citizen-philosopher guise with scroll. Moses' God-given magic strikes a blow for freedom from imperial oppression.

The miracles of Moses prepared for and confirmed the miracles of Christ. In live debate with Jewish sages, Origen asked his opponents: "Tell me, sirs: there have been two men who have come to visit the human race of whom supernatural miracles have been recorded; I mean Moses, your lawgiver, who wrote about himself, and Jesus. . . . Is it not absurd to believe that Moses spoke the truth, in spite of the fact that the Egyptians malign him as a sorcerer who appeared to do his miracles by means of trickery, while disbelieving Jesus? Both of them have the testimony of nations; the Jews bear witness to Moses, while the Christians, without denying that Moses was a prophet, prove from his prophecy the truth about Jesus, and accept as true the miraculous stories about him that have been recorded by his disciples."[49] It is from Moses that Christ receives his magic wand.

The authenticity of Moses' miracles confuted Egyptian charges of sorcery and at the same time guaranteed the authenticity of Christ's miracles, since Moses had predicted them. The repeated appearances of Christ working miracles with the wave of his wand was meant to establish this parallel to Moses whose words he fulfilled. The Moses precedent also established the pattern for Christ's stand against imperial authority.

If Christ inherited the magic of Egypt through Moses, through Daniel and his companions, the Magi, Christ inherited the magic of the Chaldeans. In these images too, a strong anti-imperial note is sounded, contrary to the usual interpretation of art historians.

Like the story of Aaron and Moses before Pharaoh, the tale of Daniel and his three companions in the court of Nebuchadnezzar is a story of a magic competition that demonstrates that the servants of Yahweh are more potent than the ruler's magicians. Here the setting is Babylon, and the rival magicians are called enchanters, sorcerers, and Chaldeans. When Daniel succeeded in interpreting Nebuchadnezzar's dream of a statue with clay feet, he was named "chief of the magicians, enchanters, Chaldeans, and astrologers" (Dn 5:11). Daniel proved his magical power by charming wild beasts, as did Orpheus; seven hungry lions treated him like family while he sustained himself on food delivered by a flying prophet (fig. 55).

The magic test of Daniel's companions was fire. Accused by jealous magicians of refusing to worship the great 60-cubit idol that the king had erected, Shadrach, Meshach, and Abednego professed their faith in a God who could deliver them from the punishment of the furnace. To defy fire or tread on live

55. Daniel in the Lions' Den, relief of the sixth century, Arkeoloji Müzeleri, Istanbul

coals has always been a test of magicians and witches. The furnace was heated seven times its accustomed heat and the three young men were bound and thrown in, dressed in their tiaras, cloaks, and shoes, but not even their clothes were singed when they came out (see Dn 3:20 and 27 in the Septuagint).

In countless frescoes and reliefs they appear in the middle of the flames, waving their hands over their heads in a kind of pentecostal glee and singing their famous canticle (fig. 56).[50] They dress in Persian pants, capes, and tiaras, sometimes called Phrygian caps. In a number of versions of the image, the three are joined by a fourth man "like a son of the gods" (Dn 3:25), who protects them with a magic wand. On the gold glass from The Metropolitan Museum the fourth man is Christ (fig. 37).[51]

Almost as common as the fiery furnace in Early Christian art is the scene that immediately precedes it in the book of Daniel, namely the Trial of the Three Young Men (Dn 3:1–18).[52] As in scripture, the three are shown before the

emperor Nebuchadnezzar, who orders them to worship a statue. The scriptural story, however, is reworked in a number of telling details. In the first place, Nebuchadnezzar, like Pharaoh in the Moses images, appears in the guise of a Roman emperor, with beard, chlamys, and diadem. Secondly, the statue he commands them to worship is not the enormous image of Baal but his own bust image set on a column (figs. 58–60). In other words, the trial has been re-read as a trial of emperor worship, the test of allegiance commonly invoked against Christians during the persecutions.[53]

But the most startling detail of the scene is the identification of the three young men with the Magi. For the brave magicians, who turn with gestures of disgust from the image of the emperor, find before them the star of the Magi.

6. The Three Young Men in the Fiery Furnace, on a silver casket found near Thessalonica, c. 400, Byzantine Museum, Thessalonica

57. *Traditio legis*, from the silver casket found near Thessalonica, c. 400, Byzantine Museum, Thessalonica

Following the star, in the sequel image panel, they find the Christ Child on his Mothers' lap and they worship him (figs. 58–61).

This has been dismissed as a mistake, on the grounds that the artists confused the figures of the three young men with the Magi because of the similarity of their dress.[54] But I submit this "mistake" was deliberate—that the artists wanted to identify the two famous sets of three magicians. *Magos* means magician, whether one finds the term in the book of Daniel, or in Matthew's account of Christ's birth. The Magi, the quintessential magicians of Early Christian art, are shown turning from emperor worship to the worship of the new God.

Along with the Entry of Christ into Jerusalem, the Adoration of the Magi was one of the first larger narrative subjects of the life of Christ introduced into the repertoire. Like the Entry it has been forced into imperial categories. The

58. The Trial of the Three Young Men and the Adoration of the Magi, sarcophagus lid from St. Gilles, fourth century

59. The Three Young Men Rejecting the Statue of Baal (seen as bust of the Roman Emperor), Daniel in the Lions' Den, and, to the right, Pharaoh (as Roman Emperor) drowning, detail of "Susanna" sarcophagus, c. 350, Musée Réattu, Arles

earliest example of the subject, a fresco significantly earlier than Constantine in the Capella Greca of the catacomb of Priscilla, shows three young beardless men wearing short tunics and oriental tiaras advancing in single file (fig.62). They bend slightly in reverence and offer gifts to a seated woman nursing an infant. The fresco omits any indication of place and setting. As it developed over time the image gained in specificity. In sarcophagi of the fourth century the Virgin sits on a wicker chair with a high, rounded back, her feet on a stool; an older

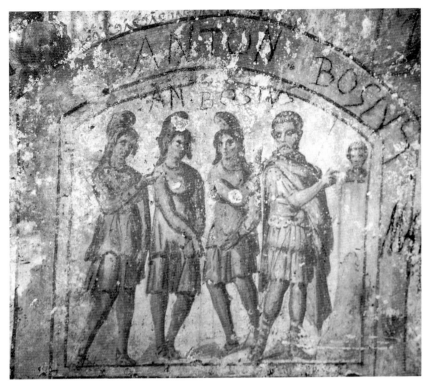

60. The Trial of the Three Young Men, one of a pair of frescoes in the Catacomb of Sts. Mark and Marcellian, Rome, fourth century

61. The Adoration of the Magi, the second of a pair of frescoes in the Catacomb of Sts. Mark and Marcellian, Rome, fourth century

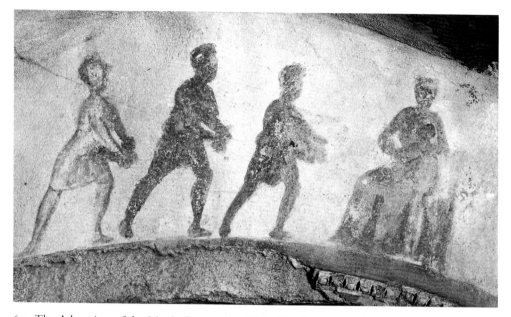

62. The Adoration of the Magi, Catacomb of Priscilla, Rome, late third century

man (to be identified with Balaam) stands behind her chair gesturing to a star overhead (fig.63). The gifts of the three men are now distinguishable as bowls and wreaths. They wear high, rounded hats, billowing capes, and silken trousers, and the camels that brought them appear behind them. By the sixth century artists begin to distinguish the Magi by age: young, middle-aged, and old, and an attendant angel is included in the scene.

Imperial models are alleged for all of these details of the image, Johannes Deckers being the lastest to restate this application of the Emperor Mystique.[55] The methodology, however, is questionable. Looking to imperial coinage, Deckers cites the appearance of a star on some coins of Augustus as precedent for the star of the Magi. But the coins are over three hundred years removed from the reliefs, and stars are a common motif in ancient art. Further Deckers describes the Virgin as seated on a "sovereign throne and footstool." But the chair is wicker, which in antiquity, as even today, was common, inexpensive domestic furniture, certainly not suited to an emperor (fig.63).[56] Nor is a footstool imperial. In the Roman world the floor of a house was generally earthen, and footstools were the usual way of keeping one's feet dry.[57] Mary's pallium is pulled over her head as a veil in the manner of noble women on countless Roman funeral stelae, but this does not make her an empress. Most important, there is nothing imperial about the object of the Magi's worship, the child on his mother's lap.

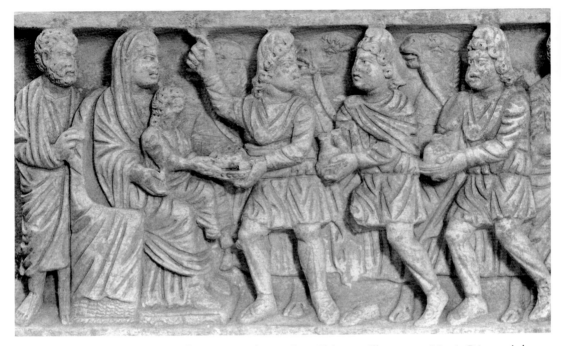

63. The Adoration of the Magi, from a sarcophagus from Trinquetaille, c. 340, Musée Réattu, Arles

The source of the problem is the dress of the Magi, which years ago Franz Cumont compared to an anonymous, tribute-bearing barbarian on a relief from a triumphal arch, now in the Villa Borghese collection, Rome.[58] One cannot deny that Romans commonly used this kind of dress to designate barbarians of various nations offering homage on imperial monuments. By the fourth century, however, the situation had changed considerably, and the costume worn by the Magi had come to designate not just foreigners but specifically oriental magicians. It was the dress of Orpheus of Thrace, famous for his ability to charm wild beasts, to descend to the underworld and lead people back, and, among Christians, for his monotheistic teaching (fig. 46).[59] It was the dress of Mithras and his Zoroastrian magicians from Persia (fig. 64).[60] Finally, it was the dress of Daniel and his companions (fig. 55, 56 & 60). All of these figures owed their popularity to the growth of the mystery religions in Late Antiquity, and they were represented with increasing frequency in the third and fourth centuries.

It has never been asked why Early Christian art preferred the Adoration of the Magi to all the other subjects of the infancy narrative. Why not the Annunciation, the dramatic moment in which God became incarnate? Or the Nativity itself, certainly an event of momentous import?

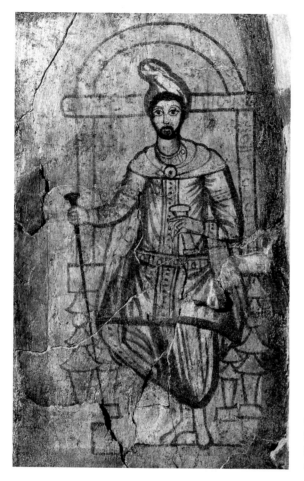

64. A Zoroastrian Magician, from the Mithraeum at Dura Europos, third century, Yale University Art Gallery

The popularity of the Adoration of the Magi in art was not a result of Christian claims that Christ was emperor, but a claim that he was the super-magician. According to Origen the efficacy of the Magi's spells and divinations rested on their familiarity with evil spirits. But when, at the birth of Christ, another, greater divinity appeared on earth, the evil spirits "became feeble and lost their strength, the falsity of their sorcery being manifested and their power being broken."[61] The Magi, trying to produce their usual results with their usual spells, suddenly found their sorcery impotent. At the same time they noticed a new star in the sky. Consulting their learned tomes they read the prophecy of Balaam, that other pagan magician who was an unwilling witness to Christ, "There shall arise a star out of Jacob and a man shall rise up out of Israel" (Nm 24:17).

The Magi, Origen continued, "conjectured that the man whose appear-

ance had been foretold along with that of the star, had actually come into the world; and having predetermined that he was superior in power to all demons, and to all common appearances and powers, they resolved to offer him homage." The magicians of the Chaldeans had found their match in the supermagician Christ. The gifts of gold, frankincense and myrrh reinforce this interpretation. According to scripture scholar Henry Wansbrough, "It is possible that Matthew here represents the members of the (magic) profession as laying down their instruments and their profits at the feet of the Messiah."[62] In the magical papyri of Egypt, Frankincense and myrrh are commonly mentioned as ingredients of magic potions.[63] Leaves of gold were used to write spells on.[64] Like Balaam, the Magi were magicians who against their own will had to acknowledge one whose magic was superior to their own.

The assertion of the superiority of Christ's magic over that of all the sorcerers and enchanters of the ancient world is the powerful principal theme that gives coherence to the otherwise staccato imagery of the fourth and fifth centuries. His miracles derive their authority from the ancient traditions of Egypt and Persia. With hand or wand he communicated a charge of electric energy; applied to the eyes of the blind it brought a flash of crisp, focused vision; touched to the door-post of a tomb, the cold corpse inside took a deep breath and smiled. Wherever one looked, images certified the authority of the new God over every aspect of life, even the most intimate.

Moreover, this power was accessible to the believer through the Church which claimed to continue Christ's work. The Acts of the Apostles describe the magic of the first of Christ's disciples, Peter, in a variety of situations. He could make the lame leap, cure the sick by the mere passage of his shadow, slip out of chains Houdini-style, and—most fearful wizardry of all—bring instant death through a curse to the deceitful Ananias and Saphira (Acts 3:3–10; 5:15; 5:1–11; 13:6–11).[65]

Peter's magic was a favorite theme in the early Church. According to the second-century Acts of Peter, his miracle working career, begun in Jerusalem, continued in Rome where, like Moses and Daniel, he had to engage in a contest of magic.[66] His competitor was the Samaritan sorcerer Simon Magus, who had developed the awesome trick of flying through the air (his fall from the heavens was represented in the frescoes of Old Saint Peter's).[67] In a public magic contest in the Roman Forum, Peter out-tricked Simon Magus by making a dog speak (one assumes in Latin), and by bringing smoked herring back to life. He also cast out a devil, which entered a statue, suitably of Caesar, and kicked it to pieces.

It is significant that in Early Christian art the most frequent narrative scene concerning Peter does not illustrate any of the great Peter stories of Acts. Rather

65. Peter's Water Miracle, from a
sarcophagus, c. 325, Museo Nationale
delle Terme, Rome

it is an obscure apocryphal legend in which Peter repeated Moses' miracle of
striking water from a stone. In a pose exactly like Moses at the rock, Peter
wields a wand, producing water from a rock with which to baptize his soldier
guards (figs.51,65).[68] Peter also is frequently shown with his wand, even in
scenes when he is not actually using it, as if it were his standard attribute
(fig.66). The energy of Christ had passed on to his successor.

Finally, like Moses and like Daniel's companions, the Magi, Peter is shown
confronting the imperial authority of Rome in his arrest and trial. The congru-
ency of all these themes cannot be accidental. The virtue of Christ's force
inevitably put his followers at odds with the secular power of the Roman
empire. Just as the Israelites' salvation was visualized as a deliverance from the
Roman emperor, and Daniel's companions were shown indignantly turning
their backs on imperial cult to worship the Christ Child, so Peter and Paul, the
heirs of this miraculous power are repeatedly shown under arrest, led away by
the imperial soldiery (fig.66). In one exceptional relief the two are even shown
on trial before the emperor Nero (fig.67). This is significant, for it is the unique
example of a specific, identifiable Roman emperor on any of the sarcophagi,
and he is the personification of cruelty and mis-government, judging the
princes of the Church.

66. Prediction of Peter's Betrayal, Peter Captive, and Peter's Water Miracle, from a sarcophagus, c. 340, Musei Vaticani, Rome

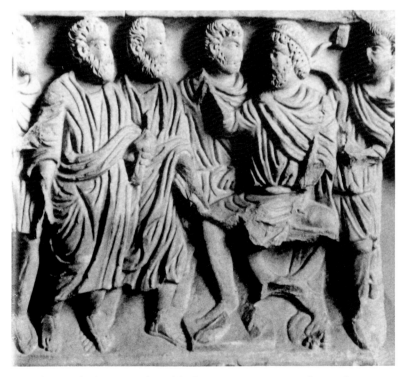

67. The Trial of Peter and Paul before Nero, on a sarcophagus from Berja, Spain, c. 340, Museo Arqueologico Nacional, Madrid

In their trial, of course, Peter and Paul are literally following the steps of their master. Christ's trial before Pilate was the commonest way of representing the passion and death of Christ. Often used with no other narrative scenes of the passion, or with the analog of Christ's death, namely the sacrifice of Isaac, the confrontation with the Roman governor Pilate was taken as emblematic of the entire story (fig.68).

Art historians have generally seen the fourth century as the period of the "establishment" of the Church and its assimilation into the orbit of the imperial court, and have tried to bend images to fit this preconception. But historically, the most notable achievement of the fourth century in church-political terms was the definition of the separation of church and state.

Constantine had proclaimed himself a bishop of the bishops, and his court theologian, Eusebius, worked out an Arian theory of kingship that modelled the emperor's role on that of the Logos. As the Logos was the mediator between the Supreme God and the created world, so the emperor was "appointed by, and the representative of the one Almighty Sovereign," as instrument or vicar of the Logos in leading the souls of his universal flock to the knowledge of the One God. The Church was clearly subordinate to the emperor. When in 394 the last Christian emperor of the fourth century, Theodosius the Great, fresh from his victory over Eugenios, prostrated himself before Bishop Ambrose of Milan, he was acknowledging a very different relationship of church and state.[69] The emperor was part of the Church and subordinate to it.

The evolution of this new relationship was tied to the failure of the imperial Arian policy, but it was also due to the firmness of powerful bishops who in a series of tense confrontations with the emperor defined the bases of the Church's freedom. The aged bishop Hosius of Cordova rebuked Constantius II, "God has put in your hands the kingdom; to us he has entrusted the affairs of the Church,"[70] and Bishop Athanasius of Alexandria defied Constantius' secret police by clandestinely running his diocese from the Egyptian desert. Basil the Great turned back the emperor Valens with his offerings at the church door when he visited Caesarea in 372.[71] Emperor of the West, Valentinian II, found himself threatened with excommunication in 384 if he should permit the proposed restoration of the pagan altar of Victory in the Roman Senate.[72] Ambrose actually excommunicated Theodosius the Great for eight months over the circus massacre in Thessalonica in 390.[73]

The outcome of this protracted confrontation of emperors and bishops was a redefinition of church-state relations. The Eusebian model of an emperor's role ("bishop of the bishops") was abandoned in favor of Ambrose's model ("the emperor indeed is within the church, not above the church").[74]

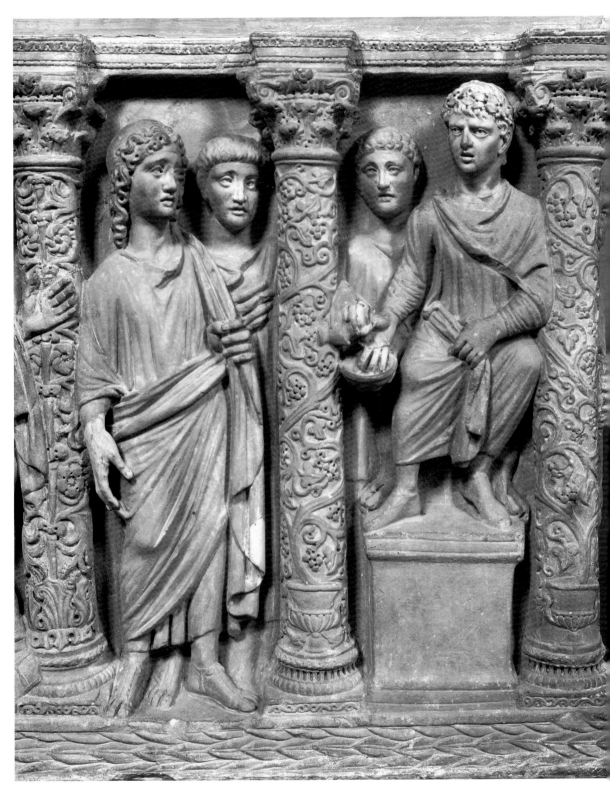

68. The Trial of Christ before Pilate, detail of a sarcophagus in the Musei Vaticani, Rome, c. 350–360

In the images of the fourth century Christ takes the attributes and attitudes of the magician; at the same time he assumes a stance of opposition to imperial authority (fig.68). Both aspects of this posture are important. Magic was too potent a power base to bypass; it had to be redirected and made to serve Christian purposes. But in the venerable tradition of Moses and the Magi (Daniel's companions), Christ the Magician confronts the emperor's representative and pulls his ultimate trick: with perfect equanimity he accepts execution, confident of his resurrection.

CHAPTER FOUR

Larger-than-Life

I N MIRACLE IMAGERY, Christ stepped into a void that none of the gods of the ancient world had managed to fill.[1] He showed himself a god of the "little man," a genuine "grass-roots" god. In succinct images, from tableware to sarcophagi, he showed himself a caring god, concerned if you were losing your sight, were bent with arthritis, or suffered menstrual problems. The ancient world, of course, had a host of gods to whom people turned in times of personal distress; this was nothing new. What was new was the imagery. Now suddenly the God was *seen* walking among his people, touching, stroking, comforting, pressing his warm and life-giving hands on them, and working a very visible magic. This was a radically new imagery of extraordinary power, and the competition had nothing to match it. The images of the pagan gods had failed to show them attending to the needs of mere mortals.

The imagery that was developed in monumental mosaic compositions was of quite a different scale and character, and drew its power from other quarters. It, too, enlarged the artistic experience, but in a very different direction from the miracle imagery. Its arena was not the personal sphere of clothing and cemeteries but the bill-board space of basilica vaults and walls. The originality of this development deserves to be recognized.

The Early Christian basilica presented a novel space for the artist. The temple of the pagans had been essentially a house for the gilded cult statue of the god. The priests had access to the god, but the people gathered to worship in the open air of the courtyard around the temple. This is where their processions took place and where their sacrificial animals were slaughtered. The Christian church building, on the contrary, was a public assembly hall (figs.69&70). Crowds gathered within it, singing hymns and amen-ing the fervent imprecations of the preacher. The passive participation of the modern Christian assem-

69. St. Pudenziana, Rome, c. 400, view of the nave as remodelled in 1588

70. St. Pudenziana, Rome, c. 400, reconstruction sketch showing bishop's cathedra beneath the mosaic

bly, dozing in their pews while the clergy "conduct" the ceremony in the sanctuary, has little resemblance to Early Christian behavior in church. There were no pews or benches to confine the people, and the crowds moved in repeated waves through the spacious columned corridors during the liturgy.[2] Entries and exits, readings, offertories and communion were all moments of public involvement. Outside of liturgical celebrations, the Christian public gathered in their basilicas to feast boisterously in commemoration of their dead, whether saints or not.[3] Drunkenness in such gatherings was frequently lamented by the clergy.

This democratization of worship required a fundamentally different kind of building from the pagan temple. The Christian solution was to adapt the Roman civic basilica by turning it ninety degrees on its axis. Thus, what had been a broad, colonnaded interior mall stretching right and left of the entering visitor became a long processional tunnel of space leading the visitor compellingly from the entrance to the holy of holies, the altar space at the opposite end of the nave (figs. 70, 120). Because Christians generally faced east to pray, their basilicas conformed by pointing their nave to the east. The adoption of this building form—a roof of timber and tile covering three or five parallel corridors, the central one higher and wider than the side ones—determined the plan that cathedral architecture would follow throughout the Middle Ages. Already in 324–329 Constantine's "Old" St. Peter's in Rome contained the layout of Notre Dame in Paris nine hundred years later.

This new space presented a fresh artistic challenge. Formally, an interior with such a compelling directional sense required a dramatic stop; the nave had to end with something that could contain and conclude the movement, and this was provided in the apse, a deep, curving niche set in an arch that spanned the whole width of the nave. The insistent motion of the nave, with its uniform columns marching in file toward the east, came to rest in the curves of the concave apse. The decoration of the apse therefore provided a climax, and works of art located elsewhere in the building deferred to the longitudinal focus on the apse.

But beyond the formal challenge to exploit a new setting, the artist had to deal with the active involvement of multitudes of worshipers in this space, with their processional movement toward the altar in the liturgy and their eastern orientation in prayer. Whatever he placed in the conch of the apse became the object of attention in worship. Whether the faithful felt they were praying *to* the image or merely praying *toward* the image, the intensity of their gaze heightened the effect of the apse painting. A work that could stand such attention, such riveted staring by a crowd over long periods of time, in the brilliant light of

morning services or the glowing candle-light of midnight vigils, had to be a new kind of painting.

A new medium was found for the situation: glass mosaic. In Early Christian art mosaic was the medium of preference; the most solemn visual discourse always required the luminescence of mosaic. In the Roman world mosaic had been used for paving floors or, on a limited scale, for decorating the surroundings of fountains and baths (fig. 46). Yet as long as it remained on the floor, the material of mosaic was necessarily limited to something that would take the tread of shoes, namely stone. White marble backgrounds set off figures in yellow and rosy stones; reds were dull, greens were somber, and blacks substituted for blues. Glass was used sparingly for accents.

The Early Christian artist saw a potential in the medium that had not been dreamed of before, extending it to cover walls and vaults. Liberated from the scuffing of floors, mosaic could now include a wide range of fragile materials: colored glass cubes of saturated red and deep blue, iridescent fragments of mother-of-pearl, even gold and silver foil sandwiched in glass. [4] Such reflective materials achieved a brilliance previously unknown (figs. 102 & 104). The iridescent medium seemed actually to contain light in itself. A radically new aesthetic was in the making, a pointillism of glass. In so far as each cube had a slightly different cut to it, the play of light was endlessly varied, producing an effect analogous to the shimmering dots of Georges Seurat.

In addition, the introduction of gold into the palette radically altered the balance of colors. Gold was at once the strongest and most spiritual color. Its possibilities fascinated the artist, and by the sixth century backgrounds of solid gold became common. Used as a sky zone behind the figures, gold created a timeless space that negated the succession of hours and seasons in our earthly skyscapes. By day it enveloped the figures in a haze of warm brilliance. By night, reflecting from innumerable oil lamps and candles, it blazed like a furnace in which the figures moved in unsubstantial silhouettes.

Compositionally, too, the wall- and vault-mosaics were handled in a novel fashion. Where the orderly Roman mind required separate frames for separate subjects, breaking a wall surface into various kinds of panelling, the artist now attempted continuous, wrap-around and run-on compositions (figs. 86, 104, 112, 130–131). Destroying the little framed boxes of space, a limitless or indefinite space spreading over the walls and curving surfaces was created.

The new surfaces inspired unconventional imagery that presented Christ in solemn, magisterial roles of eerie, seductive beauty. Symmetrical compositions came to dominate the long view of the nave: Christ enthroned, six apostles on

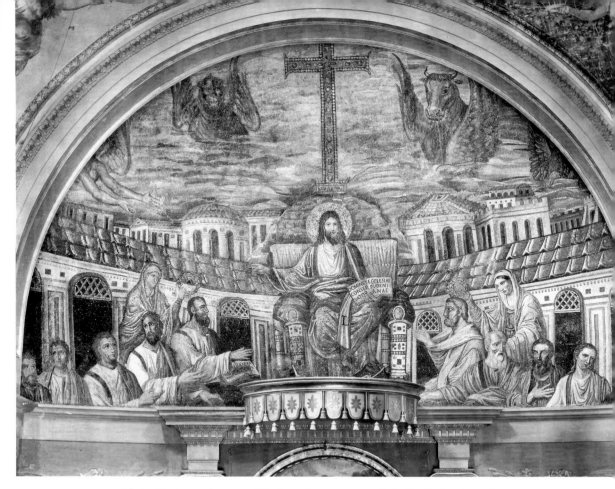

71. Christ Enthroned among His Apostles, apse mosaic in St. Pudenziana, Rome, c. 400

his right and six on his left (fig. 71), or Christ ascending into heaven attended by equal numbers of saints on either side (figs. 88, 133). These figures, unlike those of classical art, seek contact with us from a world beyond. In classical art the figures typically behave like performers on a stage. They inhabit a realm that is quite self-contained. They pose for our contemplation or act out ancient dramas among themselves, but they take no cognizance of the world "out there"—our world—beyond their stage. By contrast, the figures in the Early Christian apse seek our attention. They gaze out anxiously over the ocean of worshippers below, and from their mysterious curving space they beckon to us, inviting us to membership in their awful company. Haloes create visual targets around their faces, fixing our gaze. Their eyes search out our eyes.

The symmetry of these compositions has a force all its own. Early Christian art is often characterized as hierarchical, frontal, and symmetrical, and these are pre-eminently the traits of the great apse compositions of the basilicas. On the simplest and most visceral level, there is something reassuring about images

composed in matching parts with figures reflecting one another left and right. Because the human body is symmetrical, matching members naturally symbolize wholeness. There is a balance in the Christian world. It is a world of order under the universal control of the Son of God at the center.

The centering of these compositions implies a directional sense in life as well. Life is not an endless mix of the unplanned; there is a plumbline somewhere that rectifies all the wobbles and bumps of mundane existence. The universe converges toward something that a modern Christian philosopher like Teilhard de Chardin would call the "omega point." The world is not centrifugal but centripetal with Christ a giant magnet at the center.

The apse mosaics that proclaim this belief are the most ambitious single compositions of Early Christian art. Spanning the width of the basilica nave, the apse provided the largest unified space the artist had to work with. At St. Peter's, the grandest of the basilicas, this was over 60 feet; at the more modest basilicas of Saint Pudenziana and Saints Cosmas and Damian it was 29 and 51 feet (figs. 71, 133). We are looking at surfaces as tall and as wide as a giant movie screen. Figures in this space are larger than life; Christ is over six feet tall even while sitting down at Saint Pudenziana, and standing he is about ten feet tall in the apse of Saints Cosmas and Damian. This is as close as Early Christian art ever gets to the colossal, the super-human.

The compositions devised for these spaces are among the most enduring of Early Christian inventions. Once the formulae had been worked out, they retained their focal place in church apses down to the Gothic Age, at which point the apse of the church dissolved in stained glass. When this happened, however, the ancient apse themes were not discarded but were carried forward to facade sculpture. The elegant Christ-in-Majesty on Chartres' Royal Portal is the direct descendent of the Early Christian apse (figs. 88, 90). On smaller scale these same designs were repeated a thousand times in manuscript painting, ivory, and metalwork.

The apse composition was the primary icon of the Christian church. Its creation is one of the greatest accomplishments of Early Christian art, but once again the meaning of this creation has been seriously clouded by intimations of the Emperor Mystique. The study by Christa Ihm, which stands in splendid isolation as the only attempt to treat the subject as a whole, repeatedly falls back on the hypothesis of imperial prototypes with a confidence that is hardly justified by the scarcity of comparable images of the emperor.[5] The implication that these images derive their force from remembrance of emperors past seems to me to miss their intended impact. This reading, however, is the standard approach to apse decoration, repeated with predictable regularity in surveys of the history of art.

Artists developed several formulae, and all revolve around Christ at the center. Even those with the Mother-of-God at the center show the child-savior greeting us from her lap (fig. 86). The accompanying figures play a variety of roles; they sit with him or approach him in procession or receive crowns from him (figs. 71, 113). But the identity of the superman in the center is the most *un-studied* mystery of Early Christian art. When lowly worshippers lifted their eyes to this glowing icon of their Lord, what sort of person did they see? If Christ does not appear in regal pomp—a conclusion I believe inevitable—in whose guise does he appear, and whence does he derive his formidable authority? The imperial reading of these images implies a reverse caesaro-papist politics, the Church usurping the insignia of the emperor to bolster its claims to the authority of the empire. But if we have been mistaken about the insignia of Christ, perhaps we must look for other politics in the imagery.

The alarming truth is that, travelling from Rome to Constantinople in the fifth or sixth century, the Christian pilgrim would have encountered a dizzying diversity of Christ types. From church to church the Lord would undergo the most radical metamorphoses. Now calmly conversing with a circle of disciples (fig. 71), now climbing rosy clouds into the empyrean (fig. 133), now sitting on rainbows and waving to the viewer from a great bubble of light above the landscape (fig. 88), Christ's face was alternately old and grave, youthful and vigorous, masculine and feminine. Staring at the glittering apse must have been like experiencing a series of volatile hallucinations. The Early Christian Christ was truly polymorphous.

If we are to start at the beginning, we must start with the mosaic of Saint Pudenziana in Rome, a work of the 390s, the earliest surviving basilical apse decoration (fig. 71).[6] The mosaic was drastically trimmed on all sides in 1588, and much of what remains has been heavily restored, but the careful analyses of de Rossi and Köhler have distinguished the original sections from the restorations.[7] Generally speaking, the further one moves from the central figure of Christ the more restoration one encounters, so that the outermost apostles are entirely remade. But while these changes affect the feeling of the mosaic, they have not really altered the composition.

On a grand, pearl- and gem-studded throne sits a magisterial, larger-than-life Christ. He holds an open book which reads "Dominus conservator ecclesiae Pudentianae," "(I am) the Lord, the preserver of the church of Pudenziana." The apostles sit lower down on either side, and the first two of them, Peter and Paul, are crowned with wreaths by women. This scene is set against the background of a kind of portico, above which appears the cityscape of Jerusalem. Above the horizon looms a great gemmed cross, and four great winged crea-

72. Apse Mosaic of St. Pudenziana, Rome, drawing by Ciacconio (1595)

73. *Largitio* panel, from the Arch of Constantine, Rome, 313–15

tures hover in the sunset sky above, jarring and intrusive elements in an otherwise logical space. A drawing of 1595 by Ciacconio establishes the existence of another register to the mosaic beneath Christ's feet (fig. 72). In the center a dove descended on a lamb on a little hillock from which flowed the four rivers of paradise. One might imagine a procession of lambs on either side converging on this lamb, as is seen in the mosaic of Saints Cosmas and Damian (fig. 133).

There is general agreement, then, about the original composition of the mosaic of Saint Pudenziana. There is also general consensus among art historians in interpreting the mosaic as "imperial," even if they differ in nuances of interpretation. Ihm puts the apse of Saint Pudenziana in a category that she calls "Christ as Basileus/Rex with imperial court."[8] In this she is following the lead of André Grabar who, in his groundbreaking work on imperial iconography, described Christ as the "*panbasileus* celeste," "all-king of heaven," and derived the composition from the frieze of the Arch of Constantine (fig. 73) and analogous coin imagery.[9] Later he added another dimension to his understanding of the subject by appealing to a different source, compositions in Roman art showing a teacher and his disciples. But in the mosaic of Saint Pudenziana, he maintained, some such composition was "altered to give Christ a royal mien as the Panbasileus."[10]

However, while the relief of the Arch of Constantine shows a seated emperor, he is surrounded by standing officials to whom he throws coins in a symbolic gesture of munificence (fig. 73). The alleged numismatic prototype also lacks a seated gathering, showing simply Constantine flanked by two of his sons. Grabar clearly sensed the inadequacy of this evidence, but so convinced was he of the imperial parentage of the apse imagery that he affirmed it even in the absence of surviving prototypes. He remarked, "Despite the absence of a single example of an *imago sacra* of the emperor enthroned, it is certain that the portrait of the emperor seated in majesty surrounded by his attendants was among the formulas used for official effigies of the Roman monarch as well as for the empress, at the time of the Christian Empire."[11] But this is exactly what remained to be proved.

Nevertheless, the assumption of the missing evidence is basic to all subsequent argument. Yves Christe explains the mosaic as a Christianized "Kaisertriumph," dependent upon compositions of the emperor surrounded by his *amici*, although no such composition has survived.[12]

For some reason the modern viewer is all too ready to see imperial associations in the image. But the question must be asked whether the original viewers of c. A.D. 400, gazing on the Saint Pudenziana mosaic, would have been reminded of their earthly sovereign, whether in his actual appearances, if they had been fortunate enough to catch a glimpse of him, or in his public imagery,

which was everywhere available in coins, statuary, reliefs, or paintings. This question can be answered only by examining the elements of the image one at a time.

While it is alleged that Christ has been given imperial *insignia*, he lacks the most important of these (fig. 74). The head of the emperor, from Constantine on, was distinguished by a jewel-studded diadem.[13] Christ wears no such ornament, either in Saint Pudenziana or anywhere else in Early Christian art. He also lacks the imperial cloak or *chlamys*, the purple boots, and the scepter. These accoutrements at first were restricted to the emperor's appearances as the commander-in-chief of the military, but they gradually became the standard attributes of imperial authority, the signs by which every child learned to distinguish an emperor from a non-emperor. Christ, on the contrary, wears the civilian dress: a pallium over a tunic decorated with a pair of light blue vertical stripes—the *clavi*—and sandals. Traditionally, every male citizen on assuming the *toga virilis* also assumed a *tunica* with *clavi*. This was standard civilian attire. It is true that an emperor like Augustus, to advertise himself as just another citizen—*primus inter pares*—also appeared in civilian dress; but this did not make civilian dress imperial.

The luminous gold of Christ's garments, however, clearly sets him apart from the citizen who traditionally dressed in white. Conservative Roman taste restricted the use of gold to a modest decorative stitching in the hems. Several late Roman emperors—Commodus, Elagabal, Aurelian, Diocletian, and Constantine—disgusted their compatriots by appearing in golden garments. In such cases, however, the gold was applied to the emperor's military dress, his *vestris castrensis*, which was a gold *chlamys* or a gold tunic under a purple *chlamys*, rather than to civilian attire.[14]

The gold garments should be considered along with the gold of Christ's halo, which has also been mistaken for an imperial attribute by Matthiae and others.[15] While it is true that the halo had occasional imperial use—generally in radiating form rather than disk form—it had prior and more common use as an attribute of the gods, which is why the emperor wanted to appropriate it.[16] The same is true of gilded garments. The gods in all the great cult images of antiquity were clothed in gold,[17] and even in the fifth century Roman Vergil manuscript the artist knew Jupiter should be clothed in gold (fig. 75).

When halo and golden garments are assigned to Christ they are not meant to make an emperor of him but to signal his divinity. Nicaea, we must repeat, did not proclaim Christ emperor, but "God of God, light of light, true God of true God, begotten not made, of one substance with the Father." In the wake of the Arian controversy that dominated fourth-century theological debate, the aim of the artist was not to make an image of any mere earthly man, however

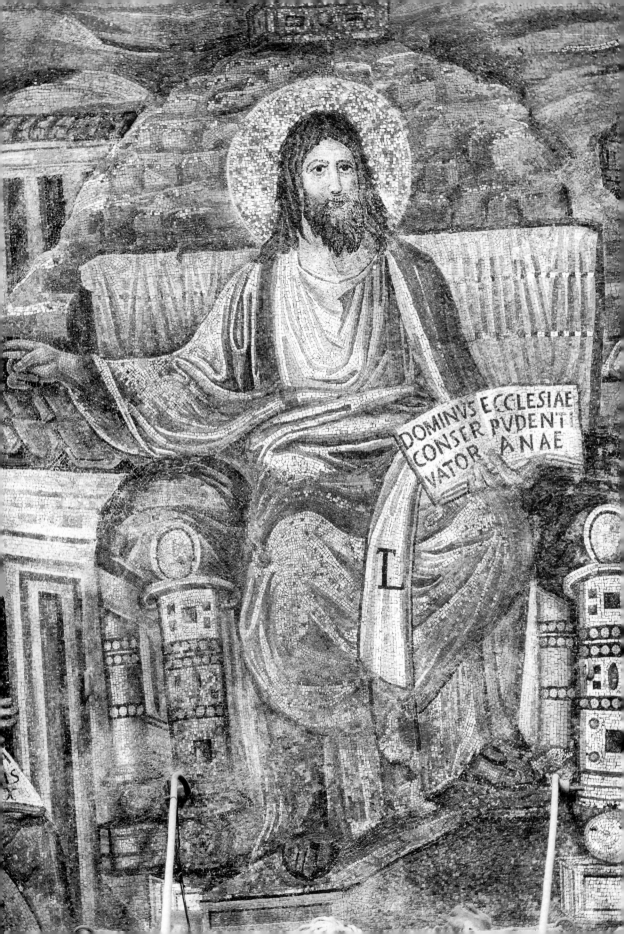

DOMINVS ECCLESIAE
CONSER PVDENTI
VATOR ANAE

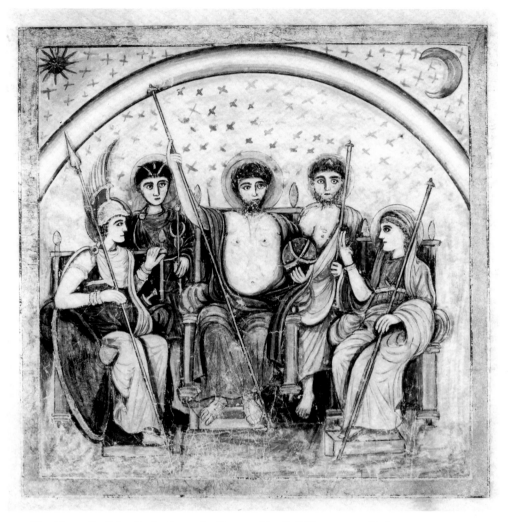

75. The Council of the Gods, from the Roman *Vergil*, fifth century, Vatican

exalted his status, but to create the true superman, a Christ who would be equal to God the Father.

This, moreover, seems to be the intention behind the most striking of Christ's attributes in the Saint Pudenziana mosaic, his enormous throne. Although this too is usually said to be imperial, it is a consistent Roman attribute of divinity.

74. (*facing*) Christ Enthroned, detail from the apse mosaic in St. Pudenziana, Rome, c. 400

76. *Sella Curulis*, reconstruction drawing

77. Magistrate on a *Sella Curulis*, in the Accademia d'Ungheria, Palazzo Falconieri, Rome, second century

Christ's seat is a most extraordinary piece of furniture. It has a great crimson cushion that has been called purple and therefore imperial.[18] But the color is bright red, much closer to orange than to purple.[19] More important is the shape of the throne. Armless, with a high back, it has round legs that are thickly studded with pearls and gems, and it has a matching footstool.

The official seat of the emperor, however, was no such extravaganza, but the much more modest *sella curulis*, or curule seat.[20] Originating in Etruscan times, the *sella curulis* was a folding stool with S-curved legs made of wood or bronze with four interlocking rails on top (fig. 76). The front and back rails often extended beyond the legs and offered a field for decoration. Across the top a leather seat was stretched on which a cushion might be placed.

Romans thought this was the seat used by their legendary king Romulus,

78. Severus Alexander on a *Sella Curulis*, Rome, A.D. 229, New York

founder of Rome, and referred to it as the *sella regia* or "royal" seat. Along with the sceptre and the *fasces*, it was the primary symbol of the authority of government, used for the exclusive seat of office of the consuls and the most important magistrates. The emperor could hardly have afforded to bypass a symbol of such authority, and Julius Caesar set the example for his successors by using a *sella curulis* of gold. Thus it became the traditional seat of the emperor for public, state occasions, and literally hundreds of representations exist in Roman coinage and relief showing him so seated (figs. 77&78).

In the Late Empire representations of seated Roman emperors become much scarcer. However, in a calendar of 354, extant in copies, Constantius II is shown on a *sella curulis* (fig. 79).[21] The curved legs have been exaggerated and splayed apart, but they are still recognizable. More telling, the peculiar sequence of rectangular shapes of the interlocking rails is shown at either side, even if the copyist did not understand the shapes. In the fifth and sixth centuries, ivory carvings of the consular diptychs supply the gap in our information on the late history of the *sella curulis*. Although its ornament became richer, its basic structure remained the same. In 518 the consul Magnus sat on a *sella curulis* whose legs were lions' legs with lions' heads above them; the end panels of the front rail were decorated with personifications of abundance, and figures of victory dance on top of the perpendicular rails (fig. 80).[22]

This is the kind of seat on which the emperor Justin II, in 565, received with haughty disdain a delegation of the Avars, his troublesome neighbors from the Danube (fig. 81). The eye-witness Corippus described the scene quite vividly, though modern historians have misread the passage: "The inner sanctum is ennobled by the imperial seat which is surrounded by four excellent columns, above which a canopy, shining bright with solid gold in imitation of the vault of heaven, overshadows the immortal leader sitting on his throne. [The latter is]

79. Constantius II on a *Sella Curulis*, drawing by Peiresc, from the Calendar of 354, Biblioteca Apostolica Vaticana

ornamented with gems and distinguished with purple and gold. Four arcs [i.e., arched legs] bend to intersect one another, and above, on the right and left side, matching Victories alight with wings outspread in the air, carrying a laurel crown in their shining right hands."[23] In her recent translation and notes on this passage, Averil Cameron takes the "arcs" to refer to the canopy overhead, and this requires her to put the Victories higher still where they would offer their crowns to the thin air. But curving interconnected arcs are the most characteristic feature of the *sella curulis*, and Victories, as the diptychs demonstrate, were part of the decoration of the cross rails of the seat in the sixth century. One can only conclude that the official imperial seat in the most august inner chamber of the palace, however richly embellished with gemstones and canopy, was still the *sella curulis* as late as the sixth century.

What the ancient world referred to as a throne (*thronos* in Greek or *solium* in Latin) was an entirely different piece of furniture. Though it admitted of many variations, it was basically a chair with straight legs and a back. The legs might be rectangular, or turned spindles, or formed as solid sides; the back might be high or low; and it might or might not have armrests. [24] Such chairs were seats of honor for guests and distinguished citizens, and were represented as seats for the gods. Ancient art shows Dionysus and Pluto and Aphrodite and Hera enthroned; but the throne is foremost the attribute of the father of the gods, Zeus or Jupiter. Indeed, from archaic vases to the Parthenon frieze, from Pompeian wall painting to Roman coinage, Jupiter reigns from a throne.

Roman coin imagery, most familiar to the public, always gave Jupiter a

81. *Sella Curulis* of Justin II, reconstruction drawing

80. The Consul Magnus on a *Sella Curulis*, leaf of an ivory diptych, 518, Cabinet des Médailles, Paris

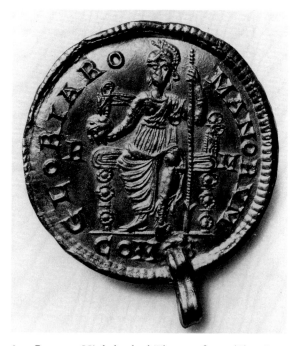

82. *Roma* on High-backed Throne, five *solidus* piece
of Honorius, Rome, c. 400, reverse, New York

straight-legged, high-backed throne imitating Phidias' renowned cultic statue at Olympia (fig. 1). Other figures allowed to occupy such a throne were the divinized personifications of Roma and Constantinople (fig. 82). This imagery was also very common and remained in circulation after Jupiter was banished from coins by Christian emperors. In the fifth century, a generation or so after the mosaic of Saint Pudenziana, the painter of the Roman Vergil still understood perfectly that the Capitoline triad, Jupiter, Juno, and Athena, belonged in high-backed thrones (fig. 75). This is the way gods ruled in their high council over the world.

The imagery of seats is consistent. On the one hand Christ is never shown on the emperor's proper seat, the *sella curulis*. On the other hand, the emperor is almost never shown on a true throne.[25]

The splendid throne of Christ in Saint Pudenziana is not intended to give Christ imperial status but divine status (fig. 72). It is precisely here that the war of images was being fought out most intensely. By usurping the attributes of the ancient gods Christ was effectively supplanting them.

Not only has he taken their seat, he has taken their face as well (fig. 74). Christ's long dark hair, broad forehead, and full, dark beard are unmistakably

divine attributes. They are most commonly associated with Jupiter, although Asclepius and Serapis have very similar features as well (figs. 1, 47, 105). In trying to give Christ a status equal to his Heavenly Father, the artist turned to imagery of the father of the gods, letting Christ borrow Jupiter's gold, his halo, his throne, his face.

Still, intent on their argument for the Emperor Mystique, art historians have argued that, even in the absence of specific imperial attributes in the Saint Pudenziana mosaic, the hieratic composition itself, with a frontal Christ in the center and the apostles grouped around him, carried imperial associations. This, they imagine, is an imperial mode of presentation, which must have reminded viewers in A.D. 400 of their seated emperor, with the senate, his counsellors, and friends seated around him. But this is impossible. Imperial etiquette would never allow it. After the first century the senate was not allowed to *sit* in the emperor's presence, nor was anyone else.[26] In his reorganization of imperial government, Constantine introduced a high council of advisors that he called the "consistorium," literally the "standing committee," because when they convened only the emperor sat. Nor were bishops allowed to sit in the presence of the Christian emperor; when Constantine attended the Council of Nicaea, since he wanted to take part as a bishop himself, he had to issue a special decree allowing the bishops to sit and deliberate with him. On one other occasion, in 362, Julian the Apostate, nostalgic for the days of the Principate, went down and sat in the curia with the senators; but this humble, egalitarian behavior was regarded as outlandish and was labelled ostentation. The emperor did not sit with other mortals.[27]

CHRIST seated in the midst of his seated apostles struck a very un-imperial note. His apostles are not senators but his co-philosophers. Philosophers were very important in the world of Late Antiquity and sets of philosophers were commonly represented in art. A nearly contemporary mosaic from Apamea in Syria shows Socrates seated in a semicircle of seated sages (fig. 83). The parallels between Christ and Socrates in ethical teaching and in acceptance of unjust death were a common theme among the Early Christian apologists.[28] In the Via Latina catacomb an unnamed philosopher is flanked by seated philosophers presiding at a sort of anatomy lesson where he faces a painting of Christ the philosopher between Peter and Paul.[29] Medical men of antiquity confer in a semicircle in the Vienna Dioscurides manuscript of 512.[30] Recent archaeological finds have furnished other sets of philosophers. The discovery at Aphrodisias, Turkey, of a courtyard that served as a school of philosophy in the late fourth or fifth century brought to light a set of shield portraits of philosophers (fig. 96).[31] Seven philosophers are named, but the group included contempo-

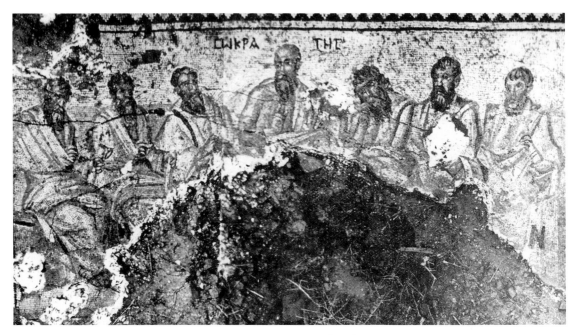

83. Socrates with Six Wise Men, mosaic in Apamea, Syria, fourth century

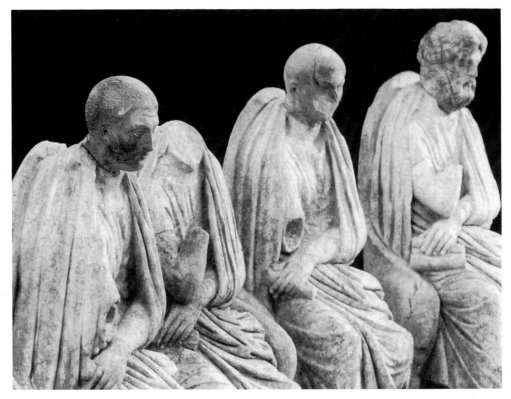

84. Four Philosophers, from the Villa of Dionysus, Dion, fourth century

rary unnamed philosophers as well. At Dion, in Greece, the excavation of the Villa of Dionysus has turned up a set of four Late Antique philosopher statues whose poses presage the apostles of Saint Pudenziana (fig. 84).[32] Their identities are unknown, but clearly they were meant to be taken as a group who together represented a sort of compendium of ancient philosophy.

It is in this context that Early Christian art developed its composition of Christ surrounded by his co-philosophers, the apostles. It is a composition that had enjoyed considerable popularity in catacomb art for generations. Saint Pudenziana may be seen as the culmination of a development visible in the frescoes of Saint Domitilla or the Via Anapo (figs. 2, 85). Implicit in such images is the bold claim of Christians to have bested their pagan adversaries in the intellectual realm. And, indeed, in sheer volume of publishing Christian writers outproduced their pagan rivals many times over in the Late Antique period. The threat posed by Christian scholars was keenly felt by the opposition, and Julian the Apostate tried to prohibit Christian professors from teaching classical literature.[33] Christ and his apostles were supplanting the academies of the Hellenes.

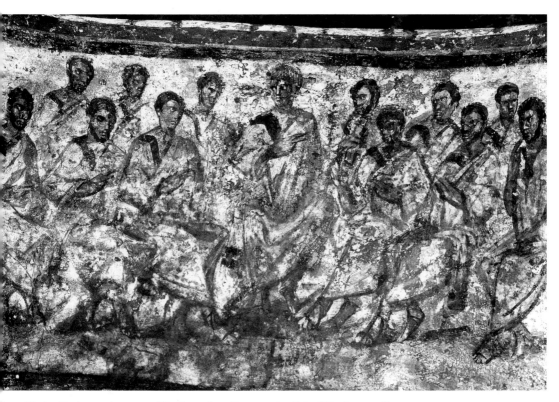

85. Christ Enthroned among His Apostles, Catacomb of the Via Anapo, Rome, c. 325

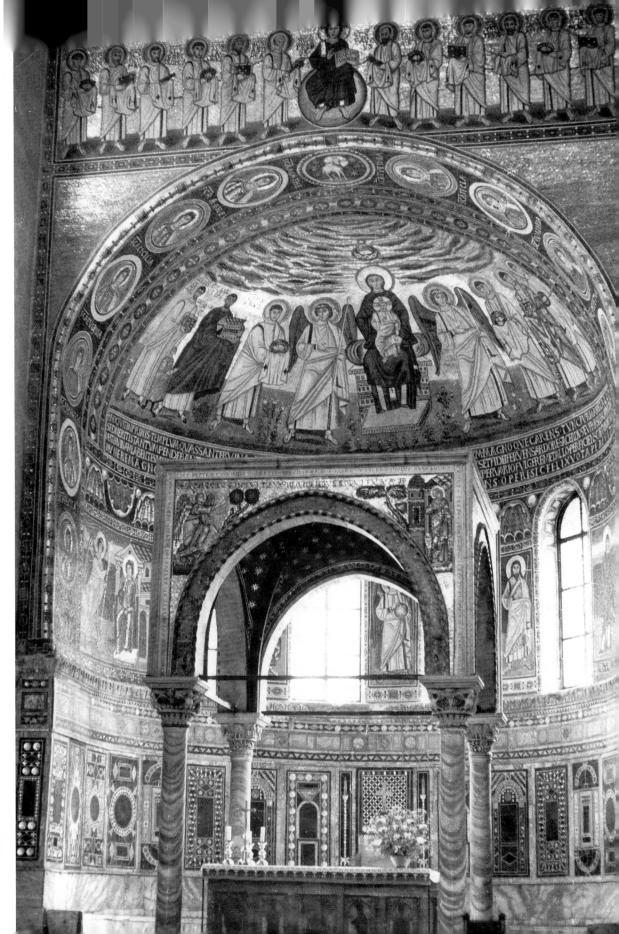

87. Cathedra and Synthronon of the Basilica Euphrasiana, Parenzo, c. 550

The absence of imperial references does not mean that the Saint Pudenziana mosaic is without political implications, but only that the politics are not those of the emperor but rather of the bishop.

The politics of the mosaic are defined by the real-life referent of the composition, which could hardly have been missed by the fifth-century church-goer. For directly beneath the mosaic sat the bishop on his elevated seat, his *cathedra*, flanked by his clergy who sat on the semicircular bench, the *synthronon*, around him (figs. 70, 86, 87). In the churches of the East, the clergy's bench was elevated in amphitheatre fashion, giving them a dramatic visibility.[34] By sitting beneath

86. (*facing*) The Basilica Euphrasiana, Parenzo, apse with synthronon below (behind the altar), c. 550

Christ and imitating his pose and gestures, the bishop claimed the right to replace Christ, to speak in his name, and to legislate for his flock. It should be observed that in modern Christian churches the congregation sits and the minister stands to preach, but in the early Church it was exactly the opposite: the people stood and the preacher sat. His seat or *cathedra* was the symbol of his authority, every bit as much as the *sella curulis* was the symbol of imperial authority.

Christ's gesture, combined with his open book, is not the menacing gesture of a judge, nor an emperor's acknowledgment of acclamation, but a teaching gesture (fig. 74). The authority of the teaching bishop derives directly from the authority of the teaching Christ. As Christ teaches from his heavenly throne so the bishop from his. The themes of the bishop's teaching are alluded to by the four beasts in the sky above who announce the four gospels, and by Peter and Paul, authors of the epistles, who merit crowns by laying down their lives for Christ.

The triumph of Nicaean Catholicism over Arianism in the late fourth century put the episcopacy on a new footing. The authority of the Church was understood to derive directly from Christ without the mediation of the emperor. Hence the inscription in Christ's book: Christ personally claims to be the "Protector of the church of Pudenziana." In so far as the struggle against the Arians was also a struggle against the emperors, who had taken the Arian side, the victory over Arianism was a vindication of the freedom of the Church from imperial control.

The lowest register of the composition, now missing, reinforced this meaning by showing the Church of Christ in symbolic form (figs. 70, 72). The rows of lambs that once converged on the Lamb of God represented the faithful who fall in line like sheep behind their leader.[35] The mosaic is propaganda not for the imperial aspirations of Christ, but for the divine origins of ecclesiastical authority.

Christ Chameleon

THE NEW CHRISTIAN IMAGES exerted an extraordinary fascination for viewers. People readily experienced visions in their presence and wove tales of miracles around them. One image of Christ was said to be the miraculous impression of his face on a piece of cloth; others were made by angels; saints were seen to step out of their images and walk on the streets with men; the touch of an icon would work instantaneous cures.[1] Unhappily, in most instances these miraculous art works do not survive and we have no way of checking what inspired the legend. A mosaic at the Stonecutters' Monastery in Thessalonica is a special exception to the rule. The story that grew around this image is indeed very peculiar.

Legend attributes the making of the mosaic to a mythical princess Theodora, purportedly the daughter of the pagan emperor Maximian (287–305) and a crypto-Christian.[2] Desiring a private place to pray, she secretly had a little bath chamber in her palace converted into a church. "When this had been done, she ordered that a painter be fetched immediately so as to paint the pure Mother of God in the eastern apse [mosaic workers were commonly referred to as painters]. So this image was being painted and the work was nearly finished when, the following day, the painter came along intending to complete the picture and saw not the same painting, but a different one, indeed one that was altogether dissimilar, namely that of our Lord Jesus Christ in the form of a man, riding and stepping on a luminous cloud and on the wings of the wind." The story further narrates how an aged Egyptian monk named Senouphios was led by divine revelation to rediscover the work, when it had been hidden during a period of persecution. At the sight of the mosaic, the holy man died in ecstasy.

In the fabulous literature surrounding holy images I do not believe there is another instance of a miraculous sex-change. Why anyone should have imag-

ined a metamorphosis of the Virgin into her divine Son is a question that involves the sexual identity of Christ. It is an issue of profound religious importance.

Contrary to the legend, the church of the Stonecutters' Monastery—now called Blessed David after a local ascetic—was not erected in the third century but in the mid-fifth. The building still stands relatively intact on the steep hillside high above the city and harbor of Thessalonica.[3] Unlike the great public basilicas we have been considering, the church is small and cross-shaped, more a chapel than a church, suggesting the domestic setting of Theodora's story. Blessed David is as intimate and mysterious as Saint Pudenziana is grand and emphatic. The apse is a bare ten feet across. Yet within the narrow confines of this space the mosaicist has created a hallucinatory vision that might easily have suggested miracles to a believing eye (figs. 88 & 89).

The ostensible subject of the mosaic is the vision of Ezekiel (Ez 1:4–28).[4] On either side of the composition we see rocky banks between which flows the River Chabar, the site of Ezekiel's vision. Ezekiel, on the left, shields his eyes from the apparition, which in his words appeared out of "a great cloud, with brightness round about it, and fire flashing forth continually" (Ez 1:4). In his effort to convey this visionary light the artist invented three different kinds of mosaic light. He represented the cloud as a great transparent disk with rays of shining white, pastel pinks, and blues. Within the disk he seated Christ on the arc of a luminous rainbow. Finally, he surrounded Christ's head with a halo of warm gold light. The winged "living creatures" that Ezekiel saw emerge from behind the cloud and are partly visible through it. The figure of Christ in front of the cloud seems to project forward toward us by his relatively larger scale and the brilliance of his coloring in deep blue and maroon red. The smaller prophets to the right and left, though physically closer to us in the curve of the conch, recede into the distance behind Christ.

Ironically, the dazzling inventiveness of this image has been obscured for us by historical hindsight. This is the earliest instance of the most popular apse theme of the Christian East, the so-called "Majestas Domini," or Majesty of the Lord, but its numerous progeny now make it seem commonplace.[5] It was far from commonplace when it was invented in the mid-fifth century.[6] Moreover, geography gives Blessed David a special importance, since it is our nearest representative of what the apses of Constantinople may have looked like. All of the early church decoration of the capital has been lost, without exception. If we may judge from the frequency of the Ezekiel vision in surviving Early Christian apses of Egypt and Armenia, as well as the Middle Byzantine apses of Cappadocia, the subject probably had considerable popularity in Constantinople.[7] Moreover, in the West, in the apses of Romanesque churches, on portal sculp-

ture and on smaller scale in manuscripts, ivories, and enamels, the composition of Christ in a circle of light surrounded by the four "living creatures" is common to the point of stereotype (fig.90). This is one of the key image-types of Christian art.

As is often the case, the term art history has assigned this image has prejudiced any scholarly discussion of it. It is hard to not to hear regal overtones in the expression the "Majesty of the Lord," and the interpretation of the mandorla motif, or the body halo, often alleges imperial connections. But the image was not called a "Majesty" in Early Christian times; the miracle legend refers to it as a "theandric," or god-man image.

The imperial associations of the mandorla depend on its alleged derivation from the Roman *imago clipeata*, or shield image.[8] This argument, however, is doubly doubtful. In the first place the shield image is a common portrait format without a special imperial connotation (figs.18,96). In the second place, compositionally the mandorla's origin is not Roman but Buddhist. The Roman shield portraits are exclusively bust images, a characteristic that emphasizes the purely pictorial status of the figures, since only in representations can figures be cut off at the bust. By contrast, in the Christian mandorla the figure is always full-length, alive, and moving freely in front of the mandorla which he can overstep or overreach.[9] The transparency of the cloud of light at Blessed David also contradicts the shield-image derivation; the "living creatures" are visible through the rays of the aureole. Furthermore, Christian mandorlas are often bordered in concentric bands of color: red, white, and green.

These features all lead us not to Roman art, which has no tradition of such body haloes, but to a source in the art of India and Central Asia. Prior to the rise of Islam the mediterranean world was in much more direct contact with the East, where the Buddha was frequently represented before an oval, circular, or flame-shaped aureole. Whether standing or seated, the Buddha is always a full-length figure enjoying the same reality status as Christ does before his mandorla. He can overstep its border and is sometimes joined by other living figures who enter his space in front of it. The concentric colored borders are also found in Buddhist art.[10] Most significant, the imagery of Buddha before his oval aureole was in circulation long before Christian art made use of the motif. A coin of King Kanishka I carrying such an image has been reliably dated to the second century (fig.91).[11]

The introduction of motifs of light into the vocabulary of Early Christian images was a decisive step with permanent consequences for the history of art. Like the halo, the aureole of light encircling the body of Christ was first introduced during the anti-Arian debate of the late fourth century. The earliest securely dated example of the aureole is found in a rare and seldom cited mosaic

in the catacomb of Saint Domitilla, in Rome (fig. 92). The location of the tomb halfway down the stair to the first level of the catacomb argues for a date in the time of Pope Damasus (366–384) or slightly later, according to the Jesuit archaeologist who found it.[12] Christ, Peter, and Paul sit on thrones with high backs. A *capsa*, or leather bucket, full of scrolls has been placed at Christ's feet, emphasizing his role as philosopher, and behind him is a great glowing circle of eerie green light. The same aqua-green tesserae were used for the halo of Christ in the neighboring scene of the Raising of Lazarus.

That this light is meant to signify Christ's divinity in an expressly anti-Arian sense follows from the inscription in bold, four-inch capital letters encircling the lunette: "Qui filius diceris et pater inveneris," that is "You are said to be the Son and are found to be the Father." In language reminiscent of the Gospel of John, "He who has seen me has seen the Father" (Jn 14:9), Christ is equated with his heavenly Father. Light was the metaphor invoked by the Council of Nicaea in its condemnation of Arius: the Son is "light of light, true God of true God, of one substance with the Father." This is how one must interpret the radiant mandorla or aureole of Blessed David. It is a circle of light, a zone of supernatural glory, meant to convey the equation of Christ with his Father, the awesome Yahweh, seen by Ezekiel in his vision. There is no hint of the Roman emperor.[13]

Strangely enough, however, the image of Christ himself departs radically from the description of the fearful Lord in Ezekiel's vision. For Ezekiel, we must remember, the terrifying experience was an omen of the destruction of Jerusalem by Nebuchadnezzar in 597 B.C. It was not an apparition that was liable to soothe the mind. The Christ of Blessed David does not sit on the imperial *sella curulis*, but neither does he sit on the throne of sapphire that Ezekiel saw. Rather he perches on a most unsubstantial rainbow. His pose is dangerously askew, the imbalance giving the effect of movement, as if he has only just arrived. And while Ezekiel saw a terrible man "as it were of gleaming bronze, like the appearance of fire" (Ez 1:27), the Christ of Blessed David is as mild as milk. The round, full face is soft and beardless, encircled with light hair that falls copiously on his shoulders. His body too lacks any masculine vigor: the shoulders are narrow and sloping, and the hips are broad. Indeed when the mosaic was re-discovered in 1926 after the withdrawal of the Turks who had been using the church as a mosque since 1430, there were some in Thessalonica who thought it must be an image of the Virgin.[14] Upon closer study, the cruciform halo and the four living creatures around the mandorla required that this possibility be dismissed, but the untutored first reaction of ordinary people to the mosaic is itself important evidence. In a simpler age one might readily have recourse to legend to explain the anomaly, imagining that it was in fact an

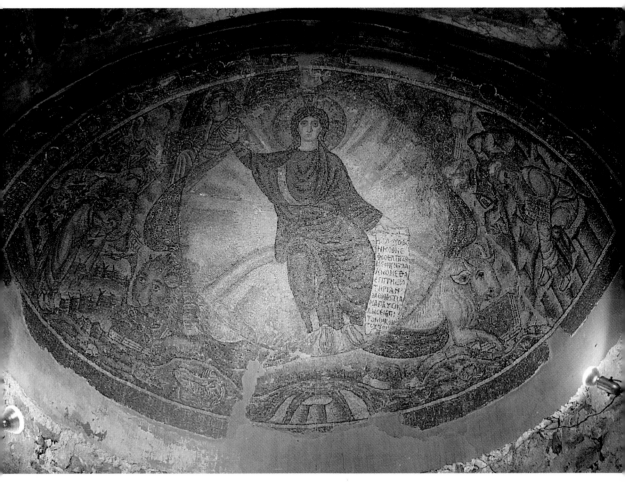

88. The Vision of Ezekiel, apse mosaic in Blessed David, Thessalonica, c. 425–50

image of Christ's mother, miraculously made over into the Savior but still preserving the contours of the previous image.

No SUBJECT is more taboo in art history than the sexuality of Christ. In Renaissance art, Leo Steinberg has documented the tactful evasions by which art historians have traditionally avoided dealing with imagery that unashamedly put the genitalia of Christ on display.[15] Steinberg has advanced a very plausible explanation for explicit sexual imagery in the Renaissance based on sermon literature of the period. Christ's male sexuality was the guarantee of his full

119

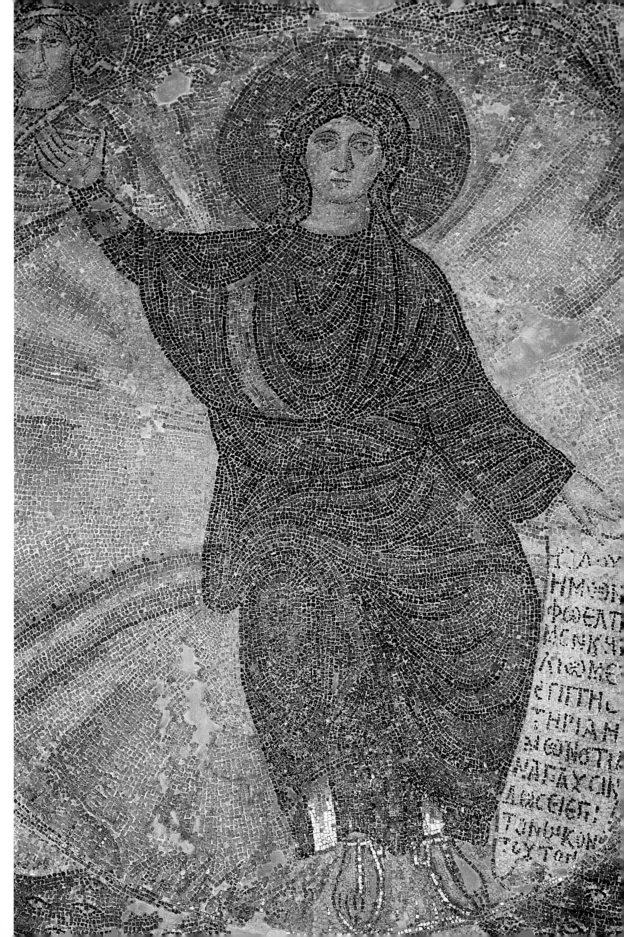

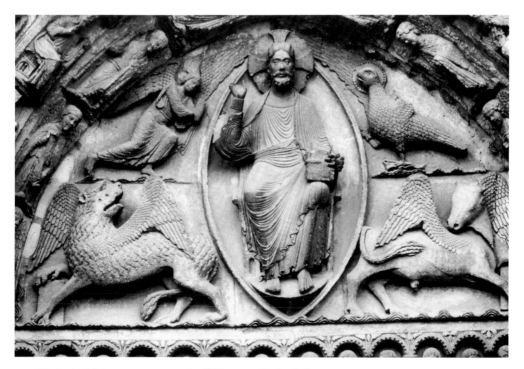

90. Christ in Majesty, west portal of Chartres Cathedral, c. 1145–1150

Incarnation; unless he assumed all of human nature he could not redeem all of human nature. Late medieval images of a maternal Christ who nourishes the faithful from the wound in his side have recently been studied by Carolyn Bynum.[16] But as a whole, the issue of Christ's sexuality is conspicuously absent from scholarly discussion; in the literature concerning the Early Christian period it is never mentioned.

If the mosaic of Blessed David were unique in this respect one might dismiss its sexual ambiguity as an aberration—worth noticing, perhaps, but not worth dwelling on. But alongside his virile manifestations, Christ in Early Christian art often showed a decidedly feminine aspect which we overlook at our own risk. It is not the unanswered but the unasked questions that undermine discourse and give an unbalanced slant to an entire field. Whether or not adequate explanations can be found, it is particularly important that this issue be raised in connection with Early Christian images, for once this feminine aspect of Christ had gained an acceptability, later artists, whether in the Middle Ages or beyond, felt free to exploit it without apologies. Judging from the rich

89. (*facing*) Christ, detail from the apse mosaic in Blessed David, Thessalonica, c. 425–50

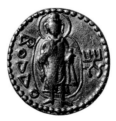

91. Buddha in Aureole of Light, coin of King Kanishka I, second century A.D., London

92. Christ in Aureole of Light, between Peter and Paul, mosaic in the Catacomb of Saint Domitilla, Rome, c. 366–84

93. Raphael, Christ Blessing,
Brescia, Pinacoteca

tradition of effeminate imagery of Christ, it appears that people were not uncomfortable with such a Savior (fig.93).

Christ's full, beardless cheeks and long hair are, of course, not unusual in Early Christian art. Though scholarship seems to have regarded the coiffure of Christ as too trivial to be worth attention, it is clear that hairstyles were very important to the artists. [17] Christ's hair always sets him apart from his companions. In the Terme Museum Entry, Peter is bearded with a compact mound of curly hair and Paul is balding in front; the other disciples and the two common men have tongue-like locks brushed forward from the crown over their foreheads (fig.10). This approximates the hairstyle popularized by Constantine and most commonly worn in the fourth century. [18] Christ, however, has a full head of large curls that twist this way and that as they fall to the nape of his neck, entirely concealing his ears (fig.20). It is a hairstyle that effectively removes Christ from the fourth-century historical setting of his companions.

There are many variations to Christ's hairstyle, but it is generally long and

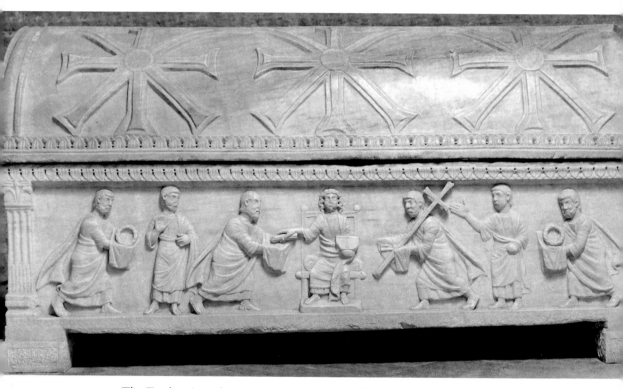

94. The Twelve Apostles Sarcophagus, Saint Apollinaris in Classe, Ravenna, mid-fifth century

loose and always has the effect of distancing him from those around him (figs.10,34,68). On the mid-fifth-century sarcophagus at S. Apollinaris in Classe, Christ's disciples again wear hairstyles that approximate contemporary fashion (fig.94). The hair is still combed forward, but now individual locks are lost in a mass that looks more like a solid cap. This is the style popularized by the court of Theodosius and visible on the reliefs of Theodosius in the hippodrome of Constantinople.[19] Christ, on the other hand, has parted his hair in the middle in a most affected way, making it fall in undulating waves to his shoulders.

Elsewhere it takes a different shape. On the silver reliquary in Thessalonica Christ's mane falls back in a great luxuriant mass (fig.57). On a great columnar sarcophagus of the 380s he wears loose, shaggy locks (fig.68). On the famous Good Shepherd statue in the Vatican, one dainty tress reaches almost to the nipple on his naked chest—a style hardly suited to the rugged outdoor life of a shepherd (fig.95).

95. (*facing*) The Good Shepherd, c. 300, Musei Vaticani, Rome

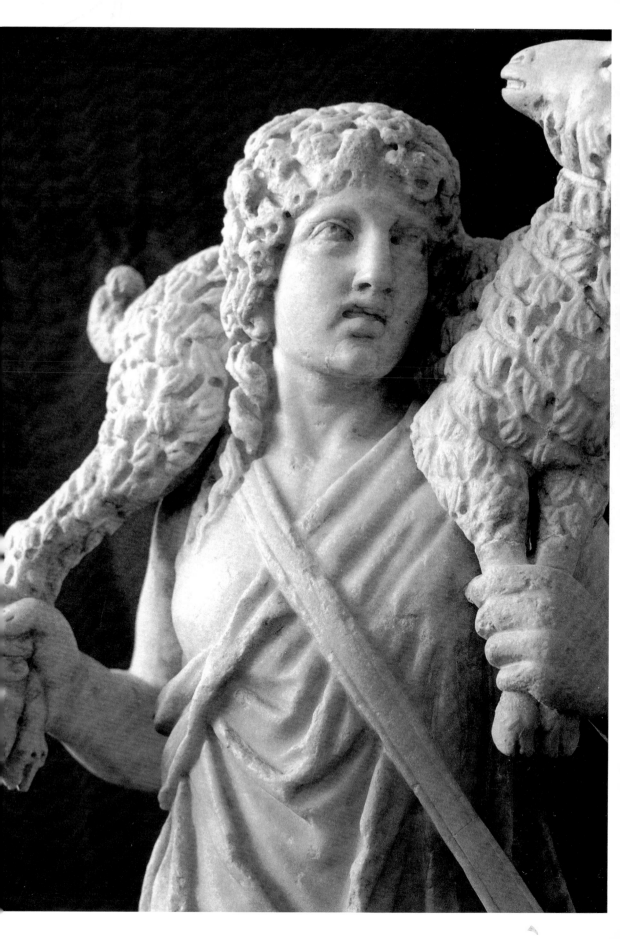

The extravagance, the sensuality, the voluptuousness of Christ's hair was clearly intentional and cannot have been missed by contemporary viewers. The question is what it all means. In the ancient world, as indeed in all periods of human history, there was a language of hairstyles. Hair is one of the ways we have of defining how we present ourselves to the world.

Clearly Christ's coiffure has nothing to do with imperial imagery.[20] No emperor, in fact, no Roman male would wear his hair like this. Paul reflected the prevailing norm in this regard when he wrote, "Does not nature itself teach you that for a man to wear long hair is degrading to him, but if a woman has long hair, it is her pride? For her hair is given to her for a covering. . . . We recognize no other practice, nor do the churches of God" (1 Cor 11:14–16). Similar moral judgments against wearing long hair can be found in Epictetus, Philo, Euphrates, and Plutarch. For the male it was not an acceptable mode of grooming.[21]

Philosophers violated the norm as a gesture of defiance of the standards of the world. Our picture of philosophers in Late Antiquity has been greatly enriched by the recent discovery at Aphrodisias of a peristyle courtyard that served as a philosophical school in the middle of the fifth century.[22] A series of clipeate images of famous ancient philosophers decorated the complex, including one unnamed, who seems to have been the contemporary master of the school (fig.96). There is nothing of the "hippie" about this gentleman, but neither is his hair the conventional style of the fifth century. While the hair on his forehead is carefully brushed forward and cut in an arc, on the sides it was allowed to grow long and thick and was carefully combed back to conceal most of his ears. In the back it covered the nape of his neck. But this is not the loose, curly look of Christ, and of course the "philosopher-look" had to include a beard. Though Christ dresses and poses as a philosopher, his face and hair say something more.

Monks, like philosophers, let their beards grow. Regarding their long hair Christian opinion was divided. Augustine found it effeminate and solemnly beseeched monks not to "veil" their heads with hair, which only women ought to do.[23] On the other hand, it must be noted that in the Roman world not even women were accustomed to wear their hair loose. In Late Antiquity women veiled their hair or put it up in a variety of braids and puffs and melon shapes (fig.17&18).

In Greek and Roman art loose, long hair was a mark of divinity. As the full, dark beard and long hair of Christ at Saint Pudenziana were a conscious usurpation of the imagery of Jupiter, or the hairstyle of the Terme polychrome slabs took up the imagery of the curing god Asclepius, so when Christ is given a youthful, beardless face and loose, long locks it assimilates him into the company of Apollo and Dionysus.

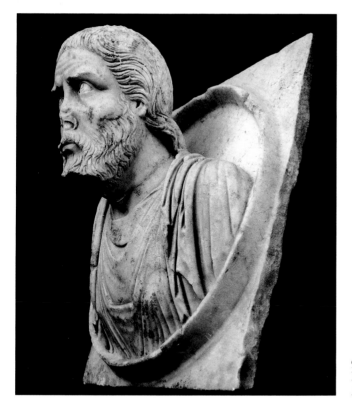

96. Anonymous
Philosopher, from
Aphrodisias, c. 400–450

Apollo, god of light and health, was also god of youth, to whom adolescents on reaching manhood dedicated their newly cut hair. For this reason
Apollo is perpetually adolescent, his nude body at the peak of pubescent youth.
His hair is abundant, often with the front locks tied up on top, ready to be shorn
in token sacrifice at coming of age. In this context abundance of hair is a sign of
"fresh and undiminished fertility."[24]

Dionysus, too, was distinguished by unshaven cheeks and loose, untied
hair (fig.106). Indeed, his hair was his most salient trait. In the *Bacchae* of
Euripides he was called a magician "with essenced hair in golden tresses
tossed," and it was this, plus his consorting with women, that most incensed the
skeptic Pentheus.[25] It is significant that both of these youthful, long-haired gods
had important androgyne aspects. As patron of the arts, Apollo led the Muses in
song and dance; he often appears with his lyre in the long chiton of a woman.[26]
Dionysus is called by Seneca a "pretended maiden with golden ringlets";[27] and
in Ovid he is "unshorn" and "girl-faced."[28] In other words, in letting his hair
down Christ took on an aura of divinity that set him apart from the disciples and
onlookers who are represented with him. At the same time, insofar as he copied

the look of Apollo or Dionysus, he assumed something of their feminine aspect as well.

If Paul and Augustine could have called Christ's long hair "degrading," what would they have said of his breasts? At Blessed David the broad hips of Christ look feminine in outline, but his heavy clothing reveals nothing of his breasts. But elsewhere, not content with hinting at a feminine side of Christ in his face and hair, Early Christian artists have expressly given him breasts.

A statuette in the Terme Museum caused a confusion very similar to that generated by the discovery of the Blessed David mosaic (fig.97). When it first entered the collection the statuette was catalogued as a "Seated Poetess." In 1914 R. Paribeni was the first to compare the image to sarcophagus versions of Christ, and he elected to so identify it in spite of the "prominent swelling of the breasts."[29] The identification as Christ was unanimous in subsequent literature, though the feminine characteristics of the figure continued to bother scholars.[30]

Swelling breasts are more noticeable in a series of sarcophagi of the fifth century in Ravenna. A large sarcophagus in the courtyard of Ravenna's Museo Archeologico is an important instance (fig.98). Made of streaked marble quarried on the Marmara Island near Constantinople, it shows Christ on a little mountain handing the scroll of his teaching to Peter. Paul assists on the other side, and, further removed and on slightly smaller scale, the couple who commissioned the sarcophagus are represented. Though the faces are badly worn, Christ is beardless with shoulder-length hair. His pallium sweeps dramatically from his upraised right arm and is pressed closely against his body, revealing both his genitals and pronounced breasts.[31] Of course all men have breasts which, depending on how much body-fat they carry, may be more or less pronounced. But in this relief one cannot avoid comparing Christ to the owners of the sarcophagus who, like him, are represented quite frontally. The bust of Christ more resembles that of the woman than that of her husband.

This sarcophagus belongs to the early fifth century. A few decades later a sarcophagus in San Francesco, Ravenna, shows a similarly ambiguous Christ (fig.100). An ungainly seated Christ seems to be assembled of unrelated parts. He perches insecurely, off balance on a low chair. His hands are over-large, his right extended to offer a scroll to Paul. Delicate curls fall down his neck, enframing a full face, and his short-sleeved tunic reveals a feminine torso with gently swelling breasts and wide hips.[32] Indeed, at times it seems that Christ is given breasts expressly to distinguish him from his apostle colleagues. On a battered fragment of a Roman sarcophagus in Cordova Christ has lost all other significant attributes, but he still stands out by reason of his feminine torso (fig.101).

Other Ravennate sarcophagi exhibit the same phenomenon: that of S.

97. Statuette of
Seated Christ,
c. 350, Rome,
Museo Nazionale
delle Terme

98. *Traditio Legis*, front of a sarcophagus in the Museo Archeologico, Ravenna, fifth century

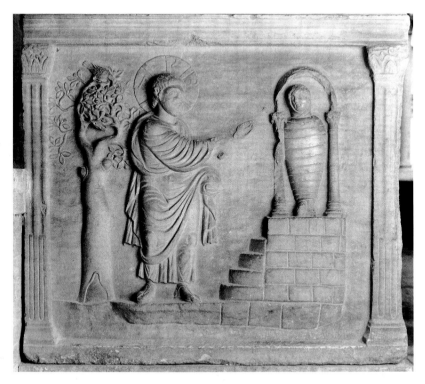

99. The Raising of Lazarus, side of *Traditio Legis* sarcophagus, Museo Archeologico, Ravenna, fifth century

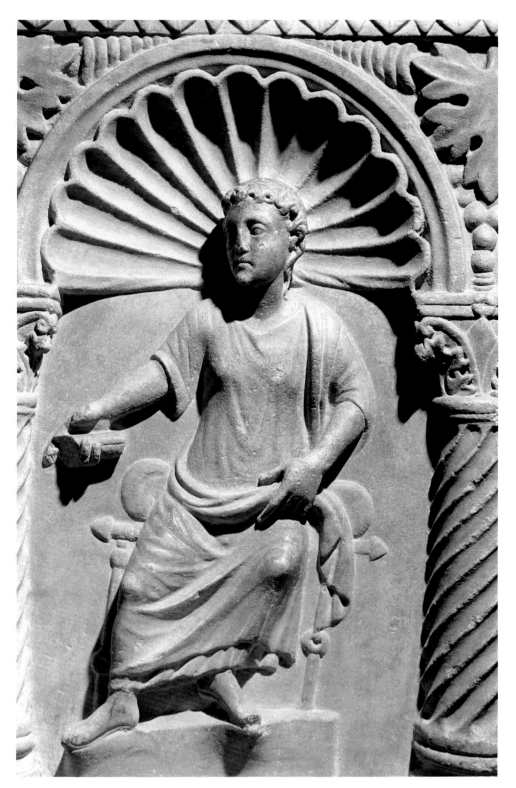

100. Seated Christ, detail of a sarcophagus in San Francesco, Ravenna, fifth century

101. Christ (second from right) with Apostles, on a sarcophagus fragment in the wall of the Great Mosque of Cordova, c. 360

102. The Baptism of Christ, mosaic in the Arian Baptistery, Ravenna, first half of the sixth century

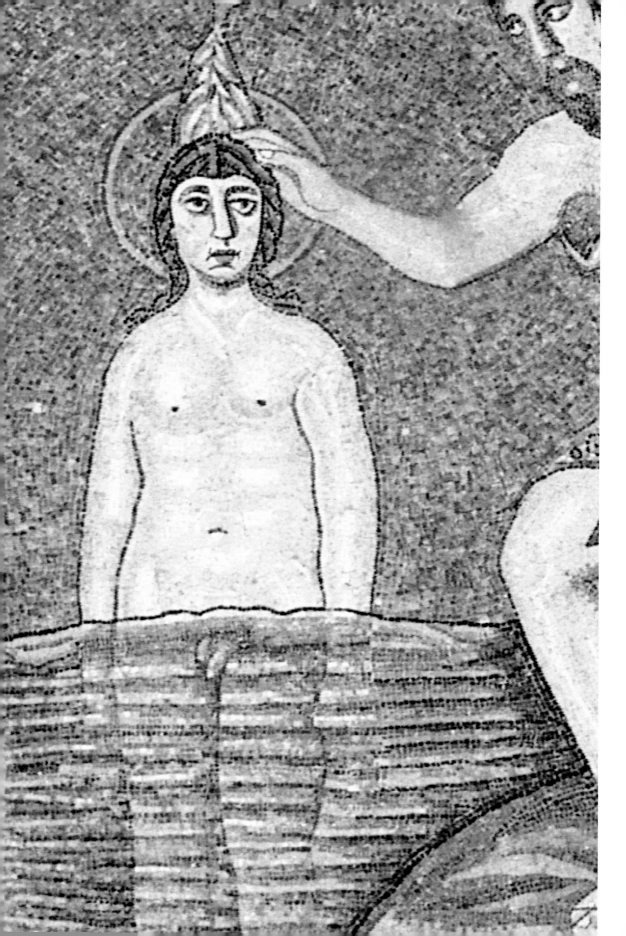

104. Procession of Apostles, detail from the mosaic in the Arian Baptistery, Ravenna, first half of the sixth century

Maria in Porto fuori and that of Bishop Exuperantius in the Cathedral,[33] and the Certosa sarcophagus in Ferrara Cathedral.[34] But the most strikingly ambiguous image in Ravenna is the mosaic of the Arian Baptistery (figs. 102&103). In 493 Theodoric the Ostrogoth, who had caused considerable embarrassment to the Byzantine government by plundering the Balkans, was persuaded to turn on his fellow Goth Odoacer in northern Italy. Here Theodoric founded his own kingdom and built churches dedicated to the Arian Christian faith of his nation. Doctrinally, however, there is nothing heretical about the mosaic in the dome of his baptistery, which copies the less well-preserved mosaic of the Catholic baptistery in Ravenna. A circular procession of Apostles surrounds a wreathed scene of the Baptism of Christ. Two hulking male figures flank the naked Christ. On the left, the god who personifies the Jordan leans on an amphora

103. (*overleaf*) The Body of Christ, detail from the mosaic in the Arian Baptistery, Ravenna, first half of the sixth century

134

from which water flows, the standard Roman convention for a river. On the right John the Baptist has climbed on a craggy rock from which he bends down to touch the head of Christ, while the dove of the Holy Spirit descends from above. Both of these men are heavily bearded and broad-chested, robust males. The muscles of Jordan's torso are boldly outlined. By contrast, Christ is beardless with slender shoulders, girlish breasts, and smoothly modelled body. His sex is visible beneath the water, but his hips are wide and his body is hairless.

THE PROBLEM of the feminine Christ cannot be easily dismissed. Appearing in Gaul, Rome, Ravenna, and Thessalonica over a stretch of time from the mid-fourth century to the beginning of the sixth, it cannot be written off as a regional or transitory development. At the same time, the variety of contexts in which the feminine Christ appears suggests that there may not be any single explanation. A number of connections present themselves that may take us part of the distance toward understanding this phenomenon.

In the first place, there are the connections to the divinities of the Greco-Roman world. Like his long hair, Christ's feminine bodily traits can be paralleled in the imagery of the pagan gods. Odd as it may seem to us, many of the most masculine gods of the pantheon also had feminine aspects. Jupiter himself, the father of the gods, had twice given birth, once to Athena from his forehead and again to Dionysus from his thigh. Consequently he was made a patron of childbirth and was venerated in images with multiple female breasts; one such image was worshipped in Rome under the title Jupiter Terminalis.[35] Serapis too, a kind of Egyptian version of Jupiter, is sometimes shown with breasts, which were meant to associate him with the fertility of the Nile (fig. 105). Similarly, the mighty Hercules, famous for his heroic feats, dressed in the garb of the Thracian woman Omphale in his role as health-giver. In Rome men celebrated the feast of *Hercules Victor* by putting on women's clothes.[36]

The feminine aspects of Dionysus and Apollo are more familiar, and an Apollo with breasts is a fairly common image type (figs. 106 & 107).[37] The parallel with Apollo is especially striking. Both Christ and Apollo represent a type of adolescent youth with just-incipient breasts.

If the feminine aspects of ancient male divinities were intended to allude to their life-giving fecundity, is there any reason why feminine aspects of Christ should not imply the same? It is certainly significant that these images often involve other kinds of fertility symbolism. This is manifest in the Baptism mosaic. The water sacrament is the principal Christian symbol of rebirth. Christ is both the prototype of reborn Christians and the fertile source of their new life. His descent into the Jordan sanctified the water so that it might renew the life of all future Christians.

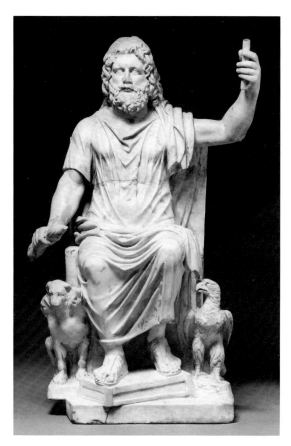

105. Serapis Seated between Eagle and
Cerberus, second century A.D., London

106. Dionysiac Sarcophagus, third century,
Museo Nazionale delle Terme, Rome

The sarcophagus in Ravenna's Museo Archeologico is also rich in fertility imagery. On either side of the threesome of Christ and his apostles stand two palm trees laden with bunches of dates, alluding to the land of plenty of the new doctrine. The uncut rock of Christ's mountain was meant to show the four springs of the Rivers of Paradise, but this was left unfinished. On either end of the sarcophagus are images of Daniel and the Raising of Lazarus, the latter another image of rebirth. Here nature is made to echo Lazarus' new lease on life: a luxuriant olive tree stands behind Christ with a womb-like opening below and breast-like protrusions above. A bird has come to feed on its fruit (fig. 99).

Streams and rivers abound in Early Christian art, but the mosaic of Blessed David outdoes them all. Christ floats in the heaven above the fish-teeming Chabar River, where the prophet had his vision, but directly underneath Christ is a hillock from which the Four Rivers of Paradise flow. Here was a Christ to

whom one came for drink and refreshment, and the inscriptions in the image reinforce this message. From his hand Christ unfurls a long scroll. A scroll was part of Ezekiel's vision. However, unlike the scroll that Ezekiel saw, which was full of "words of lamentation and mourning and woe" (Ez 2:10), and which he was forced to eat, the scroll in Christ's hand contains a message of consolation and salvation. "Behold our God in whom we hope, and let us approach our salvation that he may give refreshment to this house [i.e., to this chapel]."

In case the visitor should miss this inscription, the restorative message of the mosaic is spelled out again in an inscription on the lower border: "This venerable house is a living fountain, welcoming and nourishing souls." The feminine look of Christ reflects his role as nurturer of souls. In the Gospel he

107. Apollo in Women's Dress, first century B.C., Akademisches Kunst-museum der Universität Bonn

137

explained to the Samaritan woman who came to draw water at the well, "Who-ever drinks of the water that I shall give him will never thirst; the water that I shall give him will become in him a spring of water welling up to eternal life" (Jn 4:14). A gentle Christ who supplies succor and sustenance has been given a feminine appearance. Is this perhaps why the aged monk Senouphios swooned to death at the sight of the mosaic? He had come expecting to see the Man of Bronze of Ezekiel's vision, and instead found a Lord of womanlike compassion.

Gnostic sources might also be invoked in this connection. Claiming a secret divine wisdom specially revealed to initiates, Gnostic writers sometimes talked of God in imagery that was both male and female. "I am the Father; I am the Mother; I am the Son," God says in the Apocryphon of John.[38] Elsewhere a spirit of wisdom announces, "I am the Voice . . . in the likeness of a female . . . in the thought of the likeness of my masculinity . . . I am androgynous . . . I copulate with myself."[39] The reconciliation or unification of the opposite sexes served in early Christianity as a symbol of salvation. Wayne A. Meeks of Yale University has explored this symbolism, starting with the provocative assertion in Paul's letter to the Galatians, that in Christ "there is neither male nor female; for you are all one in Christ Jesus" (Gal 3:28).[40] Paul borrows this text, Meeks maintains, from a primitive Christian baptismal formula; the notion that there was a union of the sexes in Christ echoes an ancient belief that the original Adam, from whom the race sprang and into whose likeness the Christian was re-made, was masculofeminine. The theme of "making the male and the female into a single one" is especially prominent in the apocryphal Gospel of Thomas.[41] The new cosmos and the new kingdom to which the initiates are called, however, is not a realm of heightened libido, but one of neutralization of sexuality.[42] The metaphor of a unification of male and female was intended to work on a philosophical level to express unification of the two sides of the human personality, somewhat like Jung's *animus* and *anima*.

It is indeed tempting to view the hermaphroditic Christ of the Arian Baptistery as an attempt to express such a belief. That it occurs in a baptismal context makes the association with Paul's baptismal text very compelling. "For as many of you as were baptized into Christ have put on Christ. There is neither Jew nor Greek, there is neither slave nor free, there is neither male nor female" (Gal 3:27–28). Men and women were submerged one by one in the font directly beneath the image. The Christ into whom they were equally transformed was represented as equally male and female. While Gnosticism made conspicuous use of this symbolism, in its Pauline enunciation it was authentically orthodox and part of the mainstream Christian tradition.

Also shared by Gnostic and orthodox writers was a sense that Christ was really polymorphous, that he had many different appearances depending on

who was perceiving him. The chameleon changeability of Christ in Early Christian art may be linked to this belief. Origen returns to this theme often. He observes the "changing relation of [Christ's] body to the capacity of the spectators, inasmuch as it appeared to each one of such a nature as it was requisite for him to behold it."[43] Hence at one time the prophecy might be applied to him, "He had no form or comeliness" (Is 53:2), while at another time he might appear to be of surpassing beauty.

This changeability applies especially to Christ's apparent age. The apocryphal Acts of John relate how the apostle James in his boat saw Jesus on shore in the form of a child and pointed him out to John. "I [John] said, 'Which child?' And he answered me, 'The one who is beckoning to us.' And I said 'This is because of the long watch we have kept at sea. You are not seeing straight, brother James. Do you not see the man standing there who is handsome, fair and cheerful looking?'" When they encountered him ashore, moreover, Jesus had still two different appearances. John saw him as "rather bald but with a thick flowing beard" while James beheld "a young man whose beard was just beginning."[44]

The Magi had a similar experience, according to the Armenian Infancy Gospel. Going in to worship the Child, they each had a different vision of him which they realized only later when they compared notes. Gaspar reported seeing a child, "Son of God incarnate, seated on a throne of glory." Balthasar saw him as commander of the heavenly forces "seated on an exalted throne before whom a countless army fell down and adored." Finally, Melkon saw him dying in torment, rising and returning to life. Returning twice to resolve their problem, they each had the visions of the other two.[45] This is the source of the iconographic tradition that represents the three Magi as men of three different ages, young, middle-aged, and old.[46] However, this diversity in the viewer's experience is mirrored in the face of Christ. He may appear as a child in the Catacomb of Domitilla, even though the context calls for an adult Christ teaching his apostles (fig. 2). Or he may appear as a wrinkled old man, hunched over, with long, pointed beard, as he does in an ivory relief in Paris (fig. 108), even though this is equally unwarranted in the Gospels. According to the scriptural account, Christ never lived to old age. The meaning of these transformations is that Christ has the magical key of timelessness, the power of eternity.

If a youth might see Christ as young and an old man as aged, why should not a woman see Christ as feminine? The legend of the Blessed David mosaic attributes its commission to a woman, the princess Theodora, and (what is better evidence) the inscription below the mosaic refers to the unnamed patron with a feminine pronoun. The female patronage should have some bearing on the interpretation. Is this a woman's vision of Christ? Epiphanius, a fourth-

108. Christ between Peter and Paul, detail from an ivory book cover (the Saint-Lupicin diptych), sixth century, Cabinet des Médailles, Paris

century bishop in Cyprus, preserves the account of a Christian sect in Asia Minor that had women as well as men for bishops, priests, and deacons. A leader of the sect, one Priscilla, claimed, "In a vision Christ came to me in the form of a woman in a bright garment, endowed me with wisdom, and revealed to me that this place is holy, and it is here that Jerusalem is to descend from heaven."[47]

Whether women commonly experienced Christ as a woman is difficult to ascertain, since written sources so seldom preserve the reflections of women in the Early Christian period. But perhaps what is lacking in literary sources has been made up in the visual sources. It is not unlikely that many of the sarcophagi were commissioned by women—wives or widows—and that the imagery reflects their vision. Perhaps this is why the feminine Christ is so frequent in that medium. In the Traditio Legis sarcophagus in Arles the union of male and female has been expressed in a figure who is both an old man and a woman (fig. 109).

109. *Traditio Legis* sarcophagus, detail, c. 380, Musée Réattu, Arles

We who live in a post-Christian world think we have arrived at a certain objectivity about Christ. We have assigned him his place in history books and assessed his impact on the course of human development. The new converts of the fourth and fifth century did not find it so easy. To them he was still utterly mysterious, undefinable, changeable, polymorphous. In the disparate images they have left behind they record their struggle to get a grasp on him; the images were their way of thinking out loud on the problem of Christ. Indeed, the images are the thinking process itself.

Convergence

THE VARIABILITY of images of Christ in the early centuries stems not from an uncertainty about his identity so much as from curiosity about exploring *all* of his identity. In successive flashes the same Lord appeared now as abstract sign, now as human figure, now as Child, now as Man, now as Woman (figs. 1, 71, 88, 119). It was important to "image" as many facets of his person as possible. At the same time, this multiplicity created a certain visual confusion, and one cannot help wondering about its effects on the overall message of Early Christian art. The question is whether there was in fact an overall message, or was it just a multiplicity of partial views of a truth that was too grand to express, given the limitations of the newly developing visual language.

The greatest accomplishment of medieval art is the comprehensiveness of its image systems. The Gothic cathedral, covered inside and out with a myriad of sculpted, painted, and translucent images, conveyed a sense that there was a place for everything, that there was a complete world order.[1] Starting with the innermost image, the cross within the cross—that is the cross on the rood screen at the crossing of transept and nave—the imagery unfolded outward in four directions in encyclopedic fashion, giving the impression that nothing was left out. Human history from Creation to the Last Day, human labor from January to December, and cycles of nature from leaf to fruit and from mouse to monster, were all included.

In Byzantium the order was enunciated differently, but its claim to universal system was every bit as bold.[2] The Byzantine world view was organized hierarchically from the top down, and it was spelled out in mosaic and painting rather than sculpture and stained glass. The controlling image was Christ Pantokrator, the "All Ruler," who leaned out of his circle in the summit of the dome

to oversee all beneath him (fig. 114). Below, in the highest vaults of the church, were his angelic messengers and the Mother of God from whom his earthly career had its origin. His heroic labors on earth occupied a lower zone, and the saints of his Church a zone still lower. The commonality of humankind found their place in this system through membership in the community of saints expressed in ritual. The Byzantine system sought a comprehensiveness that was mystical rather than literal.

To what extent was Early Christian art capable of enunciating a comparable unified world view? Should we look for the germs of these two great medieval systems in the art of the fifth and sixth centuries, viewing history backwards, so to speak? Or can we find a third system in the complexity and multiplicity of Early Christian images, a system distinct from those of later centuries and rooted more appropriately in the experience of the period? Or, more realistically, should we simply accept Early Christian art as a beginning, a series of tentative steps by a culture that had yet to decide where exactly it was going?

The most ambitious claim for the development of a manifold, comprehensive system of imagery in Early Christian times is a study of dome imagery by the great classical archaeologist, Karl Lehmann. In a landmark article, made popular in reprint and cited with enthusiasm countless times, Lehmann tried to trace the assimilation into Christian art of a pagan scheme of dome decoration that contained a systematic cosmological imagery.[3] Sweeping the reader through the centuries, Lehmann attempted to demonstrate that the scheme of the Christian dome was "an offshoot and descendant of pre-Christian pagan types."[4] By a subtle process of insinuating Christian content into pagan forms, Christians gradually transformed a pagan formula of astronomical divinities into their own vision of heaven. The cosmological character of this vision, we are led to believe, remained basically intact; simply the names of the divinities changed. The Early Christian period was the critical bridge for the transmission of this grand "Dome of Heaven," as Lehmann called it, from antiquity to the Middle Ages.

Like many of his contemporaries, Lehmann loaded his theory with an imperial burden. The "Dome of Heaven" was found to be especially suited to the throne room of the Roman emperor. Alleging examples from Nero's Golden House, Hadrian's Villa, the palace of Septimius Severus on the Palatine, the hall of the Parthian emperor, and the throne room of the Byzantine emperor, Lehmann thought he had pinpointed the origin of Christian dome decoration in the imperial cult.[5]

Insofar as the "Dome of Heaven" involves the creation of an ambient imagery, a kind of wrap-around art that physically envelopes the viewer, this

particular employment of the Emperor Mystique has a special importance. Displayed on walls and vaults, it defined one's relationship to the world by creating an environment of images. Indeed if this was where medieval art learned such a lesson, it is an imperial debt of no small moment. The Lehmann thesis cannot be dismissed lightly.

Yet a number of serious methodological problems haunt his argument. Like Grabar's thesis about enthroned emperors, Lehmann's argument runs into a conspicuous gap in the surviving evidence, and like Grabar, Lehmann appeals to his hypothesis as if it in fact supplied the missing evidence. The circular nature of the logic seems not to have bothered him or his readers. Decorated Roman domes or ceilings are extremely scarce, and to fill this void Lehmann invokes a wide variety of material from other media, from floor mosaics to jewelry. But this requires prior acceptance of the unproven hypothesis that such objects reflect real dome decoration. The critical evidence is the archaeological data on Roman vaults and domes. But in his archaeological evidence it now appears Lehmann was badly mistaken.

It must be pointed out at the start that Lehmann was not concerned with simple metaphorical associations of domes with the sky, but with "symbolism of heaven on the ceiling which is expanded to an actual cosmological image," that "selects figures of divinities and demons which rule the world, or symbols of heavenly bodies, or a mixture of both."[6] Lehmann defines three elements as essential to the system, even if every example may not have all three: an allusion to a "carpet" or "canopy" of the skies, the appearance of heavenly divinities, and astrological elements.[7]

An eighteenth-century engraving from Nicolas Ponce's *Arabesques Antiques*, purportedly of a ceiling in Hadrian's Villa, presents Lehmann's most compelling example (fig. 110).[8] The support of the central circle by four herms Lehmann imagined to represent a kind of canopy. On this canopy is represented "Jupiter or Sol as the Pantokrator (sic) on a quadriga."[9] In the next surrounding zone appear four winged females who blow pairs of trumpets; the fact that they stand on globes of slightly varying sizes indicated to Lehmann that the changing strengths of the sun were intended, and these figures are therefore the four seasons. Between them are grouped the twelve signs of the zodiac, three in each corner. Elsewhere a scattering of animals, birds, and figures are taken to make reference, somewhat unsystematically, to the twelve Hours and unspecified astral divinities. In this way the ceiling is thought to present a comprehensive cosmic program. This is how Romans imagined their relationship to the powers that govern the universe. By taking his position beneath such imagery, we are to believe, the emperor defined his place in the order of the cosmos.

110. Engraving of a Ceiling, allegedly at Hadrian's Villa, by Nicholas Ponce, eighteenth century

The remains of Roman ceiling decoration, and the problem of their representations by Ponce and others, have recently come under the scrutiny of another Roman archaeologist, Hetty Joyce. None of the engravings on which Lehmann builds his argument for the ceilings of Hadrian's Villa, the Domus Aurea, and the Palatine is a reliable record of a Roman ceiling, according to Joyce's careful study.[10] Ponce was a successful Parisian engraver who popularized the most famous artists of his day and published various sets of pictures of historical and geographical interest. For his album of fourteen engravings of antique

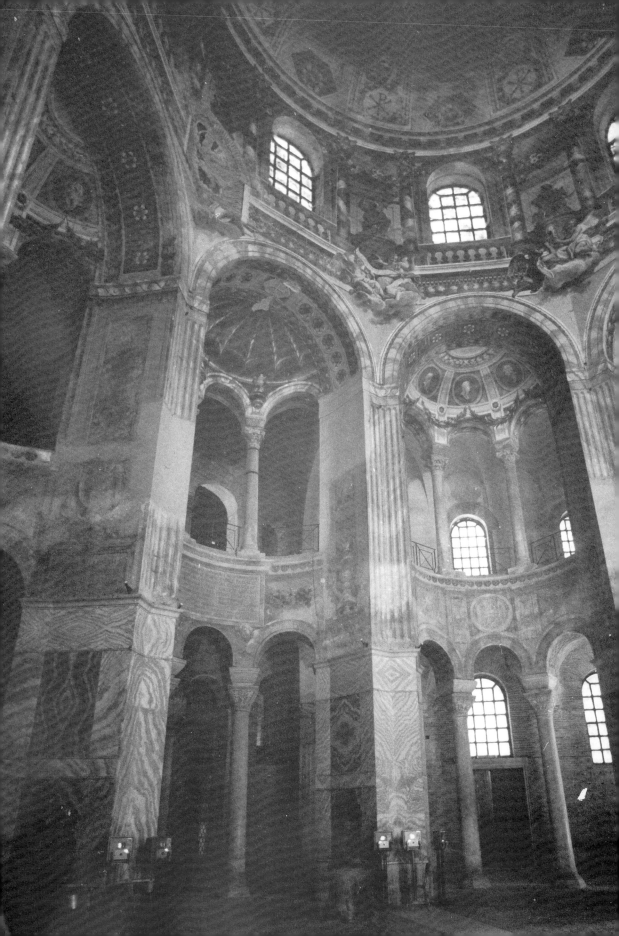

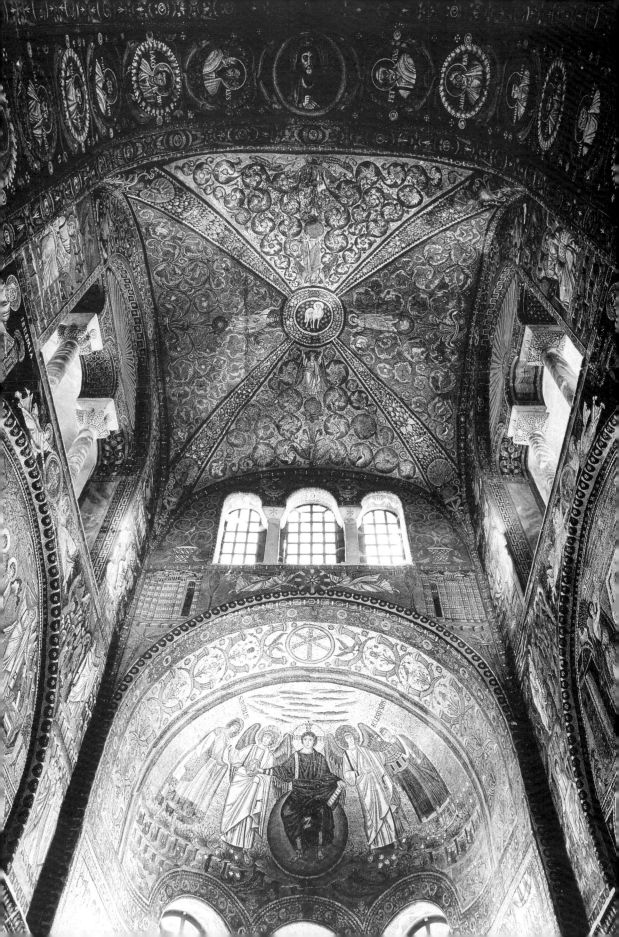

ceilings he never visited Italy but relied on others' drawings (some of which Joyce has discovered at the Cooper-Hewitt Museum in New York), which themselves had tenuous connections to the monuments. Some of the engravings reproduce authentic Roman ways of framing ceilings, dividing the field into rectilinear grids or centralized patterns. The figures that occupy these frames, however, are often free inventions; or if they are authentic they turn out to be borrowed from a wide variety of monuments, Renaissance as well as ancient.

Regarding the engraving just described, virtually all its imagery is a post-Renaissance confection. The charioteer in the center is borrowed from Raphael's vaults in the Villa Madama. The zodiac in the engraving is unparalleled in any Roman vault and is probably also a post-Renaissance invention.[11] Moreover, the women who balance on globes bear no relationship to classical personifications of the seasons; as Joyce explains, they are a creation of the Renaissance: "the two trumpets, properly one long and one short, represent good and evil fame. Finally, the insects, worms, weasels, and other odd fauna which enliven the center of the design are far more characteristic of the whimsicality of Renaissance grotesques than of ancient examples."[12]

If the Roman evidence fails to support Lehmann's thesis, the Early Christian positively contradicts it. The sanctuary vault of S. Vitalis in Ravenna is the closest Early Christian parallel to Lehmann's dome scheme (figs. 111, 112).[13] At the center, in place of the sun god we find the Lamb, not on a canopy but within a wreath against a starred background. The wreath is supported by four winged angels who might be imagined to combine the functions of the herms and the seasons in the Ponce engraving: they lift their arms to support the central medallion, and they stand on globes. Lehmann thought he saw a seasonal significance in slight variations in the coloring of the globes; but if so, it is again a perfectly anomalous way of representing the seasons, without classical precedent. Far from celestial, all the other elements of the ceiling point to terrestrial themes, as analyzed in a recent study by Henry Maguire (fig. 113). "The vault is divided into four segments by diagonal bands decorated with various fruits, flowers, and birds. In each segment the designer portrayed a considerable variety of creatures of land and air, framed by scrolls of luxuriant rinceaux that bear a profusion of fruits and flowers."[14] Two segments of the ceiling are devoted to land animals and two to birds.

Entirely missing from the program are the sun and the planets, the Hours, the astral divinities and the signs of the zodiac. The omissions turn out to be

111. (*overleaf left*) Saint Vitalis, Ravenna, interior, general view, 547

112. (*overleaf right*) Saint Vitalis, Ravenna, mosaics in the vault of the presbytery and the apse, 547

more important than the four supporting figures, which are an element of minor consequence in later medieval dome decoration. When the classic system of Middle Byzantine decoration was formulated in the ninth century, it positioned a bust image of Christ the Pantokrator in a unsupported medallion in the center of the dome; around him in the intervals between the windows of the drum, prophets give witness (fig. 114).

The Christian world-view involved not just a re-definition of God, but a re-definition of man's relationship to the physical universe. The fact that the planets and the signs of the zodiac have no role in Early Christian imagery is not accidental. They are deliberately excluded. The celestial divinities of Roman art (and they are fairly common in many contexts outside of ceilings) were not innocent decoration. They were astrological, and the refutation of astrology was a theme of universal concern among the Fathers of the Church, whether one looks at authors from Syria, Alexandria, Cappadocia, or the Latin West.[1]

Christian ethics were based on the premise of free will and individual responsibility. Astrology, on the contrary, placed the cause of human actions in extra-terrestrial necessity. According to Basil of Caesarea (c. 330–79), "If the origin of our vices and virtues is not within us, but is the unavoidable consequence of our birth, the lawgivers, who define what we must do and what we must avoid, are useless, and the judges, too, who honor virtue and punish crime, are useless. In fact, the wrong done is not attributable to the thief, nor the murderer, for whom it was an impossibility to restrain his hand, even if he wished to, because of the unavoidable compulsion which urged him to the acts. . . . Where necessity and destiny prevail, merit, which is the special condition for just judgement, has no place."[2]

Gazing at night at the heavens, the Christian beheld a different universe from his pagan neighbor. To Tatian (c. 160) the planets and the signs of the zodiac were demons introduced to men by the fallen angels. "But we are superior to Fate," he wrote, "and instead of wandering demons we have learned to know one Lord who wanders not" (in Greek the word for planet means "wanderer").[3] Hence when the Lamb is set in the heavens in S. Vitalis, it is against a background of the "fixed" stars (fig. 113). So, too, the splendid crosses that appear in the starry sky at the Mausoleum of Galla Placidia and in the apse of Saint Apollinaris in Classe (figs. 115 & 119). The old divinities have fallen out of the skies; the heaven to which Christ has ascended is above and beyond the erratic movements of planets.

In his extremely influential *Hexaemeron*, Basil set out the main lines of the new Christian cosmology based on the account of creation in the first chapter of Genesis.[4] In this view the sun and the moon have lost their claim to divinity, for they were not created until the fourth day; God himself had made light on the

first day quite independently of the sun or moon. The stars and planets God made only "for signs," says Basil, to aid man in timing the four seasons and in predicting changes in the weather. The heavens are a big clock, but they are not a giant, divine horoscope regulating the world below.[19]

"COSMIC ICONOGRAPHY," therefore, has little to do with the way Christians organized their world view. But this does not mean they lacked a grand view or were incapable of representing it effectively. The world view that governs the imagery of Early Christian churches is, I believe, much more straightforward than Lehmann's cosmic configurations. Converging processions—that is, a concourse of figures from either side, worshipfully approaching the axis at which is Christ—provide the principal organizing device.

A confluence of figures toward Christ is prominent in the art of the catacombs and sarcophagi, and this composition governs a surprising number of church programs of the widest diversity in size, shape, and function. Over sixty percent of the apse compositions catalogued by Ihm include centripetal processions. All of the mosaicked churches of Ravenna fall in this class, including basilicas, baptisteries, and the octagon of Saint Vitalis (figs. 102–104, 116 & 117, 119 & 120). In addition, converging processions constitute the organizing principle for countless works of later periods from Irish high crosses (fig. 118) to Romanesque apses, from Gothic portals to "sacra conversazione" paintings of the Renaissance. Curiously, this basic compositional mode is never discussed as such.

The processional composition makes no claims to encyclopedic comprehensiveness. It supplies a framework neither for historical narrative nor for speculation about the structure of the universe. When narrative panels are added, there is no effort to integrate them into the directional movement of the procession.

But the processional scheme has a comprehensiveness of a different nature. The target of convergence, the omega point that is Christ, can be expressed in a wide variety of ways. Christ can appear in any number of his chameleon guises. He can assume the moments of glory of his historical life—his Baptism, Transfiguration, or Ascension (figs. 102, 119, 133)—or he can fast-forward history to its end and appear as the future judge of all (fig. 116). He can appear enthroned on the globe of the cosmos, or he can vanish into the symbol of his cross (fig. 119). Moreover, the processions themselves potentially include the whole world of the saved, the hierarchically ordered communion of saints. Male and female saints are represented, the Apostles and martyrs, the clergy and members of the imperial court, and, under the symbol of a file of sheep, the common herd of the faithful.

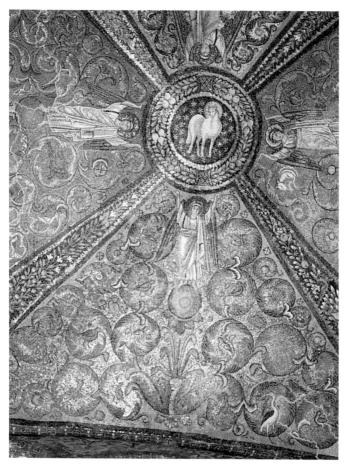

113. Lamb of God in the
Earthly Paradise, Saint
Vitalis, Ravenna, vault
mosaic in the sanctuary, 547

The centrality of the procession in Early Christian worship, a newly ex-
plored area of study, requires that we take their representations in art more
seriously. The growing proliferation of processions in the art of the late fifth and
sixth centuries, in fact, coincides with the rise of public participatory proces-
sions. The solemn concourse of figures streaming together toward a single goal
is a visual device that had deep resonances for the Christian worshipper. It was
not by accident that Early Christian art seized upon the processional mode as the
largest organizing scheme for the decoration of the church interior.

The procession has a venerable past. In the Greco-Roman world, figures in
peaceful procession were generally understood to be engaged in a religious
ritual. It is one of the oldest and commonest forms of worship, and in represen-
tations from the Parthenon to the Ara Pacis, the most august expressions of
worship assumed a processional mode. Processions abound in all quarters of the

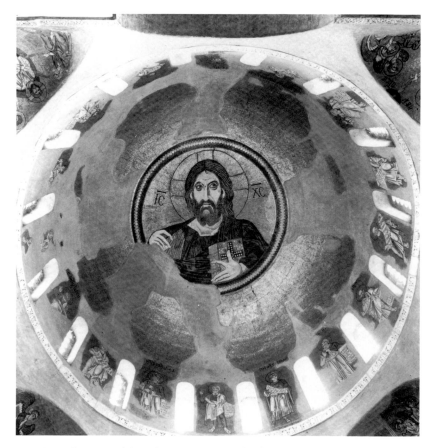

114. Pantokrator and Prophets, mosaic in the dome, Church at Daphni, Greece, eleventh century

Late Antique world. In the Aventine Mithraeum in Rome, around 220, the initiates were painted in reverent procession in hierarchic order, bearing offerings to Mithras (fig. 121).[20] Hymns sung by the members during their processions were inscribed along with the images. In Khéreddine in Carthage, in a villa of around the year 400, six hunters converge on the temple of Apollo and Diana (fig. 122).[21] The worshippers have sacrificed a crane on an altar before the temple. At about the same time, in the entry way to a Bacchic cult hall in Spain, cup-bearing servants were represented in well-paced procession, bringing in wine and napkins (fig. 123).[22] Figures in procession were instantly identified by the spectator as making a religious statement.

In Christian art, moreover, they stood as paradigmatic for the faithful in the endless processions of their cult. This connection was made long before the conversion of Constantine. At Dura-Europos on the Euphrates River, around the year 245, an ambitious program of frescoes enclosed a modest baptismal

115. Cross in Starry Sky, Mausoleum of Galla Placidia, Ravenna, mosaic in the vault, c. 425

room. Various subjects connected with baptism were distributed in staccato fashion around the room, but the largest subject and the one that gave visual unity to the room was a procession of the Wise and Foolish Virgins, three-quarter life size, that wrapped around two walls. The remains are fragmentary, and of the Foolish Virgins only the feet survived, but two and a half of the Wise Virgins were preserved (fig. 124). Clad in white, they carry lighted tapers as they walk in procession toward the tomb of the risen Christ. When the newly baptized made their way from the font to the Eucharistic hall, similarly clad in white and with lighted candles in hand, they hardly could have failed to see the parallel between their behavior and that of the Wise Virgins of the parable.[23] They were sallying forth to meet the heavenly bridegroom (Mt 25: 1–13).

Catacomb spaces were rarely large enough to call for this kind of treatment along their walls, but in the chapel of "Six Saints" in the Domitilla Catacomb

116. Christ on Globe amid Angels and Saints, Saint Vitalis, Ravenna, mosaic in the apse, 547

117. A. and B. (*facing*) Emperor and Empress taking part in the procession of the First Entrance, Saint Vitalis, Ravenna, mosaics in the presbytery, 547

the interior was unified by a procession of saints along three walls (fig. 125) Women on the left and men on the right converge with outstretched, praying hands toward the youthful, enthroned Christ in the center. The continuity of this painting tradition with that of the Aventine Mithraeum is striking (fig. 121). The processional mode also governs numerous sarcophagi of the mid- and late fourth century. On one type of fairly wide diffusion, scroll-bearing apostles follow Peter and Paul to the cross of Christ's passion, over which the apostles of Rome place a great wreath (fig. 126). On another, double processions converge on a haloed Christ-Good Shepherd (fig. 127). Both the apostles and the lambs that stand for the faithful file their way toward their Savior.

But it is in the decoration of great churches of the fifth and sixth centuries that the processional mode had its most conspicuous success. Its flexibility made it equally suitable to domes as well as walls and apses.

The two baptisteries of Ravenna, the Orthodox and the Arian, contain the best preserved Early Christian dome decorations. Lacking any allusion to the forces of the astrological world, Lehmann was compelled to omit them from his study of the dome.[24] With wall decoration of painted stucco, mosaic, and inlaid marble in *opus sectile* technique, the surface brilliance of the mosaic dome is continued onto the surrounding walls at the Orthodox baptistery. Such a complete wrap-around environment, experienced by candle-light during the night vigil of Easter when catechumens were initiated, must have been quite overwhelming.

Both baptisteries present at their apex a circular image of the Baptism of

118. Procession of Bishops, the Ahenny North Cross, Ireland, eighth or ninth century

119. Bishop Apollinaris beneath the Transfiguration of Christ, St. Apollinaris in Classe, Ravenna, mosaic in the apse, 533–49

120. St. Apollinaris in Classe, Ravenna, view of the nave, 533–49

Christ (figs. 102 & 128). Visually and conceptually this is the goal of all that happens in the building and in its mosaics. In the Orthodox baptistery the Baptism has suffered much in restoration, but in the Arian, the Christ, into whom the faithful were incorporated in the ritual bath, is the hermaphroditic Christ with whom both men and women might identify. In both baptisteries the Baptism is encircled by a double procession of apostles carrying crowns to offer to Christ. In the Orthodox baptistery they converge at a point directly below the image of the Baptism of Christ; in the Arian, the image of the Baptism is inverted and the apostles parade instead toward an enthroned cross, emblematic of Christ.[25]

Figures carry or receive crowns in four of the five Ravenna churches, and to art historians, conditioned to look for such associations, crowns suggest connections to imperial ceremonial.[26] However, the crowns under discussion are

121. Procession of Initiates, Aventine Mithraeum, Rome, c. 220

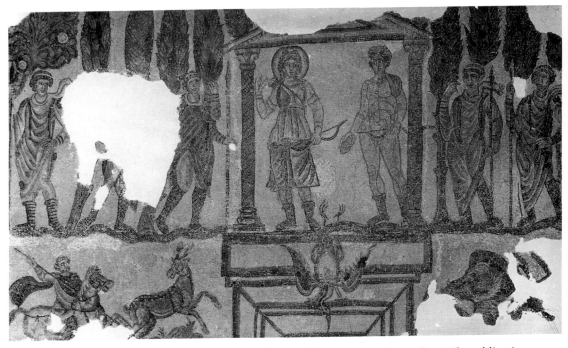

122. Procession of Hunters to the Temple of Apollo and Diana, mosaic in a villa at Khereddine in Carthage, c. 400

158

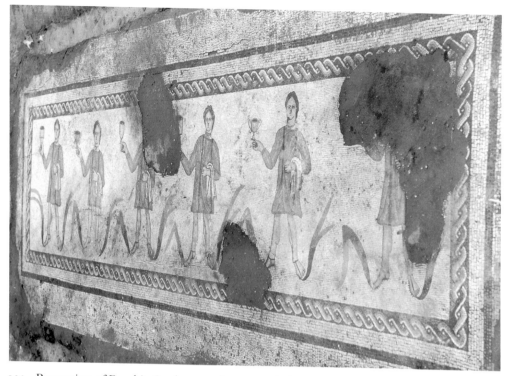

123. Procession of Bacchic Cupbearers, floor mosaic from Alcada de Henares, c. 400, Madrid

124. Procession of Virgins with Candles, Frescoes from the Baptistery at Dura Europos, c. 245, reconstruction, Yale University Art Gallery

125. Procession of Saints, in the Chapel of the Six Saints, Catacomb of Domitilla, Rome, c. 360

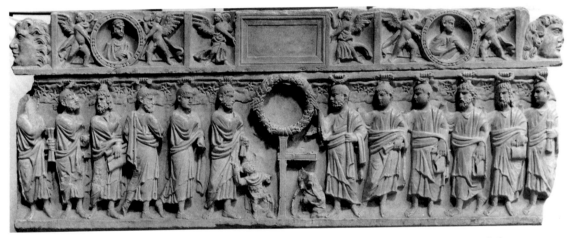

126. Procession of Apostles, on a sarcophagus from Saint-Honorat, c. 380. Musée Réattu, Arles

127. Procession of Apostles and Sheep, on a sarcophagus from Saint Lawrence outside the Walls, Rome, now in the Lateran (#177). c. 380

not the diadem that emperors, starting with Constantine, wore as part of their official regalia, but wreaths of golden leaves. These were offered routinely to the emperor on a variety of occasions other than his coronation.[27] On Roman coins and reliefs female Victories offer crowns to emperors in many settings, and on triumphal monuments barbarians carry wreaths and precious vessels as a sign of submission.

But crowns and wreaths were by no means an exclusive prerogative of the emperor. In the ancient world chaplets of woven branches—as well as golden replicas of the same—were bestowed in a wide variety of circumstances, in religious ceremonies, in athletic and poetic competitions, for marriages and deaths. We neglect this broader context of crown uses at our own peril. The question is whether the Christian observer would have attached imperial import to the crown-bearing figures he saw circling his head, for example, in the Orthodox or Arian Baptistery, or would have made associations with other crown uses.

Historically, the most fundamental implications of crowns are religious, and in antiquity it is difficult to find uses that entirely escape the realm of religion.[28] One had to be crowned to offer sacrifice; the victims and the implements were also crowned; and the cult statue of the god, before whom the sacrifice was performed, was crowned as well. Further, ritual required that wreaths and garlands—which are extended wreaths—be hung around the altars and temples, and relief sculpture repeated in stone the motifs of the living wreaths. The gods, that is their statues, expected to be honored with fresh leafy crowns whenever a suppliant made his or her appearance. "The gods turn away from those who present themselves without crowns," Sappho had said.[29] The ancients could not pray without offering wreaths. If one wanted to make a petition, one brought a wreath. It is a procession of wreath-bearing Thebans seeking remission of the plague that opens Sophocles' *Oedipus Rex*.[30] In the third century A.D., Dio Cassius speaks with feeling about the satisfaction one got from being able to crown the god's statue, as opposed to worshipping the god simply in mind and spirit.[31] A whole industry of gardeners and florists and chaplet weavers, called *coronarii*, emerged to supply the devout demand. Pliny's treatise on flowers is aimed especially at this industry, and it opens with a brief history of the making of wreaths.[32]

A very basic and primitive instinct lies behind such customs. Leafy boughs were thought to carry the life and power of the trees and plants from which they were cut. When woven in a circle they purified that which they enclosed. The circle possessed a magic; it was apotropaic, warding off demons and ill luck.

Religious sentiments seem to underlie the use of wreaths outside of cultic situations as well. The use of crowns in weddings—continued in Orthodox

Christian usage down to the present—stemmed from the need to protect the couple from ill fortune. At the same time the life of the green boughs had chthonic associations and carried a pledge of the fertility of the marriage.[33] It is because of the purifying power of the wreath that soldiers returning from battle were crowned: it cleansed them of blood-guilt and prepared them for sacrifice. Even the crowning of athletes had cultic origins and never entirely lost its religious overtones. The games stem from the cult of the dead, and the branches were sacred to the apotheosized heroes commemorated by the games. The crowning of the victor placed him in the company of the heroes and gods who went before him. On his return home from victory, he was expected to dedicate his crown at the local temple.[34]

Closer to the situation of the sainted crown-bearers in Christian art is the tradition of crowns for the deceased. As early as the Archaic period delicate gold circlets of oak and myrtle leaves appear among the finds from the tombs of Greece. "The crowning of the corpse was the most important act of a Greek funeral: at the burial the wreath of leafy twigs was replaced by a gold one if the family could afford it, or by a diadem. . . . Subsequent cults of the dead required that crowns or fillets or garlands frequently be brought to the grave."[35]

The custom of crowning the deceased (men but not women) continued into Roman times.[36] We know exactly what such wreaths looked like, for they have been preserved in Egyptian burials, such as the fourth century example from the Museum of Fine Arts, Boston (fig. 129).[37] Moreover, representations of wreaths are ubiquitous in Roman funerary art, on tombs, on altars dedicated to the memory of the dead, and on sarcophagi.

The associations behind funeral wreaths originally may have been chthonic—a prayer directed toward the gods of the underworld—but by imperial times the meaning had shifted and the crown was viewed as marking the victory of the good life. A Roman scholiast remarked, "The crown is given to the dead as to those who have won in the contest of life."[38] This obviously is the meaning of winged Victories bearing crowns on Roman sarcophagi. There is no imperial implication in the motif. The metaphor was athletic: life was a contest, and the deceased was the victor.

The Christian use of the same metaphor, therefore, grows out of the widespread diffusion of such thinking.[39] Paul was simply using a conventional figure of speech when he urged his readers to discipline themselves like runners in order to receive an "imperishable wreath" (1 Cor 9:25). The identification of the reward of the just with a crown is frequent in the New Testament, whence it passed into everyday Christian parlance.[40] Chrysostom and Basil use this meta-

128. (*facing*) The Baptism and Procession of Crown-bearing Apostles, mosaic in the Orthodox Baptistery, Ravenna, 458

129. Roman Funerary Crown from Egypt, papyrus and bronze, c. fourth century A.D.

phor, and, most pointedly, Wharton cites Ambrose's use in connection with baptism.[41] Interpreting to the neophytes their experience of baptismal anointing, he said, "You are anointed as an athlete of Christ, as if to contend in the contest of this world. . . . He who contends has what he hopes for; where there is a struggle, *there is a crown.* You contend in the world, but *you are crowned* by Christ. And for the struggles of the world *you are crowned*, for, although the reward is in heaven, the merit for the reward is established here."[42]

While Christians rejected as a pagan rite the tradition of placing crowns on the heads of their dead, they eagerly seized upon the metaphorical possibilities in the image of the crown.[43] The crowns carried by the Apostles in the baptistery mosaics were the expected reward of the good life. They were the crowns that the Apostles had won by their deeds and their martyrdom, and they were the crowns the neophytes shared through their renunciation of the world. The saints carry them instead of wearing them because they offer them and their worthy lives to their Lord and God.[44] In equal numbers from either side, the Apostles promenade in solemn file to Christ who stands at the center of the

130. (*facing*) Procession of Crown-bearing Saints, mosaic from the right-hand wall of the nave of the "New" Saint Apollinaris, Ravenna, c. 557–70

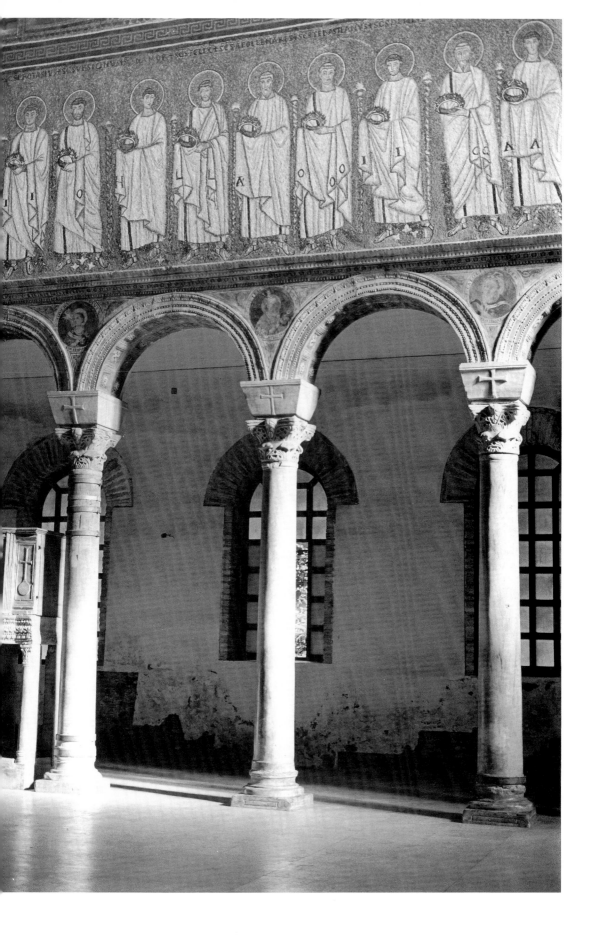

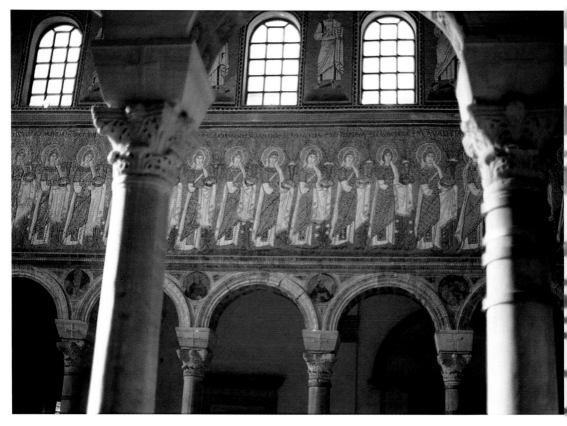

131. Procession of Crown-bearing Saints, mosaic from the left-hand wall of the nave of the "New" Saint Apollinaris, Ravenna, c. 557–70

132. The Palace of Theodoric, with Procession of Emperor and Court erased, mosaic from the right-hand wall of the nave of the "New" Saint Apollinaris, Ravenna, c. 500–26

medallion above them; at the Arian Baptistery they converge on the enthroned cross that stands for Christ (figs. 104, 128).

THE PROCESSION was basic to all Christian liturgy. At the house-church of Dura-Europos, before the Peace of Constantine, the procession from baptistery to Eucharistic hall took place entirely within the confines of a private dwelling. In Ravenna it went out of doors from the baptistery to the neighboring cathedral but still remained within ecclesiastical precincts. Much of Christian worship, however, took place in full view of the public, on the streets of the city. Readers of Early Christian literature have always been fascinated by the diary of Egeria's visit to Jerusalem at the end of the fourth century. The Spanish nun left an exact account of the elaborate patterns of processions that characterized Christian worship in the Holy City. This was generally assumed to be a feature unique to that city's possession of the biblical holy sites;[45] however, liturgical studies have begun to clarify the extent to which Christian worship in all the great cities took advantage of the entire urban space. John Baldovin's landmark study of the "stational" liturgies of Jerusalem, Rome, and Constantinople selected those three most important metropolitan centers because their evidence is most plentiful. But the patterns he observes in those cities seem to have been repeated in Milan, Antioch, Alexandria, and elsewhere.[46] Not content with the atria and aisles of their basilicas, Christians usurped the colonnaded streets and fora of the city, turning worship into parades and demonstrations.

Baldovin has outlined the development of processions in connection with the "stational" liturgy, that is, the episcopal liturgy in so far as it was mobile, changing sites with the calendar year. The stational liturgy was the principal Christian celebration of the city on the day on which it was scheduled, and it necessarily involved the procession of the bishop from his residence to the designated place of worship. Jerusalem, Rome, and Constantinople each developed a stational system reflecting local needs and topography. Further, the stational liturgy was frequently dramatized with what Baldovin calls "participatory processions." The ultimate origins lie in imitation of, or competition with, pagan religious practice. In one singular instance, the Great Litany procession in Rome on April 25 followed the very same path, petitioning for the success of the crops, as the earlier pagan Robigalia procession had taken for the same purpose on the same date.[47]

But Constantinople led in the development of public processions involving lay participation, and in Constantinople these processions pitted Orthodox against Arians. When Gregory Nazianzenus assumed the episcopacy in 381, all the major churches including Hagia Sophia were in the hands of the Arians, and it was the Arians who first introduced the practice of processions with the

chanting of antiphonal psalms.[48] By the time of Chrysostom, the Orthodox had claimed virtually the whole city, and they vaunted this claim with street processions. Chrysostom described the public procession that greeted the arrival of the relics of St. Phocas in 398. "Yesterday our city was aglow, radiant and famous, not because it had colonnades, but because a martyr arrived in procession from Pontus. . . . Did you see the procession in the forum? . . . Let no one stay away from this holy assembly; let no virgin stay shut up in her house, no woman keep to her own home. Let us empty the city and go to the grave of the martyr, for even the emperor and his wife go with us. . . . Let us make of the sea a church once again, going forth to it with lamps."[49]

The claim to urban space was a good deal more than symbolic, and it was not always peaceful. Ambrose narrates with approval how a group of orthodox monks, on their way to celebrate the feast of the Maccabee martyrs, found their psalm-singing procession blocked by a group of the heretical Valentinians, a gnostic sect. In anger at being unable to proceed, the monks set fire to the Valentinians' church.[50]

The mosaic processions that march the length of the nave of the "new" Saint Apollinaris are the most vivid illustration of this aggressive urban dimension of Christian worship (figs. 130 & 131). When the basilica was built by the Arian king Theodoric, the nave was decorated in three zones, with narrative panels of the life and Passion of Christ at the top, scroll-bearing prophets or apostles between the windows, and below the windows processions of the Arian king and his court. On the right they filed out of the palace of Theodoric, and on the left they departed from the port of Classe, to make their way to Christ and his Mother at the far end of the nave. Clearly the processions represented the Arians' very real claim to control the urban environment.

After Justinian's general reconquered the city for Orthodoxy (540), Arian church property was confiscated and turned to Catholic worship under the bishop Agnellus (557–570). The bishop let the upper zones stand, but he had to revise the processions. Theodoric and his court had to be erased, leaving shadows and an occasional detached hand where they once stood (fig. 132). Where previously the Arians had marched in procession Agnellus now inserted orthodox Catholic saints, all named in inscriptions. The procession from the palace consists of twenty-six male martyrs under the leadership of Saint Martin of Tours, to whom the church was now re-dedicated. They stride forward with crowns in hand toward the enthroned Christ at the eastern end of the nave. On the opposite wall, twenty-two female counterparts leave the port of Classe, led by the Magi to present crowns to the Christ Child in his Mother's lap (figs. 130 & 131). The saints selected are the preferred saints of Rome and Milan, empha-

sizing Ravenna's rejection of Arianism for Catholic orthodoxy.[51] The city space had been reclaimed. The orthodox replaced the Arians in the mosaic processions as well as in the processions through streets of the city.

In Rome, where Arian rule was felt much less, the victory over the Arians found a somewhat subtler expression in mosaics. Upon the death of Theodoric in 526, his daughter Amalaswintha, a Catholic, made a gift to Pope Felix IV (526–530) of a piece of imperial real estate in the forum for use as a church. Dedicated to Saints Cosmas and Damian, it was the first church in the city center.[52]

The recent cleaning of the apse by the Italian Soprintendenza dei Monumenti, reveals an image of intense and eerie beauty. An heroic Christ effortlessly ascends a bank of orange-flecked clouds (fig. 133).[53] Ten feet tall, he is out of scale with the saints on the ground, and the eye readily believes he is still many times larger as he steps on the far distant clouds. Like Elijah who mounted live into heaven over the River Jordan (2 Kgs 2:11), Christ is shown ascending above the River Jordan, which spreads in a light blue band across the entire horizon. Dressed as a philosopher in tunic and pallium and holding the scroll of his philosophy, he gazes down from the intense blue of deep space. His wide eyes seem to control all that he sees, both the figures who move toward him in the apse, three on either side, and the lowly bystander in the nave of the church, whom he greets by raising his right hand.

Peter and Paul lead a procession of figures from either side, their motion convincingly represented by increasing the size of the step from figure to figure. Behind the two princes of the Apostles walk the patrons of the church, Cosmas and Damian, a pair of Syrian physicians who offered their services gratis (the one on the right is shown with the satchel of his medical equipment). Further to the right, dressed in a lavish military cloak, the soldier saint Theodore, name saint of the deceased Theodoric, steps more quickly. The Arian king has been caught up in the Catholic procession under the guise of his heavenly patron. Like Cosmas and Damian, he carries a crown in reverent, veiled hands. On the opposite side Pope Felix offers his church.[54]

The processions of the Catholic monarchs in Saint Vitalis are the most discussed mosaics of the entire Early Christian period (fig. 117); this in itself signals a significant bias in our view of the material. Vivid portraits of monarchy fascinate the modern viewer. In panels located on either side of the apse the emperor and empress move in cautious steps toward the image of Christ in the conch, while they transfix us with their steady gaze. The emperor Justinian, of course, had not visited Ravenna, any more than had Saint Martin and his companions the church of Saint Apollinaris. Yet the procession of the imperial

133. Christ and Processions of Saints, mosaic in the apse of Sts. Cosmas and Damian, Rome, c. 526–30

court is the most realistic liturgically of all the processions of Ravenna.

While modern church-goers park themselves in pews like spectators at a cinema, the early church was without seats, and the liturgy of the Eucharist was dominated by processional movement. The Roman liturgy, moreover, unique among Christian rites, involved the laity in offertory as well as communion processions. Elsewhere deacons were assigned the task of bringing bread and wine to the sanctuary, but in the Roman rite this was a function of the laity. First men and then women would proceed to the sanctuary carrying offerings of bread and wine, from which the celebrant would select sufficient for the mass.[55] It can be assumed that the liturgy of Ravenna, like that of neighboring Milan, conformed substantially to that of Rome. Later in the liturgy, after the consecration of the elements, the double processions of men and women would form a

second time for communion. The faithful were segregated by sex in the early Church, women on the left and men on the right, so that the grand mosaic processions of the "new" Saint Apollinaris were echoed in the real-life processions of the faithful below (figs. 130&131).

The processions of the Saint Vitalis mosaic represent the liturgy in a more graphic way, but the exact moment represented has been in dispute.[56] Von Simson and Stricevic contended that the mosaic represented the presentation of bread and wine in the offertory ceremony. But the procession is led by Bishop Maximianus with a jewelled cross, preceded by one deacon carrying the Gospel and another with incense.[57] These would have no place in the offertory ceremony, whether in the Roman or the Byzantine liturgy. But they are the leaders in the First Entrance, the opening ceremony of the Byzantine liturgy. Moreover, a woman—even an empress—would not have been allowed to carry a wine-filled chalice. When offering wine she would have presented an *amula*, a little bottle, which would be emptied into the chalice. But whenever the imperial couple attended church they were expected, during the First Entrance, to make donations of gold, whether in the form of a purse of coins or in vessels. This interpretation is re-inforced by the fact that Theodora is shown entering one of the doors of the church from the atrium; the location is indicated by the fountain, a common feature of church atria. In the liturgy of Constantinople the laity, having first assembled in the atrium, would have followed their clergy and monarchs into the church in the First Entrance procession.[58]

Yet for all the attention that art historians have given the emperor and empress, it must be pointed out that royalty are doubly out-ranked by clergy in the mosaic program at Saint Vitalis. In contrast to the ceremonial of Rome, Byzantine ceremonial followed the rule of "seniores priores"; the higher in rank went first. In Justinian's panel the Gospel, the Word of God, accompanied by incense, occupies first place. In second place it is Bishop Maximianus, carrying his cross, for in church the bishop always preceded the emperor. Then comes Justinian.[59] Furthermore, the imperial panels are at a lower level than the mosaic of the conch, where the converging processions meet at their goal in Christ (figs. 112, 116). The emperor has no place beside Christ, but another bishop, the deceased Ecclesius, under whom the church was founded, offers his building to Christ on equal footing with the martyr Saint Vitalis. The bishop is presented to Christ by an angel.

THE WORLD VIEW of Early Christian art is a vision of the confluence of humankind toward an omega point in Christ. The mosaic figures that circle the beholder's head in the dome, or stream down the walls of the nave, converge on a

134. The Great Mother Goddess, lead plaque,
third century A.D., The Metropolitan Museum
of Art, New York

135. Saturn-Baal, on a funerary stele from Tunis,
late third century A.D., Musée National du
Bardo, Tunis

symmetrically organized image of Christ with attendant angels and saints. These symmetrical, core compositions, it is important to emphasize, no less than the processions themselves, have their closest precedents in the religious art of the ancient world.

Though art historians have imagined that such compositions as the apse of Saint Vitalis echo the deportment of eager courtiers around their emperor, no images of such courtly behavior survive.[60] In the religious realm, however, the centrally placed god, flanked by lesser divinities, by attendants, or by worshippers, is a very common occurrence. Numerous examples might be found in the time-honored imagery of the classical temple, whether in great facade pediments or in sculptural groups of cultic images within *cellae*. But the most striking precedents are to be found in the private votive reliefs and gravestones of Late Antiquity, particularly in art devoted to the mystery religions, with which Christianity had so much in common. These objects represent the diversity of religious life around the Roman Empire.

From the Danube come an assortment of lead plaques of the third century, like the one in New York's Metropolitan Museum of Art (fig. 134), dedicated to a Great Mother goddess.[61] On the principal register the goddess is greeted by the mounted Dioscuri, twin sons of Jupiter and gods of the underworld, while female and male votaries stand at right and left. Helios drives his chariot across the sky in the upper register and the sacred Mithraic meal is celebrated in the lower. A similar symmetrical organization can be found in a third-century funerary stele from Tunis in North Africa (fig. 135).[62] Now it is Saturn-Baal as the "grim reaper" who is in the center. He rides a bull with a sickle in hand between the Dioscuri. Above are the eagle of Jupiter and two Victories, while below the deceased couple and their farm appear.

Celtic gods were shown in similar symmetrical Compositions, such as Cernunnos, the god of wealth on a first-century grave stele from Rheims (fig. 136), or Epona the goddess of the horse on a third-century relief from Thessalonica (fig. 137).[63] Cernunnos is accompanied by Apollo and Mercury, and from beneath his throne flows a river of gold coins to which the bull and the stag have come to drink. A plaque from Rome mixes Roman and Egyptian deities in a powerful symmetrical composition (fig. 138).[64] In the center, above a wreathed, burning altar, Serapis and Isis hover on the wings of Jupiter's eagle; to either side Jupiter and Juno ride bull and hind, flanked by the Dioscuri.

Like Early Christian apses, all of these reliefs share a strong axial organization and a visionary, irrational handling of space. All show a centrally placed deity flanked by lesser or attendant divinities, as Christ is flanked by angels or saints. Powerful magical beasts figure in all of them, presaging the role of Four Living Creatures that carry Christ at Holy David or fly over his head at Saint

136. Cernunnos Flanked by Apollo and Mercury, on a grave stele from Rheims, early first century A.D., Musée Lapidaire, Rheims

137. Epona, Goddess of the Horse, relief of the third century A.D., Thessalonica

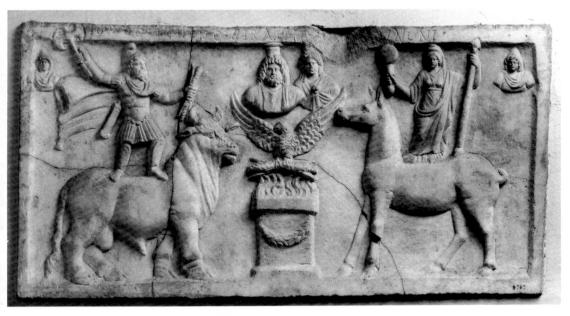

138. Jupiter Dolichenus and Egyptian deities, relief from the Aventine, second century A.D., Rome

Pudenziana (figs. 88, 71). The parallel between the Cernunnos' river of gold and the rivers of Paradise that flow from the throne of Christ is most striking. These Late Antique divinities establish the genre of images to which the great Early Christian apse mosaics belong.

Processional convergence on an axially organized core image provided a formula for the program of the Early Christian church. As an overall image-structure this is a far cry from the omni-systems of medieval art. Yet it served its purpose. In their solemn stride the saints provided an exemplar to believers, whose life was a procession in metaphor as well as in ceremonial. The faithful were invited to fall in line behind their clergy as they marched to the vision of the future. At Saint Apollinaris in Classe the first bishop of Ravenna raises his hands in prayer as he mediates the vision of the Transfigured Christ to the sheep of his flock (fig. 119). All in step, heads held high, the sheep pick their way through a flower-strewn landscape. The church, in the imagination of Late Antiquity, was replacing eternal Rome and all her gods as the universial vehicle of hope.

The Intimate Icon

Public ecclesiastical art appealed to a shared religious experience mediated through a clerical hierarchy who both oversaw the decoration of the churches and conducted the services within them. It was the task of bishops to stir up the enthusiasm of their religious rallies and to channel it to profitable ends. Thus the grand images on wall or apse gained their force from group affirmation. At the same time, both because of their scale and their church location, such images functioned at a certain remove from the individual Christian in his quotidian experience: they hovered overhead, out of reach.

But in the security of their homes the devout prayed to private images, where, because they escaped the control of the clergy, they posed a real danger. The locus of this peril was the icon, that is the portable panel painting, which Christians hung on the wall, decorated with wreaths of flowers, spread prayer cushions before, offered candles to, and touched or kissed with affection. Here images exerted their strongest pull and Christian cult came closest to pagan.

When Constantia, sister of Constantine the Great, requested an icon of Christ for her use, Bishop Eusebius expressed his disapproval in no uncertain terms, saying "these are excluded from churches all over the world."[1] At the same time, Eusebius admits that when a woman brought him an icon of Paul and Christ clad as philosophers, he did not destroy the work but confiscated it and kept it in his own house to prevent its improper use by the woman.[2] Anxious over the infiltration of pagan uses into the Christian community, he would allow icons in the home only if he himself could oversee their use. Indeed, elsewhere he explicitly associated the custom with pagan practices. "I have examined images of his apostles Paul and Peter, and indeed of Christ himself, preserved in color paintings; which is understandable, since the ancients used to honor saviors freely in this way following their pagan custom."[3]

But icons are mentioned in Christian use much earlier than Eusebius, and the impetus came from the private sector.[4] Marcellina, leader of a Christian splinter group in Rome under Pope Anicetus (ca. 154–166), venerated icons of

Christ on which she hung wreaths and "observed other rites that are just like those of the pagans."[5] The earliest detailed description of the Christian veneration of icons, the apocryphal *Acts of John* composed in the third century, also alludes to the pagan roots of this practice.[6] According to the narrative, one of St. John the Evangelist's first disciples in Ephesus was the praetor of the city, one Lycomedes. Slow to leave his pagan practices behind, Lycomedes had a painting of John made which he kept in his bedroom, wreathing it with garlands and lighting candles before it.[7] The modern reader might legitimately demand: Why did Lycomedes want to venerate an icon of John when he could go next door and venerate the saint in person? Clearly, Lycomedes saw the possession of the saint's image as a way of physically controlling the saint's miraculous power. Lycomedes' conversion, we are told, was prompted by St. John's cure of his wife Cleopatra, who was paralysed by an enemy's "evil eye."[8] The staring eyes of the saint's image must have seemed an effective protection against any further dangers from that quarter. The magical power of the gaze for good or for evil is a subtheme in the *Acts of John*; Christ, it narrates, was different from ordinary men in that he never closed his eyes.[9]

The reaction of the apostle to Lycomedes' practice is extremely interesting, and it must reflect attitudes of the time in Christian circles in Asia Minor. While John rebuked Lycomedes, he phrased his admonition in surprisingly mild terms, merely calling the behavior "childish and imperfect."[10] At the same time he looked for positive values in the practice—for John first verified the likeness in the icon. He called for a mirror and was surprised to find that the old man in the picture looked exactly like himself. This verification of similitude is a common topos in later literature on icons: one cannot use an icon unless one is guaranteed that it is authentic.[11] In the second place, the apostle used the icon as an allegory for the interior image that the Christian should cultivate. Jesus, John explained, is the true painter (a most remarkable designation), who supplies the colors for the soul: faith, love, purity, and so on.

Some Christians, then, were known to be using icons in a domestic situation the way pagans used painted images of their gods in the third century, and while dangers of pagan practice were recognized, spiritual possibilities were also being sought in the images. This is the atmosphere in which icons, or painted panels, were first adopted for Christian use.

WHILE THE ANCIENT GREEK word *eikon* could mean any sort of image, even a mental image, icon in the strict art historical sense of the term means a wood-panel painting of a sacred subject intended for veneration. In material terms icons are the medieval heirs of the ancient Greek and Roman techniques of panel painting in wax (encaustic) and tempera, and as such they are the forerunners of

European panel painting. But their special role in Christian art is their cultic use. Commonly nonnarrative, they present figures that face the viewer and invite veneration and conversation, and in Orthodox Christianity they came to be accepted as necessary intermediaries in worship. They are therefore one of the most permanent contributions of the Early Christian period to the history of art.

For the art historian the first problem of icons is the gap in physical evidence at the outset. The first flowering of Christian icons comprises a group of about three dozen panel paintings ascribed to the sixth and seventh centuries. A few are found from Rome,[12] a dozen come from the Nile,[13] and the rest, the most important group, have survived at the Greek monastery of St. Catherine on Mount Sinai.[14] But so rich and diverse a body of material presupposes a development.

As the Christian sarcophagi of Rome represented a linear development from their pagan precedents, so the earliest Christian icons grew out of a strong tradition of pagan panel paintings of the ancient gods, and a considerable body of Late Antique pagan icons survives. Early Christian scholarship, however, has skipped over this body of material. While a recent theory would trace icons to the mummy portraits of the Fayum,[15] the majority view still prefers to look for imperial precedents.[16] Imperial connections, however, are difficult to document in the icons themselves, while the connections with Late Antique religious panels are numerous and very specific, whether in construction, in composition, or in imagery.

To date, the corpus of Late Antique icons numbers twenty-two panels, a sampling large enough to permit some generalizations.[17] They date from the second to the fourth century and are chiefly from the Fayum, but the find of two from outside the Fayum demonstrates that they were not restricted locally in Egypt, and literary sources further attest to their popularity throughout the Greco-Roman world. Both Pausanias and Pliny refer to panels, *pinakes* in Greek or *tabulae* in Latin, showing individual gods in nonnarrative settings. Whether found in temples or in private homes, some of these pagan icons were associated with religious and miraculous phenomena, such as Parrhasius' painting of Herakles done from a vision, and another of Parrhasius' paintings of Herakles that was struck three times by lightning without suffering damage.[18] The individual compositions are not described, but those that involved enthroned figures must have presented frontal views of the gods in typical icon fashion, such as Zeuxis' *Enthroned Zeus among the Gods*, Nikomachus' *Kybele on a Lion Throne*, or Asclepiodorus' *Nemea Enthroned on Lions*.[19] Pliny even describes the staring gaze of one icon by the painter Famulus, who also decorated Nero's *Domus Aurea*. "By his hand there was a Minerva which continued to face the viewer no matter

from what angle he looked at it."[20] In addition, Pliny discusses the growing use of panel paintings of Epicurus; they were so popular in domestic cults that he blames them for the decline of the Roman tradition of verist ancestor portraiture.[21]

Most Late Antique icons have come to us without precise provenance, but of those found in controlled excavations, significantly, four were found in houses and one in a temple.[22] Clement of Alexandria, at the beginning of the third century, berated his pagan contemporaries for hanging in their homes panel paintings of their indecent gods (he uses the terms *pinakes* and *eikones*), one of which he describes as a painting of Ares and Aphrodite;[23] by chance a painting of Ares and Aphrodite is among the surviving Late Antique panels, now in the Pushkin Museum in Moscow.[24] Aphrodite wears a chiton that slips from her shoulder to expose her left breast as she throws her mantle over Ares' head; he wears his characteristic helmet and chlamys. People wanted to have in their homes the same gods they venerated in their temples. The practice was not much different from the common Roman cult of the *lararium*, a diminutive domestic shrine, except that *lararia* more commonly contained statuettes rather than painted images.[25]

The lines of continuity between these pagan panels and Christian icons are manifold. Half- and full-length figures are represented in frontal poses holding symbols of their divine power. They stare boldly at the beholder, their countenances ringed with haloes. A house in Tebtynis in the Fayum, which was abandoned around the start of the third century, was excavated by the German archaeologist Otto Rubensohn; he uncovered two of these pagan icons, one complete with its frame and the hemp cord by which it hung from the wall (fig. 139).[26] A pair of haloed divinities sit on a broad throne. Isis, Egypt's great mother goddess, is recognizable on the right by her bouquet of grain and the horns and globe on her head. Her consort, the water god Suchos with a crocodile in his lap, assumes a Jupiter-like pose, with raised arm holding a scepter. Her divine son Harpocrates (damaged) was represented between the two, above the throne.

The construction of the Late Antique icons offers immediate precedent for Christian icons. Thin boards, generally less than a centimeter thick, are placed side by side, their edges slightly tapered to fit into the groove of a surrounding frame that holds them together. The panels are lightly gessoed before painting. The Isis and Suchos frame was quite peculiar, for besides the grooves to hold the painted boards of the icon itself, it had a second set of grooves to accommodate a protecting lid that could slide over the painting. Rubensohn, writing at the beginning of the century, did not know how to interpret this feature, but it now has exact parallels in three of the early Sinai icons reported by Weitzmann (*Three*

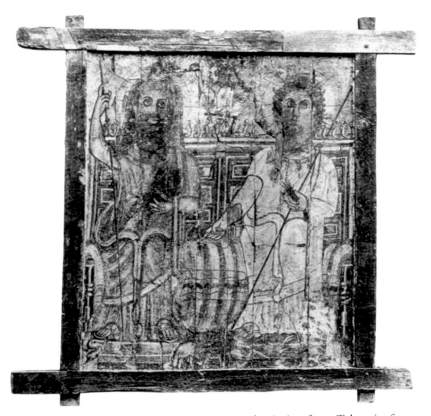

139. Isis and Suchos Enthroned, tempera panel painting from Tebtynis, formerly in the Agyptische Museum, Staatliche Museen, Berlin (now destroyed)

Hebrews, the *Ascension*, and the *St. Plato and Companion*).[27] Like the provision of doors on *lararia*, the sliding lid was a device for closing and concealing the icon when not in use. Temples of both Isis and Suchos were found in Tebtynis, but the icon itself was a miniature temple for use at home.

Doors in triptych format were a more popular way of concealing and revealing the divine presence in icons. Fully a third of the Late Antique icons are panels from triptychs, and the same proportion maintains among the Christian icons of Sinai. A pair of panels of Isis and Serapis in the J. Paul Getty Museum retain the pintles by which they swivelled in the frame of a now missing central panel (fig. 142).[28] The St. Theodore panel on Mount Sinai had separate dowel pintles at the right corners which have broken off (fig. 145). When not in use the icons would have been closed; during prayer one opened the doors and let the gods' gaze shine forth.

Beyond these parallels in construction, the pagan and Christian panels are linked by strong connections in composition and imagery. The highest gods of

140. Isis Nursing Harpocrates, fresco from house in Karanis

the pantheon were often shown enthroned. Besides the Isis and Suchos icon, a panel in Berkeley shows another enthroned male god in a Jupiter-like pose.[28a] In addition, a fresco painted directly on a house wall in Karanis to serve as a permanent icon shows the enthroned Isis nursing Harpocrates (fig. 140).[29] The enthroned Mother of God with the Christ Child in her lap is one of the most popular of all Christian icon types, and three early examples are known (fig. 141).[30] The Sinai icon transforms the wood throne of Isis into a massive golden throne with a high cushion, and it copies the engaging gaze of both mother and child. Out of modesty, however, it refrains from showing the naked breasts of the goddess. Pagan icons had no reservations about nudity; in addition to Isis one might cite the bare-breasted Aphrodite in Moscow and a Harpocrates in Cairo in which the child spreads his legs to show his sex.[31] Not only Clement of Alexandria but Christian authors generally made sexual renunciation a special road to sanctity,[32] and significantly the allegorical spiritual icon that the *Acts of John* extols is said to "cut off that which is below" the belly; in other words, it is imagined to be an icon of a half-length figure.[33] About a third of the Early Christian icons are half-length figures, and this proportion increases over time. Such icons spare the viewer the least allusion to sexuality.

141. Mother of God Enthroned with Child, icon of St. Catherine's Monastery, Sinai, seventh century

Icons of Christ himself also offer a remarkable demonstration of the authority of pagan sacred images. Among the sixth-century icons at Sinai, three very different types of Christ's face can be observed: a young-man type with a rather triangular head, short hair reaching only to the ears and a short beard; an old-man type with long white hair and pointed beard; and the Blessing Christ, commonly called the Pantocrator type, first witnessed in the famous Sinai icon.[34] It is this last type, adapted in coinage and monumental mosaics, that eventually came to predominate, determining our notion of the savior down to modern times. Here a Christ with broad forehead and heavy neck wears a great mass of dark hair and a full but fairly short beard. The potency of this type had

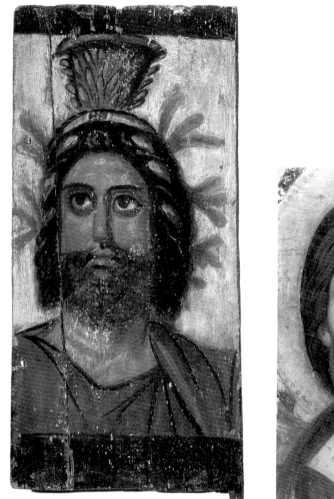

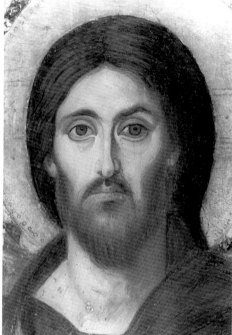

142. Serapis, triptych wing, the Collection of the J. Paul Getty Museum, Malibu, California

143. Detail of Head of Christ, pantocrator icon of St. Catherine's Monastery, Sinai

nothing to do with its portrait accuracy; it was more potent because of its divine pagan associations with the father of the gods.

In Antiquity the Jupiter facial type was adopted by a number of the most potent male gods, including Neptune, Asclepius, Serapis, and Suchos. The Getty Museum panel of Serapis illustrates this borrowing (fig. 142).[35] Especially cultivated in Alexandria, where his Serapeum was one of the great shrines of the ancient world, Serapis united in himself the underworld powers of Osiris with the healing powers of Asclepius. His head is given the broad brow and copious hair of Jupiter; he wears a wreath of laurel and balances a *modius* or grain

144. Equestrian God from Medinat Qouta, the Egyptian Museum, Cairo

145. St. Theodore, sixth-century icon of St. Catherine's Monastery, Sinai

measure, on his head. In approximately the year 400 even a Christian author, Rufinus of Aquileia, understood the association of Serapis with Zeus: "Some think him (Serapis) Jupiter, upon whose head a *modius* is superimposed, either because he fixes how all things are to be governed with measure, or because he supplies life to mortals by an abundance of produce."[36] Similarly, Christians were conscious of the connection of some of their images of Christ with Jupiter, and they saw this as a danger. In the time of Bishop Gennadius of Constantinople (458–71) "a painter who dared to paint the Savior in the likeness of Zeus" found his hand withered. The bishop healed him and instructed him that "the other form of Christ, that is the one with short, frizzy hair, is the more authentic."[37] Historically, Gennadius was probably closer to the truth as far as first-century hair styles were concerned, but the Jupiter type came to win out because it was the more forceful (fig. 143). Christ stole the look of the gods with whom he was in competition.

Alongside Isis, Serapis, Harpocrates, Suchos, Ares and Aphrodite, gods of the first rank, the corpus of Late Antique icons includes a number of lesser attendant gods of a military and equestrian character. With a variable set of attributes and no identifying inscriptions, their names are unknown, but they were so popular that they account for fully half of the pagan icons. Two panels in the Egyptian Museum of Cairo and the Louvre are fragments of larger paintings, presenting youthful equestrians in a graceful Hellenistic style of the second century.[38] The Cairo piece is important for its known archaeological provenance, since it was found in 1939 in a domestic context by Ahmed Fakhry Eff in his excavation of Medinat Qouta on the western extremity of the Fayum (fig. 144). The haloed and laurel-crowned god stands before his horse holding a spear and wearing a sword on his belt.

These military gods continued to be popular into the fourth century, when the evidence breaks off with the depopulation of the Fayum. But the continuity with Christian icons of the sixth century is striking, when military saints attend Christ and the Mother of God. Like the Cairo god, the St. Theodore in the Sinai collection stands frontally at ease holding a spear in his right hand and a shield in his left, but now the spear terminates in a little cross (fig. 145).[39] The chief differences are in figure proportions and the evolved military dress: he wears armor of gold with a floral design, a carmine chlamys, and brown trousers. Arguing from the style, Weitzmann assigns this panel an Egyptian origin. St. Theodore must have filled analogous religious needs to his pagan ancestors of the second to fourth centuries.

The lines of continuity between the body of Late Antique icons and the Early Christian icons also include the evidence of dedicatory inscriptions. Three

of the pagan icons and five of the Early Christian icons include such inscrip-
tions. Typically the pagan inscriptions identify the donor, who is represented
on diminutive scale behind the god, along with the formula "ep'agatho," mean-
ing for a favor or benefit.[40] This is a characteristic of the Christian icons as well:
if the donor enters into the picture he is represented on reduced scale, and an
inscription is added to identify him and sometimes spell out his prayer. Thus we
have on Sinai icons the inscriptions of a Deacon Leo, who appears behind St.
Theodore, a Ioannes, a Nikolaos Sabatianos and, in the most explicit inscrip-
tion, a Philochristos with his prayer, "For salvation and forgiveness of sins."[41]
In both pagan and Christian use the painted images were being offered as
supplications to the superior powers.

The break in the surviving evidence between fourth and sixth centuries
should not mislead us into imagining that pagan and Christian icons did not
exist contemporaneously. Literary sources, we have seen, confirm the existence
of Christian icons from the second century on; on the pagan side a single icon
survives from the seventh century (one Anthousa, the tutelar divinity of Con-
stantinople[42]), while references to pagan icons continue down to the eighth
century. The continued production of pagan icons depended on the survival of
pagan cults. While legislation against paganism became ever more stringent, it
was directed at public observances, particularly sacrifices; cult in the privacy of
one's home was generally beyond the reach of the law.[43] The vitality of pagan-
ism down to the sixth century is attested to by Justinian's attempt to destroy its
intellectual base by closing the Academy of Athens in 529, and by his harsh
measures against pagan cults. Malalas tells us that in 561 he put pagans in
Constantinople under arrest. "Their books were burnt . . . together with pic-
tures (*eikones*) and statues of their loathsome gods."[44] Perhaps it was the success
of Justinian's policy that cleared the way for the sudden flourishing of Christian
icon painting in the sixth century.

But the success was far from complete. In the early eighth century, John of
Damascus, an ardent proponent of icon worship, was still embarrassed to find
people comparing Christian to pagan icon use. "If you speak of pagan abuses,
these abuses do not make our veneration of images loathsome. Blame the
pagans, who make images (*eikones*) into gods! Just because the pagans use them
in a foul way, that is no reason to object to our pious practice."[45] But the
theologian is at a loss to find a difference between pagan and Christian use,
except that the pagans' gods are false. "Pagans make images of demons which
they address as gods, but we make images of God incarnate and of his servants
and friends, and with them we drive away the demonic hosts." When he found
pagan icons, he tells us, he delivered them to the flames.[46]

BYPASSING entirely the phenomenon of pagan panel paintings of the gods, modern historians have erected another imperial hypothesis for the origin of icons, tracing them to the *lauraton*, the official painted portrait of the emperor promulgated from Rome upon his accession.[47] The argument fits nicely with the general tendency to seek imperial precedents for everything in Early Christian art, but it involves the fallacy of squeezing art historical evidence out of an abstract theological debate.

Casting about for theological arguments to bolster the Christian use of icons, the early theologians saw the scandalous parallel between Christian and pagan usage, and they therefore generally observed a discreet silence on the subject. One could hardly expect them to cite the pagan practice in justification of the veneration of icons. Instead, they invoked the analogy of veneration of the imperial image. For example, a seventh-century bishop of Neapolis in Cyprus named Leontius wrote, "The honor paid to God's saints courses back to himself. Thus it is that men destroying or insulting icons of the emperor are punished with extreme severity as having insulted the emperor himself and not merely the painted board."[48] John of Damascus and the patriarch Nikephoros invoked the same topos, and eventually it was enshrined in the Second Council of Nicaea in 787: "When the population rushes with candles and incense to meet the garlanded images of the emperor, it does not do so to honor panels painted with wax colors, but to honor the emperor himself."[49] On this basis, Kitzinger and Belting argue the development of the Christian icon out of the imperial image, both in the cult practice and in the imagery involved.

The theologians, however, never alleged any such connection. In invoking a philosophical analogy between two kinds of images and their veneration, they never argued that the Christian icon cult originated from the imperial, for the Christian tradition, they believed, was handed down from the apostles; nor did they argue that icons themselves depended in construction, composition, or imagery on the imperial images. This is the art historians' contention, and it must be evaluated on archaeological and art historical evidence. We must recall that the theologians' argument about imperial images is a commonplace of Neoplatonic philosophy that was already invoked by Julian the Apostate, but to justify his veneration of pagan statues.[50] Yet, no art historian would infer that images of the pagan gods depended on or were derived from images of the emperor; for, clearly, pagan gods were much older in Classical art than were emperors.

In an ecclesiastical history referring to the years 554–561, a miraculous icon of Christ purported to have been painted by no human hand was carried about Cappadocia to raise money for church building.[51] The history repeats a legend that the image had been made by Christ himself for a catechumen named

Hypatia in apostolic times. In 574, according to the historian Cedrenus, the image was brought from the village of Camouliana to Constantinople and, by the time of the emperor Heraclius, this icon, or a copy of it, had become the palladium of Constantinople, being carried to battle before the imperial troops. Both Kitzinger and Belting, as before them Dobschütz had done, cite this history as critical evidence for the transfer of imperial ceremonial to Christian images. In the priestly processions, Kitzinger argues, "an image of Christ is described as receiving the same kind of public display which was traditional in the cult of the imperial image."[52] Belting explains, "Previously, the ceremonial procession of an image had been reserved for the effigy of the emperor, which served to represent him in the provinces. These rites were now for the first time usurped by a religious image."[53]

But this is to overlook the fact that processions of religious images were enormously popular throughout the ancient world apart from any imperial connections,[54] and indeed in the Cappadocian procession neither the emperor nor his representatives took any active role; it is described as exclusively a priestly affair for the purpose of raising money to replace a church the Persians had burned. Heraclius' adoption of the image in a context in which earlier the image of the emperor had been used is much better evidence; but 626 is rather late if we are discussing icon origins. Kitzinger and Belting pass over the important evidence that the story of the Camouliana image places its origins in the private devotion of Hypatia and attribute its propagation to still another woman in Cappadocia who brought a copy of it to her own village.[55] Clearly, Heraclius' adoption of the Camouliana image is evidence of the impact of private icon worship on imperial uses rather than the reverse.

Format and construction are also important considerations. Unfortunately, the most important evidence for the imperial argument, namely the *laurata* or official painted portraits of the emperor, that were sent about the realm upon his accession, are all missing. Belting proposes that they assumed a clipeate format of a bust within a disk, and argues that this was a characteristically imperial type of image.[56] But, as we have argued above, the clipeate format had very wide use in Roman portraiture outside of imperial images. In surviving icons, moreover, it is used only in subordinate medallions. Christian icons generally carry more than busts; it was important to insist that Christ and the saints had human bodies, and they are shown half length or full length. Hence, there is nothing especially imperial about the format of Christian icons.

Icons of Christ are critical to the entire argument. In the early icons Christ has no articles of imperial dress, no scepter or diadem, and he carries a very unimperial codex. None of the three icon types of Christ's face—the young man, the old man, or the Pantocrator—resembles imperial portraiture. Con-

cerning the last type, both Belting and Kitzinger admit its obvious "Jovian" or Zeus derivation.[57]

In terms of physical evidence, the votive panels of the ancient gods exhibit many strong correspondences with Christian icons. Some of these correspondences are in details of construction: the thin panels with grooved frames; the sliding lids; the pintle-hinged triptychs. Other correspondences are in composition or format: the frontal figures, whether full length or half length, single or multiple; the donors on diminutive scale. Still other correspondences are in particular features of iconography: the engaging gaze, the halo, the throne, the Zeus-type face, and the military or equestrian garb. Even the inscriptions invite comparison with inscriptions on Christian icons.

The modern historian is necessarily cautious about venturing beyond the physical to reconstruct the emotional reactions of the ancients to their art. Yet what evidence exists must be acknowledged, and it points to the strong parallel between the pagan and the Christian reactions to their icons. In trying to justify the cult of sacred pagan images, Julian the Apostate casts about for analogies that would illustrate the pleasure he took in these images: "He who loves the emperor delights to see the emperor's statue, and he who loves his son delights to see his son's statue, and he who loves his father delights to see his father's statue. It follows that he who loves the gods delights to gaze on the statues of the gods, *and on their icons* (eikonas), and feels reverence, and *shudders with awe* of the gods who look at him from the unseen world."[58] The icon carried the same effect as the statue; to experience it was to quiver under the gaze of the god who peered out at you. Two centuries later the poet Agathias speaks of the very same aweful trembling before the archangel Michael gazing out of an icon: "The mortal man who beholds the image (*eikona*) directs his mind to a higher contemplation. His veneration is no longer distracted: engraving within himself the [archangel's] traits, he *trembles* as if he were in the latter's presence. The eyes encourage deep thoughts (or: The eyes stir up the depths of the spirit)."[59] Like his pagan predecessors, the devout Christian trembled in awe of the divine presence that looked out through the eyes of the icon, while he offered flowers and candles in veneration.

LIST OF
ABBREVIATIONS

AB *Art Bulletin*

Age of Spirituality Kurt Weitzmann, *Age of Spirituality, Late Antique and Early Christian Art* (N.Y., 1979)

CA *Cahiers Archéologiques*

DACL *Dictionnaire d'archéologie chrétienne et de liturgie*

DOP *Dumbarton Oaks Papers*

Early Christian Art Wolfgang F. Volbach, *Early Christian Art* (New York, 1962)

Iconography André Grabar, *Christian Iconography, A Study of its Origins* (Princeton, 1968)

Ikonographie Gertrud Schiller, *Ikonographie der christlichen Kunst*, vol 1–5 (Gütersloh, 1966–1991)

JÖB *Jahrbuch der Österreichischen Byzantinistik*

JRS *Journal of Roman Studies*

Lexikon Engilbert Kirschbaum, *Lexikon der christlichen Ikonographie*, vol. 1–8 (Breisgau, 1968–76)

MM *Madrider Mitteilungen*

ODB *Oxford Dictionary of Byzantium*, ed. Alexander Kazhdan et al., 3 vols. (N.Y. 1991)

PG *Patrologiae cursus completus*, Series Graeca, ed. J.-P. Migne

PL *Patrologiae cursus completus*, Series Latina, ed. J.-P. Migne

RAC *Reallexikon für Antike und Christentum*, ed. Th. Klauser et al. (Stuttgart, 1950–)

RM *Römische Mitteilungen*

RQ *Römische Quartalschrift*

NOTES

CHAPTER ONE

1. Catacomb painters belonged to the association of *fossores*. H. Leclercq, "Fossoyeurs," DACL, 5: 2065–91.

2. On the sign carried by Constantine's troops see H. Leclercq, "Labarum," DACL, 8: 927–962. For recent literature, see Paul Corby Finney, "Labarum," in *Encyclopedia of Early Christianity*, ed. Everett Ferguson (New York, 1990), 523–24.

3. See Paul Zanker, *The Power of Images in the Age of Augustus*, trans. Alan Shapiro (Ann Arbor, 1988); David Freedberg, *The Power of Images: Studies in the History and Theory of Response* (Chicago, 1989). Neither of these studies deals with the formative stage of Christian imagery that occupies us here.

4. Bassett casts doubt on Cedrenus' identification of this statue as Phidias' original and suggests it might have been a Roman copy. The statue was destroyed in a fire in the sixth century. Sarah E. Bassett, *"Omnium Paene Urbium Nuditate": The Reuse of Antiquities in Constantinople, Fourth through Sixth Centuries* (Ph.D. diss., Bryn Mawr College, 1984), 112–15.

5. The story of the miraculous storm is found in Claudian, *De tertio consulatu Honorii*, verses 87–101; Augustine retells the story with the added details about the statue of Jupiter, *De civitate dei*, V: 26, 1. See André Piganiol, *L'Empire chrétien (325–395)*, 2nd ed., ed. André Chastagnol (Paris, 1972), 293–95.

6. For a recent discussion of Theodosius' anti-pagan legislation, see Pierre Chuvin, *A Chronicle of the Last Pagans*, trans. B. A. Archer (Cambridge, Mass., 1990), 57–72.

7. See Johannes Geffcken, *The Last Days of Greco-Roman Paganism*, trans. Sabine MacCormack, Europe in the Middle Ages, Selected Studies, vol. 8 (New York, 1978), original title *Der Ausgang des Griechisch-Römische Heidentums* (Heidelberg, 1920). On survivals of the cult of Zeus into the sixth century in Edessa, see G. W. Bowersock, *Hellenism in Late Antiquity*, Jerome Lectures 18 (Ann Arbor, 1990), 36, 38.

8. Ralph Merrifield, *The Archaeology of Ritual and Magic* (New York, 1987), 96–106; instance from Aphrodisias.

9. Augustine, *Sermo*, XXIV: 6.

10. On the use of these table supports, see T. Stephanidou-Tiveriou, *Trapezophora tou Mouseiou Thessalonikis* (Thessalonica, 1985), 13–14.

11. Gisela M. A. Richter, *The Portraits of the Greeks* (London, 1965), 1: 109–119; abridged and revised by R. R. R. Smith (Ithaca, 1984), 198–204.

12. On the absence of a portrait tradition of Christ in the first two centuries, see Johannes Kollwitz, *Das Christusbild des dritten Jahrunderts* (Münster Westf., 1953), 5–6; Grabar, *Iconography*, 66–68.

13. J. Irmscher, "Late Antiquity," in *Encyclopedia of the Early Church*, ed. Angelo Di Berardino (New York, 1992), 1: 473; Peter Brown, *The World of Late Antiquity*

(London, 1971); H. I. Marrou, *Décadence romaine ou antiquité tardive?* (Paris, 1977).

14. Erica Cruikshank Dodd, *Byzantine Silver Stamps* (Washington, 1961), passim.

15. On the state of research on Late Antique portraiture, see R. R. R. Smith's review article, "Roman Portraits: Honours, Empresses, and Late Emperors," JRS 75 (1985): 209–21.

16. Ernst Kitzinger, *Byzantine Art in the Making* (Cambridge, Mass., 1977). See especially his summary conclusion in "Epilogue," 123–126.

17. Grabar, *Iconography*, 5–54.

18. Grabar called them "image-signs," but it is difficult to conceive of an image that is not a sign. An equivalent term, "signitive images" is used by Kitzinger, *Byzantine Art in the Making*, 20. Others refer to them as "abbreviated images," as if they were pared down from more developed images elsewhere, which is an unnecessary assumption. Erich Dinkler, "Abbreviated Representations," in *Age of Spirituality*, 396–402. The German term is "Kurzszenen." Friedrich W. Deichmann, *Einführung in die Christliche Archäologie* (Darmstadt, 1983), 161.

19. Grabar, *Iconography*, 41.

20. For bibliography, see note 4 to chapter 2 and note 8 to chapter 5.

21. See discussion, pages 89–91.

22. In the fourth century, the liturgy, it is alleged, "takes on more and more of the character of court ceremonial—before the invisible, but present, King of glory." Per Beskow, *Rex gloriae: The Kingship of Christ in the Early Church* (Stockholm, 1962), 15.

23. Richard Krautheimer attaches imperial overtones to the choice of a basilica-form building for the Early Christian Church. "The Constantinian Basilican," DOP 21 (1967): 117–40; *Early Christian and Byzantine Architecture*, rev. ed. with Slobodan Ćurčić (Harmondsworth, 1986), 41–50.

24. In the sources the arch was described by the neutral term "arcus maior"; only in Carolingian times did authors begin to call it the "arcus triumphalis." Richard Krautheimer, "The Carolingian Revival of Early Christian Architecture," AB 24 (1942): 34, repr. *Studies in Early Christian, Medieval and Renaissance Art* (New York, 1969), 233.

25. Richard Krautheimer proposes a derivation of central-planned churches from palace designs, making the domed nave a stage for emperor and bishop. *Early Christian and Byzantine Architecture*, 218, 230–32.

26. Otto G. von Simson, *Sacred Fortress: Byzantine Art and Statecraft in Ravenna* (Chicago, 1948), 116.

27. See pages 143–44.

28. Yakov Malkiel, essay on Ernst H. Kantorowicz in *On Four Modern Humanists*, ed. Arthur R. Evans (Princeton, 1970), 146–219.

29. *The Fundamental Issue: Documents and Marginal Notes on the University of California Loyalty Oath* (printed privately, San Francisco, 1950), 7. It was Kantorowicz' crusading suit against the Regents of the University that finally had the oath set aside.

30. Stefan George's political mystique was handed down in his circle orally, in unsigned editorials in *Blätter für die Kunst*, and in some of his poems. See his last volume, *Das neue Reich*, 1928. George himself was anti-Hitler and chose voluntary exile in Switzerland in 1933.

31. *Kaiser Friedrich der Zweite*, 1st ed. (Berlin, 1927). The third edition of 1931 included a supplemental volume of notes, *Ergänzungsband: Quellennachweise und Exkurse*. See David Abulafia "Kantorowicz and Frederick II," *History* 62 (1977): 195–210.

32. Ernst Kantorowicz, "The 'King's Advent' and the Enigmatic Panels in the Doors of Santa Sabina," AB 26 (1944): 206–31; *Laudes Regiae: A Study in Liturgical*

Acclamations and Medieval Ruler Worship; *The King's Two Bodies: A Study in Medieval Political Theology* (Princeton, 1957).

33. A brief account of his life and scholarship can be found in *Andrew Alföldi, 1895–1981*, ed. Harry Woolf (Princeton, 1982).

34. See remarks by Frank P. Kolb in Woolf, *Andrew Alföldi*, 16–18.

35. "Der neue Weltherrscher der vierten Ekloge Vergils," *Hermes* 65 (1930): 369–85.

36. Andreas Alföldi, "Die Ausgestaltung des monarchischen Zeremoniells am Römischen Kaiserhofe," *Mitteilungen des deutschen archäolgischen Instituts, Romische Abteilung* 49 (1934): 1–118; "Insignien und Tracht der römischen Kaiser," ibid. 50 (1935): 1–158; reprinted in a single volume under the title *Die monarchisch Repräsentation im römischen Kaiserreiche* (Darmstadt, 1970).

37. "Die Germania als Sinnbild der kriegerischen Tugend des römischen Heeres," *Germania* 21 (1937): 95–100.

38. See brief biography by Richard Krautheimer, Ihor Sevcenko, and Ernst Kitzinger, *Speculum* 66 (1991): 723–25. I am grateful to Oleg Grabar for sharing his father's autobiographical notes with me.

39. André Grabar, *L'empereur dans l'art byzantin* (Paris, 1936).

40. André Grabar, *Christian Iconography: A Study of Its Origins*, The A. W. Mellon Lectures in the Fine Arts, 1961, The National Gallery of Art, Washington, D. C. (Princeton, 1968). A French translation appeared under the title: *Les Voies de la création en iconographie chrétienne* (Paris, 1979).

41. H. P. L'Orange, *Studien zur Geschichte des spätantiken Porträts,* Instituttet for sammenlignende Kulturforskning B, 22 (Oslo, 1933).

42. Friederich Gerke, "Studien zur Sarkophagplastik der theodosianischen Renaissance," *RQ* 42 (1934): 1–34; *Der Sarkophag des Junius Bassus* (Berlin, 1936), *Christus in der spätantiken Plastik* (Berlin, 1940).

43. Johannes Kollwitz, "Das Bild von Christus dem König in Kunst und Liturgie des christlichen Früzeit," *Theologie und Glaube* (1947–48): 97ff. This spirit animates his earlier *Oströmische Plastik der theodosianischen Zeit* (Berlin, 1941), and *Das Christusbild des dritten Jahrhunderts,* Orbis Antiquus 9 (Münster Westf., 1953).

44. H. P. L'Orange, *Studies on the Iconography of Cosmic Kingship in the Ancient World* (Oslo, 1953). Further see L'Orange's "The Antique Origin of the Medieval Portraiture," in *Acta, Congressus Madvigiani* (Hafniae, 1954) 3: 53–70; *Fra Principat til Dominat* (Oslo, 1958), published in English as *Art Forms and Civic Life in the Late Roman Empire* (Princeton, 1965); *Likeness and Icon: Selected Studies in Classical and Early Medieval Art* (Odense, 1973).

45. Francis Dvornik, *Early Christian and Byzantine Political Philosophy*, 2 vols. (Washington, D. C., 1966).

46. Otto G. von Simson, *Sacred Fortress: Byzantine Art and Statecraft in Ravenna* (Chicago, 1948). For a recent challenge to this thesis, see T. S. Brown, "La chiesa di Ravenna durante il regno di Justiniano," *Corsi di cultura sull' arte ravennate e bizantina* 30 (1983): 23–47.

47. Karl Lehmann, "The Dome of Heaven," *AB* 27 (1945): 1–27.

48. To cite a sampling of the current handbook literature, the following all invoke the "Emperor Mystique": Ekkart Sauser, *Frühchristliche Kunst: Sinnbild und Glaubensaussage* (Munich, 1966), 402–61; Friedrich Gerke, *Spätantike und frühes Christendum,* Kunst der Welt (Baden-Baden, 1967), passim; Gertrud Schiller, *Ikonographie der christlichen Kunst,* 5 vols. (Gütersloh, 1966–90), 3: 165–240; Ernst Kitzinger, *Byzantine Art in the Making,* 39, 42–43, 72–73; Herbert Kessler, "Narrative

Representations," in *Age of Spirituality*, 451–52; F. W. Deichmann, *Einführung in die Christliche Archäologie*, 150–55; Graydon F. Snyder, *Ante Pacem: Archaeological Evidence of Church Life before Constantine* (Macon, 1985), 56; Arne Effenberger, *Frühchristliche Kunst und Kultur von den Anfängen bis zum 7. Jahrhundert* (Munich, 1986), 181–85. See also Beat Brenk, "The Imperial Heritage of Early Christian Art," in *Age of Spirituality*, 39–52; and Josef Engemann, "The Christianization of Late-Antique Art," in *The Seventeenth International Byzantine Congress, Major Papers* (New Rochelle, N. Y., 1986), 83–116.

49. A. Schweitzer, *The Quest for the Historical Jesus: A Critical Study of its Progress from Reimarus to Wrede*, trans. W. Montgomery (New York, 1959).

CHAPTER TWO

1. The substance of this chapter was delivered as a lecture entitled "How Art History Mistook Christ for the Emperor," at the Institute for Advanced Study in Princeton, 11 January 1990.

2. Peter Brown, *The World of Late Antiquity, AD 150–750* (London, 1971), 67.

3. Erich Dinkler, *Der Einzug in Jerusalem: Ikonographische Untersuchungen im Anschluss an ein bisher unbekanntes Sarkophagfragment* (Opladen, 1970), 67.

4. A. Grabar's discussion was seminal, *L'empereur dans l'art byzantin* (Paris, 1936) 234–36; it is restated in summary in *Iconography*, 44–45. Kantorowicz took up the theme in "The King's Advent and the Enigmatic Panels in the Doors of Santa Sabina," AB 26 (1944): 207–31. The most recent extended statements of the Emperor Mystique thesis are Erich Dinkler, *Der Einzug in Jerusalem* and Dagmar Stutzinger, "Der Adventus des Kaisers und der Einzug Christi in Jerusalem," in *Spätantike und frühes Christentum*, Ausstellung

im Liebieghaus Museum alter Plastik (Frankfurt am Main, 1984), 284–307. Summary discussion and bibliography can be found in E. Lucchesi Palli, "Einzug in Jerualem," in Kirschbaum, *Lexikon*, 1: 593–97, and Schiller, *Iconographie*, 2: 28–33.

5. Sabine G. MacCormack, "Change and Continuity in Late Antiquity: the Ceremony of the *Adventus*," *Historia: Zeitschrift für Alte Geschichte* 21 (1972): 721–52. For the study of the *adventus* the treatment by Andreas Alföldi was fundamental, "Die Ausgestaltung des monarchischen Zeremoniells," RM 49 (1934): 88 ff. MacCormack has recently reviewed the rhetorical descriptions of imperial *adventus* in *Art and Ceremony in Late Antiquity* (Berkeley, 1981), but she has left critical questions unanswered, such as who the participants in the ceremony were, in what order the various parts were played out (reception, *adlocutio*, *largitio*, barbarian submission, sacrifice, parade, etc.), and where they took place. More useful in this respect is Michael McCormick, *Eternal Victory: Triumphal Rulership in Late Antiquity, Byzantium and the Early Medieval West* (Cambridge, 1986).

6. Plutarch, *Lives*, VIII: 13. Michael McCormick has called attention to the situations in which people other than emperors were honored with *adventus* in Late Antiquity. "Analyzing Imperial Ceremonies," JOB 35 (1985): 15 and n.47; *Eternal Victory*, 211, 252–58, 330–31.

7. In his *adventus* parade the emperor would not have appeared on horse or on foot; a triumph on horse or on foot was a lesser honor called an *ovatio*, accorded to generals whose accomplishment did not measure up to a full triumph. McCormick suggested that Arcadius was shown on horse in *adventus* on his column in Constantinople (*Eternal Victory*, 50), but this is a misinterpretation according to J. H. W. G.

Liebeschuetz, *Barbarians and Bishops: Army, Church, and State in the Age of Arcadius and Chrysostom* (Oxford, 1990), 273–78.

8. Ammianus Marcellinus, *Res Gestae*, XVI: 10, 6–10, Loeb translation followed except in the last phrase where "figmentum hominis" has been rendered as "a lay figure."

9. Erich Dinkler has listed them in *Der Einzug in Jerusalem*, 18–19 and 27.

10. Sometimes instead of tearing off branches the man in the tree is transformed into Zacchaeus, who in an earlier part of the story climbed a tree to get a view of Christ. Dinkler, *Der Einzug in Jerusalem*, 29 and 53.

11. Three sarcophagi, the so-called Bethesda ones, have arches. Dinkler, *Der Einzug in Jerusalem*, 27.

12. Walter Burkert, *Homo Necans: The Anthropology of Ancient Greek Sacrificial Ritual and Myth*, trans. Peter Bing (Berkeley, 1983), 278.

13. W. R. Farmer, "The Palm Branches in John 12, 13," *Journal of Theological Studies*, n. s. 3 (1952): 62–66; Charles W. F. Smith, "No Time for Figs," *Journal of Biblical Literature* 79 (1960): 315–27; idem, "Tabernacles in the Fourth Gospel and Mark," *New Testament Studies* 9/2 (1963): 130–46; B. A. Mastin, "The Date of the Triumphal Entry," *New Testament Studies* 16/1 (1969): 76–82; *A New Catholic Commentary on Holy Scripture*, ed. Reginald C. Fuller et al. (Nashville, 1969), nos. 732a and 758b.

14. Aeschylus, *Agamemnon*, lines 918–957. See commentary by Eduard Fraenkel, *Agamemnon* (Oxford, 1950), 416–17. Surprisingly enough the far-reaching Fraenkel could find only a single other reference in classical literature to the spreading of materials before a king and that is a reference to flat woven carpets spread for the king of Persia in Herakleides of Kume.

15. Guntram Koch and Helmut Sichter-

mann, *Römische Sarkophage*, Handbuch der Archäologie, Handbuch der Altertumswissenschaft (Munich, 1982).

16. L. von Sybel, *Christliche Antike: Einführung in die altchristliche Kunst Marburg* (Marburg, 1906–1909), 2: 113. For recent bibliography see "Jonah," in *Lexikon*, 2: 414–21.

17. Erich Dinkler, *Der Einzug in Jerusalem*, 46.

18. Friedrich Gerke, *Die christlichen Sakophage der vorkonstantinischen Zeit* (Berlin, 1940), 53, n. 3.

19. For another example of men climbing olive trees, see the sarcophagus from Auletta in the Museo Nazionale, Naples, in Gerke, *Die christlichen Sarkophage*, pl. 13.2. The similar motif of men or putti climbing grapevines is common in Dionysiac sarcophagi.

20. Katherine M. Dunbabin, *The Mosaics of Roman North Africa: Studies in Iconography and Patronage* (Oxford, 1978), 118–21. For other examples see: a third-century grave relief in the Trier Landesmuseum, in *From Pagan Rome to Byzantium*, ed. Paul Veyne, trans. A. Goldhammer, vol. 1 of *A History of Private Life* (Cambridge, Mass., 1987), 271; the mosaics of c. 300 at Piazza Armerina in Sicily, in Gino V. Gentili, *La Villa Erculia di Piazza Armerina* (Milan, 1959), 18, pl. I; the fourth-century mosaic of Centcelles at Costanti in Spain, in Theodor Hauschild and Helmut Schlunk, "Vorbericht über die Arbeiten in Centcelles," MM 2 (1961): 145, fig. 3.

21. A sarcophagus was likely to cost as much as a year's salary of a centurion. On the class that bought sarcophagi, see Koch and Sichtermann, *Römische Sarkophage*, 22–23. Inscriptions identify some of the persons who were ordering sarcophagi in Arles in the second and third centuries, and there is good reason to believe that this pattern continued through the fourth century as well: the wife of a centurion, a *mag-*

ister (general), a *flamen* (priest), a *procurator* (governor), a stone-cutter, a navigator, and a *trierarch* (captain). Paul-Albert Février, "Arles aux IV et V siècles, ville impériale et capitale régionale," *Corsi di cultura sull' arte ravennate e bizantina* 25 (1978): 142.

22. S. Pelekanidis, "Die Malerei der Konstantinischen Zeit," Akten des VII Internationalen Kongresses für Christliche Archäologie, Trier, 1965, *Studi di Antichita Cristiana* 27 (1969) 215–35.

23. See discussion on pages 128–36.

24. The tomb was discovered in April of 1988 during a badly conceived "restoration" of the Theodosian Walls of the city under the direction of Ümit Serdaroğlu, who failed to report the find and left it to be destroyed by vandals. Fragments of the sarcophagi are now in the Istanbul Archaeological Museum.

25. On the status of the philosopher, see Paul Veyne, in *From Pagan Rome to Byzantium*, trans. A. Goldhammer, vol. 1 of *A History of Private Life* (Cambridge, Mass., 1987), 223–29; Peter Brown, "The Philosopher and Society in Late Antiquity," *Center for Hermeneutical Studies in Hellenistic and Modern Culture: Colloquy 34* (Berkeley, 1978), 1–31; R. R. R. Smith, "Late Roman Philosopher Portraits from Aphrodisias," JRS 80 (1990): 127–55, esp. 153–55.

26. Anthony McNicoll, Robert H. Smith, and Basil Hennessy, *Pella in Jordan 1: An Interim Report on the Joint University of Sydney and The College of Wooster Excavations at Pella 1979–1981*, pp. 88–101 and pl. 27a.

27. Jaroslav Pelikan, *The Christian Tradition, A History of the Development of Doctrine* vol. 1, *The Emergence of the Catholic Tradition (100–600)* (Chicago, 1971), p. 126.

28. Wolfgang F. Volbach, *Elfenbeinarbeiter der Spätantike und des frühen Mittelalters*, 2nd ed. (Mainz, 1952), 70–72.

29. Robert F. Taft, *The Great Entrance, A History of the Transfer of Gifts and other Pre-*

anaphoral *Rites of the Liturgy of St. John Chrysostom, Orientalia Christiana Analecta* no. 200 (Rome, 1975), pp. 53–118.

30. For example, G. Millet, *Recherches sur l'iconographie de l'évangile* (Paris, 1916); E. Lucchesi-Palli, "Einzug in Jerusalem," in Kirschbaum, *Lexikon*, 1: 593–97; Schiller, *Ikonographie*, 2: 28–33.

31. Hans Gerstinger, *Die Wiener Genesis* (Vienna, 1931), 23. Notice also that in the parable of the Good Samaritan, in the Rossano Gospel, the disabled robbery victim is placed side-saddle on the ass. Antonio Munoz, *Il Codice Purpureo di Rossano* (Rome, 1907), pl. 12.

32. See examples in *Die Römer an Mosel und Saar*, ed. Heinz Cüppers et al. (Mainz, 1983), 119–21.

33. Charles W. F. Smith, "The Horse and the Ass in the Bible," *Anglican Theological Review* 27/2 (April 1945): 86–97.

34. Chrysostom, *Homily 66 on Matthew*, chap. 2.

35. The ass in these Dionysiac scenes, however, is always male and often ithiphallic, while Christ's is always female, following the Gospel story. The she-ass in Old Testament literature is reserved for dignitaries to ride on. Charles W. F. Smith, "The Horse and the Ass": 94.

36. See the lengthy article by H. Leclercq, "Ane," DACL, 1: 2041–68.

37. Antonio Ferrua, *Catacombe sconosciute: una pinacoteca del iv secolo sotto la Via Latina* (Florence, 1990).

38. Irenaeus, *Fragments*, XXIII, ANF, 1, 572.

39. H. W. Janson, *The Sculpture of Donatello*, 2 vols. (Princeton, 1957), 2: 170–81.

40. The inscription reads, "Dominus Noster Jesus Christus Dei Filius." H. Leclercq, DACL, 1: col. 2064.

41. Wolfgang Helbig, *Führer durch die öffentlichen Sammlungen klassischer Altertümer in Rom*, rev. ed., ed. Hermine Speier

(Tübingen, 1966), 861–63. See other ass-headed Christs in Leclercq, DACL, 1: col. 2041–47, and Sergio Bettini, "Un crocifisso amuleto onocefalo scoperto a Montagnana," *Nuovo Didaskaleion* 1 (1947): 60–70.

42. John J. Gager, *The Origins of Antisemitism* (New York, 1983), 46 and 79.

43. Morton Smith, *Jesus the Magician* (San Francisco, 1981), 62–63.

44. Rowan Williams, "Arianism," in *Encyclopedia of Early Christianity*, 84–89; R. P. C. Hanson, *The Search for the Christian Doctrine of God: The Arian Controversy 318–381* (Edinburgh, 1988).

45. E. A. Thompson, *The Visigoths in the Time of Ulfila* (Oxford, 1966).

46. *Dialogus adversus Luciferianos*, 19, PL, 23, 181C.

47. Leslie L. B. MacCoull, "Redating the Inscription of El-Mouallaqa," *Zeitschrift für Papyrologie und Epigraphik* 64 (1986), 232.

48. M. Sacopoulo, "Le Linteau copte dit l'al-Moallaka: CA (1957), 99–115; Athanasius, *Discourse against the Arians*, PG, 26, 332–33.

CHAPTER THREE

1. See the child's sarcophagus in the Campo Santo Teutonico Erich Dinkler, *Einzug*, fig. 6.

2. See the Lateran Jonah sarcophagus Friedrich Gerke, *Die christlichen Sarkophage der vorkonstantinischen Zeit* (Berlin, 1940), pl. I, 1.

3. Martine Dulaey, "Le symbole de la baguette dans L'art paleochrétien," *Revue des études augustiniennes* 19, 1–2 (1973): 3–38.

4. See the Diptych of Museo Nazionale, Ravenna; Throne of Maximianus, Museo Archivescovile, Ravenna; Pyxis of the Musée Cluny, Paris; Schiller, *Iconography*, 1: figs. 424, 468, 508, 561.

5. For Circe, see *Odyssey* X: 293, 388; Virgil, *Aeneid*, VII: 189–91; Ovid, *Metamorphoses*, XIV, 278, 413. Mercury has two rods, one the *caduceus* which is the messenger's staff and the other the wand with which he conducts the dead; for the latter see *Odyssey*, XXIV: 1ff; Virgil, *Aeneid*, IV: 242ff; Prudentius, *Contra Symmachum*, I: 89–91. Cf. H. Leclercq, "Baguette," DACL, 2: 69–70. A series of "philosophers" carrying wands appears in the third-century Hypogaeum of the Aurelii in Rome, but their interpretation is problematical because apart from Christian representations of "magicians" (Moses, Elijah, Peter, Christ) there are no parallels. N. Himmelmann proposes that they are miracle workers of some sect of "irrational philosophy." "Das Hypogäum der Aurelier am Viale Manzoni: Ikonographische Beobachtungen," in *Akademie der Wissenschaften und der Literatur*, Abhandlungen der Geistes und Sozialwissenschaftlichen Klasse, 7 (Mainz, 1975), 17.

6. Giovanni Previtali, *Giotto e la sua bottega* (Milan, 1967), 347–48.

7. Asterius of Amasia, *Homily*, I, PG, 40, 165–68, translated in Cyril Mango, *The Art of the Byzantine Empire, 312–1453, Sources and Documents* (Englewood Cliffs, 1972), 51.

8. For a representative selection of this material, see *The Age of Spirituality*, passim.

9. Morton Smith, *Jesus the Magician* (New York, 1978). A brief article by Claudia Nauerth approaches the miracles from a kind of semiotic point of view, asking what are the minimal gestures and props necessary to convey each miracle story. "Heilungswunder in der frühchristlichen Kunst," in *Spätantike und frühes Christentum*, 339–46. L. De Bruyne's older article, "L'imposition des mains dans l'art chétien ancien, Contribution iconologique à l'histoire du geste," RAC 20 (1943): 113–266

(esp. 129–74) took an equally narrow approach, reading the miracles in a Catholic sacramental sense as "ritual" gestures. The tendency in contemporary literature is to launder the magic out of the miracle scenes and make them into pale allegories of "deliverance." See, for example, G. F. Snyder, *Ante Pacem: Archaeological Evidence of Church Life before Constantine* (Macon, Ga, 1985), 55–56, 59–61. I have found the articles on individual miracle subjects in DACL very helpful.

10. *Age of Spirituality*, 439. Dinkler-von Schubert is not the first to make this suggestion; there is a long history to this thesis in connection with a passage in Eusebius, *Ecclesiastical History*, VII, in which the author describes a bronze statue group in Pineas, Palestine, which represented Christ and the woman. For this bibliography, see H. Leclercq, "Hémorroïsse," DACL, 6: 2200–2209.

11. On the Jewish attitude, see Mishnah, *Niddah*, 1:1–2:4; for Christian legislation, see Dionysius of Alexandria, *Epistle to the Bishop Basilides*, canons II and IV; both passages are found in Ross S. Kraemer, *Maenads, Martyrs, Matrons, Monastics: A Sourcebook on Women's Religions in the Greco-Roman World* (Philadelphia, 1988), 43–47. Jewish and Christian attitudes toward menstruation, along with the exegesis of this miracle, are reviewed in Marla J. Selvidge, *Woman, Cult, and Miracle Recital: A Redactional Critical Investigation on Mark 5:24–34* (London, 1990).

12. Grabar, *Iconography*, 32–33.

13. For a listing of the miracles that Christ works by touch, see L. De Bruyne, RAC 20 (1943): 129–74.

14. Gary Vikan, "Art, Medicine and Magic in Early Byzantium," DOP 38 (1984): 65–86; Eunice Dauterman Maguire and Henry Maguire, *Art and Holy Powers* (Chicago, 1989), 3–9, 18–33, 197–219; James Russell, "The Evil Eye in Early By-

zantine Society: Archaeological Evidence from Anemurium in Isauria," XVI Inter. Byz. Cong. Akten=JÖB 32, 3 (1982): 539–48.

15. The terms "magic" and "magician" I would like to use in the common senses that they were given in Late Antiquity, applying to rites and formulae employed to produce supernatural effects, whether benevolent or malicious, and applying equally to works of Christ and his pagan and Jewish adversaries. I am prescinding, therefore, from the sticky philosophical problem of whether magic should be regarded as a "decomposition or decay" of religion, as maintained by A. A. Barb, "The Survival of Magic Arts," in *The Conflict between Paganism and Christianity in the Fourth Century*, ed. Arnaldo Momigliano (Oxford, 1963), 100–125; or whether it is simply a disparaging way of referring to "the other fellow's religion," as in Jacob Neusner, "Introduction," in *Religion, Science, and Magic: in Concert and in Conflict* (New York, 1989), 12.

16. "Magic" is ultimately a loan word from Persian, in which "magus" denoted a member of the priestly cast.

17. H. Leclercq, "La Magie," DACL, 10: 1067–1114.

18. "Of all the Greek gods it was Asclepius who kept his hold over the people by far the longest. When the Oriental religions had almost completely superseded the Greek and Roman cults, Asclepius was still a powerful deity." Emma J. Edelstein and Ludwig Edelstein, *Asclepius: A Collection and Interpretation of the Testimonies*, 2 vols. (Baltimore, 1945), 2: 110. On the rivalry between Christ and Asclepius see 2: 132–38. See also Antje Kruge, *Heilkunst und Heilkult, Medizin in der Antike*, Archäologische Bibliotek series (Munich, 1985), 120–87; "None of the fading ancient gods dedicated himself with such exclusivety to the individual person, his cares and his

feelings. Beyond the narrow range of a strictly single-purpose divinity, he was the one who confronted the changing needs of the individual." Ibid., 121.

19. Julian, *Contra Galilaeos*, 235 C.

20. Edelstein, *Asclepius*, 1: 251.

21. Ibid., 237.

22. See especially Pliny, *Natural History*, XXVIII to XXX.

23. Libanius, *Orat.* I: 244; A. F. Norman, *Libanius' Autobiography* (London, 1965), 127.

24. John G. Gager, *The Origins of Anti-Semitism: Attitudes towards Judaism in Pagan and Christian Antiquity* (New York, 1983), 118ff. On the situation in Antioch, see Robert L. Wilken, *John Chrysostom and the Jews: Rhetoric and Reality in the Late Fourth Century* (Berkeley, 1983).

25. John Chrysostom, *Sermon*, VIII: 5–8.

26. The fourth century witnessed a number of sensational witchcraft trials. See recent discussion by Peter Brown, "Sorcery, Demons and the Rise of Christianity: from Late Antiquity into the Middle Ages," in *Witchcraft Confessions and Accusations*, Association of Social Anthropologists Monographs, 9 (1970), 17–45, repr. *Religion and Society in the Age of Saint Augustine* (New York, 1972), 119–46.

27. Origen, *Contra Celsum*, I: 68; cf. Morton Smith, *Jesus the Magician* (San Francisco, 1978), 82–83.

28. Origen, *Contra Celsum*, I: 68; II: 51. In the latter passage Origen supports faith in Christ's miracles by an a fortiori argument from belief in the magic of sorcerers.

29. Origen, *Contra Celsum*, I: 67; also I: 6,: "The name of Jesus is so powerful against the daemons that sometimes it is effective even when pronounced by bad men."

30. Chuvin, *A Chronicle of the Last Pagans*, 128.

31. Lactantius, *Divine Institutes*, V: 3,9;

Eusebius, *Against Hierocles;* Morton Smith, *Jesus the Magician*, 89–91.

32. *Scriptores Historiae Augustae*, Alex. Sev., 29, 2. See Ernst von Dobschutz, *Christusbilder* (Leipzig, 1899), 28.

33. Richter, *Portraits of the Greeks*, 3: 284.

34. A few reliefs from the fifth and fourth centuries B.C. show Asclepius in the act of curing his clients, but this genre of narrative scene was not continued. Bernard Holtzmann, "Asclepios," in *Lexicon Iconographicum Mythologiae Classicae*, vol. 2. 1 (Zurich, 1984).

35. John Scarborough, *Roman Medicine* (Ithaca, 1969), figs. 37, 47, 48.

36. John G. Gager, *Moses in Greco-Roman Paganism* (Nashville, 1972), 21.

37. Ibid., 77–78.

38. Janine Bourriau, *Pharaohs and Mortals: Egyptian Art in the Middle Kingdom* (Cambridge, 1988), 110–16.

39. The latest survey of this material is by Clementina Rizzardi, *I sarcofagi paleocristiani con rappresentazione del passaggio del Mar Rosso*, Saggi d'arte e d'archeologia dell'istituto de Antichità ravennati e bizantine dell' università degli studi di Bologna, 2 (Faenza, 1970).

40. Except for the fresco of the Synagogue of Dura Europus of A.D. 245 which is a very different composition, there are no surviving manuscript or monumental representations of the Crossing of the Red Sea that are earlier in date than the fifth century. Lassus thought the model must have been in "oriental" manuscripts; Wessel in Roman illuminations; Rizzardi in catacomb paintings. Jean Lassus, "Quelques représentations du 'Passage de la Mer Rouge' dans l'art chrétien d'orient et d'occident," *Mélanges d'archéologie et d'histoire* 46 (1929): 159–81. Kurt Wessel, "Durchzug durch das Rote Meer-Kunst," *RAC* 4, 385–90. Clementina Rizzardi, op. cit., 135.

41. E. Becker, "Konstantin der Grosse, der 'neue Moses,' Die Schlacht am Pons

Milvius und die Katastrophe am Schilf-meer," *Zeitschrift fur Kirchengeschichte* 3 (1910): 161–71; idem, "Protest gegen den Kaiserkult und die Verherrlichung des Sieges am Pons Milvius in der christlichen Kunst der konstantinischen Zeit," in *Konstantin der Grosse und seine Zeit*, ed. F. J. Dölger (Freiburg im Breisgau, 1913), 155–90.

42. A. Weckwerth, "Durchzug durch das Rote Meer," *Lexikon*, 1: 556; MacCormack, *Art and Ceremony in Late Antiquity*, 38.

43. Eusebius, *Eccl. Hist.*, IX: 9, 1–10.

44. On the arch, Constantine stands on the left surrounded by three gods—Roma, Victory, and the Tiber River—and he watches his troops charge before him from left to right over the bank, driving the troops of Maxentius into the river. The defeated emperor does not appear. On the Christian sarcophagi, the Pharaoh, moving from left to right, rides to his doom on a chariot surrounded by his troops, while Moses and his people escape unarmed to the right. H. P. L'Orange, *Der Spätantike Bildschmuck des Konstantinsbogens*, Studien zur spätantiken Kunstgeschichte, 10 (Berlin, 1939/78), 1: 65–71.

45. Marion Lawrence, "City-Gate Sarcophagi," AB 10 (1927): 20–23; Theodor Klauser, *Frühchristliche Sarkophage in Bild und Wort*, Beiheft Antike Kunst no. 3 (Olten, 1966), 80–82.

46. See the many citations in Jean Danielou, *The Bible and the Liturgy* (Notre Dame, 1956), 86–98. To Christians, starting with St. Paul (1 Cor 10:2–6), the deliverance of Israel was an event of enormous symbolic importance. The explanation of the Syrian author Aphraates is typical of patristic commentaries on the event: "The Jews escaped at the Pasch from the slavery of Pharaoh; on the day of the crucifixion, we were freed from the captivity of Satan. They immolated the lamb and were saved by its blood from the Destroyer; we, by the

blood of the well beloved Son, are delivered from the works of corruption that we have done. They had Moses for a guide; we have Jesus for our head and Savior. Moses divided the sea for them and had them cross it; our Lord opened hell and broke its gates, when he went down into its depths and opened them and marked out the path for those who come to believe in him." Aphraates, *Demonstrations*, XII: 8.

47. Carl H. Kraeling, *The Excavations at Dura-Europos: The Synagogue* (New Haven, 1956), pls. LII-LIII.

48. See the six sarcophagi identified by Clementina Rizzardi as belonging to the decade 320–30 (her catalogue numbers 10, 12, 17, 18, 24, and 27), *I sarcofagi paleocristiani con rappresentazione del passagio del Mar Rosso*.

49. Origen, *Contra Celsum*, I: 45.

50. Marie Panayotidi and André Grabar, "Un reliquaire paléochrétien récemment découvert près de Thessaloniki," CA 24 (1975): 33–42.

51. For other examples of the "fourth man" with his wand see the S. Nazaro reliquary and the ivory diptych of Murano Volbach, *Early Christian Art*, pls. 114 and 223. Also the icon of the "Three Young Men" at Catherine's on Mt. Sinai George and Maria Soteriou, *Eikones tes Monis Sina* (Athens, 1956), 1: pls. 12–13.

52. B. Ott, "Jünglinge, Babylonische," *Lexikon*, 11: 464–66; Max Wegner, "Das Nabuchodonosor-Bild: Das Bild im Bild," *Pietas, Festschrift für Bernhard Kötting*, ed. E. Dassmann and K. Suso-Frank (Münster-Westfalen, 1980), 528–38.

53. That the cult of the emperor was specifically the test of loyalty that was administered to Christians is witnessed by Pliny the Younger's famous *Letter*, X: 96, to Trajan, and by Tertullian's account in *Apologeticum*, 10.

54. H. Leclercq, "Hébreux, Les trois jeunes," DACL, 6: 2107–26.

55. Johannes G. Deckers, "Die Huldigung der Magier in der Kunst der Spätantike," in *Die Heiligen Drei Könige, Darstellung und Verehrung* (Cologne, 1982), 20–32. For earlier statements of the imperial theme in connection with the Magi, see Grabar, *Iconography*, 44–45, and Schiller, *Ikonographie*, 1: 105–24.

56. G. M. A. Richter, *The Furniture of the Greeks, Etruscans and Romans* (London, 1966), 101 and figs. 506–507.

57. Ibid., 104–105.

58. Franz Cumont, "L'adoration des Mages et l'art triomphal de Rome," *Memorie Pont. Accad. Rom. di Archeologia* 3 (1932–1933): 81–105.

59. John B. Friedman, *Orpheus in the Middle Ages* (Cambridge, Mass., 1970); H. Leclercq, "Orphée," DACL, 12: 2735–55.

60. L. A. Campbell, *Mithraic Iconography and Ideology* (Leiden, 1968).

61. Origen, *Against Celsus*, I, 60.

62. *A New Catholic Commentary on Holy Scripture*, ed. Reginald C. Fuller et al. (Nashville, 1969), 908, sect. 713e.

63. For use of frankincense and myrrh in potions, see *Papri Graecae Magicae*, IV: 1265–74, 1830–35, 1990–95, in *The Greek Magical Papyri in Translation, Including the Demotic Spells*, trans. Hans Dieter Betz (Chicago, 1986), 62, 71, 73, and elsewhere.

64. *Papyri Graecae Magicae*, IV: 1815 and VII: 920, in Betz, 70 and 142.

65. Paul, too, did battle with magicians in Acts 13:6–12, 19:13–20.

66. Edgar Hennecke, *New Testament Apocrypha*, ed. Wilhelm Schneemelcher, trans. R. McL. Wilson (Philadelphia, 1964), 2: 276–322.

67. Jacopo Grimaldi, *Descrizione della Basilica Antica di San Pietro: Codex Barb. Lat 2733*, ed. Reto Niggi (Vatican City, 1972), fig. 38.

68. Manuel Sotomayor, *S. Pedro en la Iconografia Paleocristiana* (Granada, 1962). The usual explanation for the choice of this miracle is its baptismal symbolism. But why choose so obscure a baptismal story when there are the solid scriptural accounts of Peter baptizing the Ethiopian eunuch and Cornelius the centurion, in Acts 8:26–40, 10:47–48? Clearly it was important to show Peter using his magical wand.

69. André Piganiol, *L'Empire Chrétien (325–395)*, 2nd ed., ed. André Chastagnol (Paris, 1972), 295, 298.

70. Athanasius, *Historia Arianorum*, chap. 44.

71. Gregory Nazianzus, *Oration 20* on St. Basil the Great.

72. Ambrose, *Epistle*, 17.

73. André Piganiol, *L'Empire Chrétien (325–395)*, 283–84.

74. George Huntston Williams, "Christology and Church State Relations in the Fourth Century," *Church History* 20 (1951): no. 3, 3–33; no. 4, 3–46; Glen W. Bowersock, "From Emperor to Bishop: The Self-Conscious Transformation of Political Power in the Fourth Century," *Classical Philology* 80 (1986): 298–307; Arnaldo Momigliano, "The Disadvantages of Monotheism for a Universal State," in *On Pagans, Jews and Christians* (Middletown, 1987), 142–58.

CHAPTER FOUR

1. Much of this chapter was delivered as a lecture, called "The Alleged Imperial Derivation of the Apse Mosaic of Santa Pudenziana," at a conference in Rome entitled *Rome: Tradition, Innovation, Renewal* on 13 June 1987.

2. For the public participation in the liturgy of Rome, see Mathews, "An Early Roman Chancel Arrangement and Its Liturgical Uses," *Rivista di Archeologia Christiana* 38 (1962): 71–95; for Constantinople see Mathews, *The Early Churches of Con-*

stantinople: Architecture and Liturgy (University Park, 1971).

3. On the cult of the dead in the churches of Rome see Joseph Alchermes, *Cura pro mortuis and Cultus martyrum: Commemoration in Rome from the Second through the Sixth Century* (Ph.D. diss., N.Y.U., 1988).

4. On the materials of Early Christian mosaics see H. P. L'Orange and P. J. Nordhagen, *Mosaics*, trans. Ann E. Keep (London, 1966), 33–65. The Romans called floor mosaics *opus tessalatum*, while wall mosaics they called *opus musivum*, because of its common use to decorate fountains or shrines to the muses.

5. Christa Ihm, *Die Programme der christlichen Apsismalerei vom vierten Jahrhundert bis sur Mitte des achten Jahrhunderts*, Forschungen zur Kunstgeschichte und christlichen Archäologie, 4 (Wiesbaden, 1960). A similar approach is taken in Schiller's section on "Der Erhöhte Christus," in *Ikonographie*, 3: 165–249.

6. A date between 387 and 398 is based on the original dedicatory inscription found in St. Paul's book; a later inscription of Pope Innocent (401–417) may have referred to some further embellishment of the church. For the epigraphical evidence, see Renzo U. Montini, *Santa Pudenziana*, Le chiese di Roma illustrate (Rome, 1959).

7. Giovanni Battista de Rossi, "I monumenti del secolo quarto spettanti alla chiesa di S. Pudenziana," *Bolletino di archeologia cristiana* 5 (1867): 49–60; Wilhelm Köhler, "Das Apsismosaik von Sta. Pudenziana in Rom als Stildokument," *Forschungen zur Kirchengeschichte und zur christlichen Kunst* (1931), 167–79. See also Gulielmo Matthiae, *Mosaici medioevali delle chiese di Roma* (Rome, 1967), 55–76. Matthiae also discusses the most recent restoration of the mosaic in "Restauri: il mosaico romano di Sta. Pudenziana," *Bolletino d'arte* 31, 3 (1938): 418–25; For an excellent tessera-by-tessera color reproduction see Josef

Wilpert, *Die römische Mosaiken und Malereien der kirchlichen Bauten vom IV bis XII Jahrhundert*, 4 vols. (Freiburg im Breisgau, 1917), 3: pls. 42–44. On the right hand side only the section from the head of Peter to the lower half of the symbol of Luke can be guaranteed as original. On the left, Paul's head and shoulders and the woman and apostle behind him are intact while the other apostles, though old, are heavily restored; in the background above, the round building and its flanking wings and most of the sky and two evangelists' symbols are original. The figure of Christ has been restored in a patch-work fashion that has affected the nose, mouth, and beard, the drapery over his right arm and right knee. All of the right side of the throne (i.e., viewer's right) is new, but the back of Christ's throne and the mountain and cross behind it are original. The most recent loss in the mosaic was occasioned by the building of the present altar in 1711 destroying a section beneath Christ's feet containing the monogram of Adrian I (added 771–95), the dove, and the Lamb of God on a hillock of Paradise from which the four rivers flowed.

8. Ihm, *Apsismalerei*, 12–15.

9. Grabar, *L'Empereur*, 196–97, 207–8.

10. Grabar, *Iconography*, 71–72.

11. Ibid., 79.

12. Yves Christe, "Gegenwärtige und endzeitliche Eschatologie in der frühchristlichen Kunst: Die Apsis von Sancta Pudenziana in Rom," *Orbis scientiarum: Versuch über historische Interpretation* 2, 1 (1972): 47–60. Though their emphases may differ, others follow the same overall lines of interpretation. Dassmann proposed to integrate the various kinds of content by seeing them as "layers": a philosophical layer in the composition of Christ as teacher; an imperial layer in his ruler's attributes; and an apocalyptic layer in the four beasts and the lambs. E. Dassmann,

"Das Apsismosaik von S. Pudentiana in Rom," *Römische Quartalschrift* 65, 1–2 (1970), 67–81. Matthiae also acknowledges various layers of meaning in the image, but affirms that "Il Cristo grandeggiante e frontale, seduto sul trono è desunto da immagini di imperatori." Matthiae, *Mosaici*, 64; see also 56–57. Ernst Kitzinger refers to "Christ enthroned in imperial splendour." *Byzantine Art in the Making: Main Lines of Stylistic Development in Mediterranean Art, 3rd–7th Century* (Cambridge, Mass.,1980), 42. Geir Hellemo describes Christ as a sovereign sitting on an emperor's throne. *Adventus Domini: Eschatological Thought in 4th-century Apses and Catechesis*, trans. E. R. Waaler (Leiden, 1989), 41–63.

13. Andreas Alföldi, "Insignien und Tracht der römischen Kaiser," RM 50 (1935): 19–22, 38–41; M. Mau, "Diadema," *Paulys Realencyclopädie*, 5: 303–35.

14. Alföldi, "Insignien," 57–59.

15. Matthiae, *Mosaici*, 56.

16. See extensive discussion of pre-Christian use of the halo in Marthe Collinet-Guérin, *Histoire du Nimbe des origines aux temps modernes* (Paris, 1961); also Alföldi, "Insignien," 50 (1935), 139–45; W. Weidle, "Nimbus," *Lexikon*, 3: 323–32. On the emperor's divine aspirations see Alföldi, "Insignien," 68–95.

17. L. de Ronchaud, "Aurum," *Dictionnaire des Antiquités grecques et romaines*, ed. C. Daremberg (Paris, 1877), 1: 574–78.

18. Matthiae, *Mosaici*, 56.

19. The colors are faithfully reproduced in Josef. Wilpert, *Römischen Mosaiken*, 3: pls. 42–44.

20. M. Kübler, "Sella curulis," in *Paulys Realencyclopädie*, 2A, 2, 1310–15. Ole Wanscher, *Sella Curulis, the Folding Stool, an Ancient Symbol of Dignity* (Copenhagen, 1980); Thomas Schäfer, *Imperii Insignia, Sella Curulis und Fasces, zur Repräsentation Römischer Magistrate*, Mitteilungen des Deutschen Archäologischen Instituts Römische Abteilung, 29 (Mainz, 1989).

21. Henri Stern, *Le Calendrier de 354* (Paris, 1953), 154.

22. Four silver gilt figures made to fit on the ends of the perpendicular rail of a sella curulis survive in the British Museum, London. They represent not Victories but the great cities of Rome, Constantinople, Antioch, and Alexandria. Jocelyn M. C. Toynbee, "Roma and Constantinopolis in Late Antique Art from 312 to 365," JRS 37 (1947): 135–44.

23. Corippus, *In laudem Justini*, III: 194–203, ed. Averil Cameron (London, 1976), 66–67. See translation on 106 and note on 188. The description is quite orderly: l. 194 is transitional; ll. 195–198 describe the canopy; ll. 199–203 describe the seat itself. The seat is first referred to as "sedes" and later as "solium," a loose usage of the latter word.

24. G. M. A. Richter, *The Furniture of the Greeks, Etruscans, and Romans* (London, 1966), 13–33, 85–89, 98–101, and accompanying figures.

25. I know of only two exceptions to this rule and neither could have been well known in antiquity. The first is a headless porphyry statue in Alexandria showing a togate emperor in a bejewelled high-backed throne with straight legs. Richard Delbrueck, *Antike Porphyrwerke* (Berlin, 1932), 96–98 and pls. 40–41. This, Delbrueck supposed, is a cultic image of Diocletian intended for the cella of a temple dedicated to the imperial cult. The other example is a medallion commemorating the founding of Constantinople on which Constantine sits in a high-backed throne holding a sceptre while his sons stand on either side. Jocelyn M. C. Toynbee, *Roman Medallions*, repr. with introduction by William E. Metcalf (New York, 1986), 175 and 179, pl. XXXIX, 1–3. Medallions

by their very nature were of restricted circulation.

Literary evidence for the emperor's use of a proper throne is also very slight. Alföldi found four references to the emperor's use of a *basileios thronos*, "kingly throne" in the historian Herodianus. Alföldi, "Insignien," 125–126. But the historian gives no details about the appearance of the seat in question, and the use of the term *thronos* by itself is no more iron-clad than that of the Latin equivalent *solium*; the latter could be extended to designate a *sella curulis*, as in Corippus or earlier in Claudianus, when the seat was especially ornate. Corippus, *In laudem Justini*, III: 198, ed. Cameron, 66; Claudianus, *De Consulatu Stilichonis*, III, 199, Loeb Classical Library series, ed. and trans. Maurice Platnauer (London, 1922), 2: 56.

26. Alföldi, "Die Ausgestaltung des monarchischen Zeremoniells am römischen Kaiserhofe," RM, 49 (1934): 1–118. See also Otto Treitinger, *Die oströmische Kaiser- und Reichidee nach ihrer Gestaltung im höfischen Zeremoniell* (Darmstadt, 1956), 94–96.

27. Libanius, *Orationes*, XVIII: 154.

28. George M. A. Hanfmann, "Socrates and Christ," *Harvard Studies in Classical Philology* 60 (1951): 205–33; Klaus Döring, *Exemplum Socratis: Studien zur Sokrates-nachwirkung* (Wiesbaden, 1979), 143–61.

29. Antonio Ferrua, *Catacombe sconosciute* (Florence, 1990) fig. 111.

30. Hans Gerstinger, *Diosorides, Codex Vindobonensis med. gr. 1* (facsimile), fol. 2v and 3v.

31. R. R. R. Smith, "Late Roman Philosopher Portraits from Aphrodisias," JRS 80 (1990): 127–55.

32. These philosophers were discovered by Dimitris Pandermalis of the University of Thessalonica, who is preparing their publication.

33. *Codex Theodosianus*, XIII: 3, 5. See

Glen W. Bowersock, *Julian the Apostate* (London, 1978), 83–84.

34. Mathews, *The Early Churches of Constantinople, Architecture and Liturgy,* (University Park, 1971). The parallel between the mosaic and the clergy below was noted by Guglielmo Matthiae, *Mosaici medioevali delle chiese di Roma* (Rome, 1967), 56.

35. For patristic references to the faithful as lambs or sheep see H. Leclercq, "Agneau," DACL, 1: 877–905.

CHAPTER FIVE

1. For a selection of these stories, see Cyril Mango, *The Art of the Byzantine Empire, 312–1453, Sources and Documents* (Englewood Cliffs, 1972), passim.

2. Ignatius the Monk, "Edifying narrative concerning the image of Our Lord Jesus Christ in the likeness of a man at the Stonecutters' Monastery in Thessalonica," first published in A. Papadopoulos-Keramis, "Varia Graeca Scripta," *Zapiski istor.-filol. Fakult. Imp. S. Petersburg Univ.* 95 (1909): 102–13. Partial English translation by Cyril Mango in *The Art of the Byzantine Empire*, 155. Judging from its reference to iconoclasm, the story seems to belong to the period after the restoration of icons in the ninth century.

3. Richard Krautheimer and Slobodan Ćurčić, *Early Christian and Byzantine Architecture,* rev. 4th ed. (Harmondsworth, 1986), 239–41.

4. Many of the features of Ezekiel's vision (Ez 1:4–28) are repeated in the visions of Isaiah and John (Is 6:1–4; Rv 4:2–9); the river argues for an identification of the Blessed David mosaic with Ezekiel's vision, and the legend so interprets it.

5. F. Van der Meer, *Maiestas Domini, Théophanies de l'apocalypse dans l'art chrétien* (Rome, 1938); Schiller, "Majestas Domini," *Ikonographie*, 3: 233–49; Annemarie

Weyl Carr, "Majestas Domini," in ODB, 1269–70.

6. Although its date was widely debated when it was first discovered, scholars are now content with placing it in the mid-fifth century. Volbach, *Early Christian Art*, 337; Ihm, *Die Programme der christlichen Apsismalerei*, 183.

7. Ihm, *Die Programme der christlichen Apsismalerei*, passim; Sirarpie Der Nersessian, *Armenian Art* (Paris, 1978), 69–72.

8. For the use of the *imago clipeata* in Roman art, see Johannes Bolten, *Die Imago Clipeata: Ein Beitrag zur Porträt- und Typengeschichte,* Studien zur Geschichte und Kultur des Altertums, 21/1 (Paderborn, 1937); R. Winkes, *Clipeata Imago: Studien zu einer römischen Bildnisform* (Bonn, 1969); R. R. R. Smith, "Late Roman Philosopher Portraits from Aphrodisias," JRS 80 (1990): 131. For its alleged connection to the Christian mandorla, see G. W. Elderkin, "Shield and Mandorla," *American Journal of Archaeology* 42 (1938): 227–36; O. Brendel, "Origin and Meaning of the Mandorla," *Gazette des Beaux Arts* 25 (1944): 5–24; A. Grabar, "L'imago clipeata chrétienne," *L'art de la fin de l'antiquité et du moyen age* (Paris, 1968), 1: 607–13.

9. See my discussion of the mandorlas in the Ejmiatsin and Rabbula Gospels, "The Early Armenian Iconographic Program of the Ejmiacin Gospel," in *East of Byzantium*, ed. Nina G. Garsoïan et al. (Washington, D. C.,1982), 208.

10. For examples, see *Along the Ancient Silk Routes: Central Asian Art from the West Berlin State Museums* (New York, 1982). On the meaning of the aureole in Buddhist art, see A. C. Soper, "Aspects of Light Symbolism in Gandharan Sculpture," *Artibus Asiae* 12 (1949): 252–83, 314–30, 13; (1950), 63–85.

11. J. M. Rosenfield, *The Dynastic Arts of the Kushans* (Berkeley, 1967), 253–58.

12. Antonio Ferrua, " 'Qui filius diceris

et pater inveneris' mosaico novellamente scoperto nella catacomba di S. Domitilla," *Atti della Pontificia Accademia Romana di Archeologia, Rendiconti* 33 (1960–61): 209–24. The mosaic had been discovered in 1742, but was subsequently lost.

13. Imperial claims for the imagery can be found in Grabar, *Iconography*, 44; James Snyder,"The Meaning of the 'Maiestas Domini' in Hosios David," *Byzantion* 37 (1967): 143–152; Schiller, "Die Majestas Domini," *Ikonographie*, 3: 233–36.

14. The discovery is recounted in Charles Diehl, "Une mosaique byzantine de Salonique," *Comptes rendus de l'Académie des inscriptions et belles-lettres* (1927): 256–61, and in V. Grümel, "Dieu Sauveur au monastère du 'Latome' à Salonique," *Echos d'Orient* 33, 158 (April-June 1930): 157–75.

15. Leo Steinberg, *The Sexuality of Christ in Renaissance Art and in Modern Oblivion* (New York, 1983).

16. Carolyn W. Bynum, *Holy Feast and Holy Fast: The Religious Significance of Food to Medieval Women* (Berkeley, 1987).

17. By exception Friedrich Gerke made careful observation of Christ's hair styles, *Christus in der spätantiken Plastik* (Mainz, 1948). Gerke distinguished three styles in Constantinian and immediately post-Constantinian images of Christ, an heroic style, a style dependent on personifications of the four seasons, and a style of *Christus puer* or the boy Christ. The "heroes" he found for the first comparison were the companions of Hippolytus, hardly types of manly courage. In the seasons he established a convincing Dionysiac link. But what he called the "Christus puer" type does not represent Late Antique boys' hair but a copious adolescent hair.

18. Rolf Hurschmann, "The Ancient World," in *Hairstyles: A Cultural History of Fashions in Hair from Antiquity up to the Present Day*, ed. Maria Jedding-Gesterling (Hamburg, 1988); Alessandro Manoni, *Il*

Costume e l'arte delle acconciature nell' antichità (Milan, 1895).

19. Volbach, *Early Christian Art*, pls. 54–55.

20. For a recent review of emperor's portraits see Marianne Bergmann, "Zum römischen Porträt des 3. Jahrhunderts n.Chr.," and Urs Peschlow, "Zum Kaiserporträt des 4. bis 6. Jh. n.Chr.," in *Spätantike und frühes Christentum* (Frankfurt am Main, 1984), 41–68, as well as catalogue entries nos. 1–80, 380–478.

21. See references in Wayne A. Meeks, "The Image of the Androgyne: Some Uses of a Symbol in Earliest Christianity," *History of Religions* 13 (1974): 180, n.72.

22. R. R. R. Smith, "Late Roman Philosopher Portraits from Aphrodisias," JRS 80 (1990): 127–55.

23. Augustine, "De opere monachorum," chaps. 39–40.

24. Evelyn B. Harrison, "Greek Sculptured Coiffures and Ritual Haircuts," *Skrifter Utgivna av Svenska Institutet i Athen* 4, 38 (1988): 251.

25. Euripides, *Bacchae*, lines 234–235.

26. Wassilis Lambrinudakis, "Apollo," *Lexicon Iconographicum Mythologiae Classicae,* II, 1: 183–327.

27. Seneca, *Oedipus*, line 420.

28. Ovid, *Metamorphoses*, IV, 13 and 20.

29. R. Paribeni, "Statuina di Cristo del Museo Nazionale Romano," *Bollettino d'Arte* 8 (1914): 381–86.

30. Josef Wilpert, "Early Christian Sculpture, Its Restoration and Its Modern Manufacture," AB 9 (1926–27): 88–141; O. Thulin, "Die Christus-Statuette im Museo Nazionale Romano," *Mitteilungen des deutschen archäologischen Instituts, Römische Abteilung* 44 (1929): 201–59; Volbach, *Early Christian Art*, 319.

31. Neither of these details are noted in the lengthy description of Johannes Kollwitz and Helga Herdejürgen, *Die Ravennatischen Sarkophage*, Die antiken Sarkophagreliefs, 8, part 2 (Berlin, 1979), 56–57, 112–14.

32. Kollwitz and Herdejürgen note the "fast weiblich Form des Körpers," without further comment, op. cit, 116.

33. See Kollwitz and Herdejürgen, *op. cit.*, pls. 42.3 and 45.3

34. Marion Lawrence, *The Sarcophagi of Ravenna*, College Art Association Monographs, 2 (New York, 1945), fig. 3.

35. Marie Delcourt, *Hermaphrodite: Myths and Rites of the Bisexual Figure in Classical Antiquity*, trans. Jennifer Nicholson (London, 1961), 18–20.

36. Delcourt, *Hermaphrodite*, 21–22.

37. See especially Apollo with lyre, *Lexicon Iconographicum Mythologiae Classicae*, II,1: nos. 82–238.

38. Apocryphon of John, 2.9–14. James McC. Robinson, *The Nag Hammadi Library in English* (New York, 1977), 99. Elaine Pagels collects some of these texts in her chapter "God the Father/God the Mother," in *The Gnostic Gospels* (New York, 1979), 57–83.

39. Trimorphic Protennoia, 4.4–26; 45.2–10, *Nag Hammadi Library*, 465–67.

40. Wayne A. Meeks, "The Image of the Androgyne: Some Uses of a Symbol in Earliest Christianity," *History of Religions* 13, 3 (1974): 165–208.

41. Gospel of Thomas, logion 22, in Hennecke and Schneemelcher, *New Testament Apocrypha*, 1: 513.

42. Meeks, "History of Androgyne," 193–97.

43. Contra Celsum, VI: 77. See also Contra Celsum, II, 14; IV: 16.

44. Acts of John, 88–89, in *New Testament Apocrypha*, 2: 225. Cf. Elaine Pagels, *The Gnostic Gospels*, 87–88.

45. Armenian Infancy Gospel, chap. XI, 19–20; French trans. by Paul Peeters, *Évangiles Apocryphes, II: L'Évangile de l'Enfance* (Paris, 1914), 143–44.

46. Mathews, "The Early Armenian

Iconographic Program of the Ejmiacin Gospel," in *East of Byzantium: Syria and Armenia in the Formative Period* (Washington, 1982), 205–9.

47. Epiphanius, *Panarion*, 49. Translation in Ross Kraemer, *Maenads, Martyrs, Matrons, Monastics*, 226.

CHAPTER SIX

1. Emile Mâle, *The Gothic Image, Religious Art in France of the Thirteenth Century*, trans. Dora Nussey (N.Y., 1972).

2. Otto Demus, *Byzantine Mosaic Decoration* (London, 1948); but see my reservations on this description of the system in "The Sequel to Nicaea II in Byzantine Church Decoration," *Perkins Journal of Theology* 41, no. 3 (1988): 11–21.

3. Karl Lehmann, "The 'Dome of Heaven,'" AB 27 (1945): 1–27, repr. in W. Eugene Kleinbauer, *Modern Perspectives in Western Art History* (New York, 1971), 228–70. The article served as inspiration for studies of dome decoration in the Orient and in Islam: Alexander C. Soper, "The 'Dome of Heaven' in Asia," AB 29 (1947): 225–48; Oleg Grabar, "From Dome of Heaven to Pleasure Dome," *Journal of the Society of Architectural Historians* 49 (1990): 15–21. I discussed my reservations on Lehmann's thesis in "Cracks in Lehmann's 'Dome of Heaven,'" *Source* 1 (1982): 12–16.

4. Lehmann, "Dome of Heaven," 1.

5. Ibid., 21–27.

6. Ibid., 4.

7. Ibid., 6.

8. Ibid., 7.

9. Lehmann's misuse of the terms "pantokrator" and "kosmokrator" is symptomatic of a basic disinterest in exploring the mentality behind Christian art. The term "pantokrator" Lehmann applied to the pagan divinities in his central "canopy," whatever their identity. Thus we find Helios, Jupiter, Saturn, Minerva, and Diana all in turn called "pantokrator." (Op. cit., 5–7, 9, 15, 16, and 18.) But the term "pantokrator" (literally "all-ruler") is not part of the classical vocabulary; it was invented in the 2nd century B.C. by the translators of the Septuagint to render the Hebrew expression "yahweh elohai sebaoth," a phrase that is commonly put into English as "the Lord God of Hosts." The Greek translators rendered this "kyrios ho theos *pantokrator*." Subsequently, "Pantokrator" was the term used in the Nicene Creed where the English has, "I believe in one God, the Father *almighty*"; and it was the term which in Middle Byzantine art designated the bust image of Christ blessing with his right hand and holding the Gospel in his left. (Carmelo Capizzi, *Pantokrator: Saggio d'esegesi letterario-iconografica*, Orientalia Christiana Analecta 170 [Rome, 1964]; on the iconographic subject, see Jane Timken Matthews, *The Pantokrator: Title and Image*, [Ph.D. diss., New York University, 1976].) Perversely, Lehmann applied the scriptural term to the classical divinities while he used the pagan term "kosmokrator" for Christ (Op. cit., 2 and 22). "Kosmokrator," literally the "world-ruler," was a good classical epithet for Uranus, the god of the sky, or for the planets. By extension the term was also used for the earthly kings, who rule the world. (Henry G. Liddell and Robert Scott, *A Greek-English Lexicon*, [Oxford, 1968], s.v.) But in Christian sources the term was used pointedly for the rulers of *this* world, that is, the adversaries of Christ. Paul is the origin of this usage in his famous passage: "We are not contending against flesh and blood, but against the principalities, against the powers, against the *world rulers* of this present darkness, against the spiritual hosts of wickedness in the heavenly places" (Eph 6:12). For the Christian use of

the term, see G. W. H. Lampe, *A Patristic Greek Lexicon* (Oxford, 1961), s.v. To call Christ a "kosmokrator" is to call him a demon.

10. Hetty Joyce, "Nicolas Ponce's *Arabesques Antiques*: A Problem in Eighteenth-Century Archaeology," *Gazette des Beaux-Arts* 114 (1989): 183–201; idem, "Hadrian's Villa and the 'Dome of Heaven,'" *Mitteilungen des Deutschen Archäologischen Instituts, Römische Abteilung* 97 (1990): 347–81. See also Joyce, *The Decoration of Walls, Ceilings, and Floors in Italy in the Second and Third Centuries A. D.* (Rome, 1981).

11. The only known Roman ceiling with a zodiac is the quite un-Roman Temple of Bel in Palmyra. Malcolm A. R. Colledge, *The Art of Palmyra* (Colorado, 1976), 38–39.

12. Joyce, "Hadrian's Villa," 366.

13. Mathews, "Cracks in Lehmann's 'Dome of Heaven,'" *Source* 1 (1982): 12–16.

14. Henry Maguire, *Earth and Ocean, The Terrestrial World in Early Byzantine Art* (University Park, 1987), 76.

15. For a sampling on the subject one might consult, from Syria, Tatian (see n. 17 below) and the Pseudo-Clementine *Recognitions*, X: 1–12. From Alexandria consult Origen, *On Matthew*, XIII: 6; from Cappadocia, Basil as in following note. From the Latin West, see Tertullian, *On Idolatry*, IX, and Augustine, *City of God*, V, 1–10, and *On Christian Doctrine*, II, 20–24.

16. Basil, *Hexaemeron*, homily VI, 7.

17. Tatian, *Oration to the Greeks*, IX.

18. For a recent discussion of Basil's place in the development of a Christian cosmology, see Cyril Mango, "The Physical Universe," in *Byzantium: The Empire of New Rome* (New York, 1980), 166–76. For Basil's interpretation of the creation of the sun and moon, see *Hexaemeron*, homily V, 1, and VI, 1–4; on the stars see homily VI, 5–11.

19. On astrology in Antiquity, see E. Riess, "Astrologie," Paulys-Wissowa, *Real-Encyclopadie der classischen Altertumswissenschaft* (Stuttgart, 1896), 2: 1802–28. See also Ptolemy's own introduction to his *Tetrabiblos*.

20. M. J. Vermaseren and C. C. Van Essen, "The Aventine Mithraeum Adjoining the Church of St. Prisca," *Antiquity and Survival* 1 (1955–1956): 3–36.

21. Katherine M. D. Dunbabin, *The Mosaics of North Africa: Studies in Iconography and Patronage* (Oxford, 1978), 57–59.

22. J. M. Blazquez et al. *Mosaicos Romanos del Museo Arqueologico Nacional, Corpus de Mosaicos de Espana*, fasc. 9 (Madrid, 1989), 27–28.

23. On the use of candles at baptism, see Hugh M. Riley, *Christian Initiation: A Comparative Study of the Interpretation of the Baptismal Liturgy in the Mystagogical Writings of Cyril of Jerusalem, John Chrysostom, Theodore of Mopsuestia, and Ambrose of Milan* (Washington, 1974), 351 and 417.

24. Spiro Kostof made an effort to associate the twelve apostles of the Arian Baptistery with the twelve months of Lehmann's "Dome of Heaven," but the evidence for domes with twelve months is most dubious. *The Orthodox Baptistery of Ravenna* (New Haven, 1965), 115.

25. Annabel Jane Wharton suggests very plausibly that the Baptism in the Arian baptistery was rotated to address the bishop whose position was in the eastern apse. "Ritual and Reconstructed Meaning: The Neonian Baptistery in Ravenna," *AB* 69 (1987): 370.

26. Carl-Otto Nordström argued that the procession of apostles in the Orthodox baptistery subsumed the imperial ceremony of the *aurum coronarium*, by which golden crowns were offered to the emperor on the occasion of his coronation. *Ravennastudien: Ideengeschichtliche und ikonographische Untersuchungen über die Mosa-*

iken von Ravenna (Stockholm, 1953), 42–46. Christ's baptism, he maintained, was equivalently his kingly investiture. Other art historians, without making so specific an argument, are in general agreement that the ritual of the *aurum coronarium* furnished the model for Christian images of crown-bearing saints. K. Baus, *Der Kranz in Antike und Christentum* (Bonn, 1940); Theodor Klauser, "Aurum Coronarium," RM 59 (1944): 129–43; André Grabar, *L'Empereur*, 54–57, 131–33, and *Iconography*, 44–45; Otto von Simson, *Sacred Fortress: Byzantine Art and Statecraft in Ravenna* (Chicago, 1948), 94–101. Klaus Wessel, "Kranzgold und Lebenskrönen," Archäologischer Anzeiger 65–66 (1950–51): 103–114; Schiller, *Ikonographie*, 3: 173, 195, 200, 211.

27. For examples in Late Antiquity, see Michael McCormick, *Eternal Victory* (Cambridge, 1986), 19 and 210.

28. Emile Egger and Eugène Fournier, "Corona," in *Dict. des antiquités grecques et romaines* (Paris, 1877–1918), 1: 1520–37. Josef Köchling, *De coronarum apud antiquos vi et usu* (Giessen, 1914). Jokob Klein, *Der Kranz bei den alten Griechen* (Günzburg, 1912). A summary of this evidence is provided by Erwin R. Goodenough, "The Crown of Victory in Judaism," AB 28 (1946): 139–59, esp. 150–53. M. Blech, *Studien zum Kranz bei den Greichen* (Berlin, 1982).

29. Sappho, *Frag. 81, Poetarum Lesbiorum Fragmenta* ed. Edgar Lobel and Denys Page (Oxford, 1955), 55–56. The various gods had different preferences in the wreaths they expected. Zeus preferred oak, Aphrodite myrtle, Apollo laurel, etc. With the greenery, all sorts of flowers were entwined, but roses and violets were most popular.

30. Sophocles, *Oedipus Rex*, lines 2–3.

31. "On account of our belief in the divine, all men have a strong yearning to honor and worship the deity *close at hand*, approaching and laying hold of him with persuasion by offering sacrifice and *crowning him with garlands.*" Dio Cassius, *Orat.*, XII: 12, 61. Emphasis added.

32. Pliny, *Natural History, XXI*: 1–9.

33. It is a custom in Greece today to save the wedding wreath and bury it with the first of the couple to pass away.

34. The sense of the religious value of the games was still so strong in the third century that Tertullian forbade participation by Christians. Being crowned, he felt, was an impersonation of Jupiter or other pagan gods. Tertullian, *De corona*, 13; *De spectaculis*, 13.

35. Goodenough, "Crown of Victory," 151. For evidence from Plutarch, see *Homo Necans, The Anthropology of Ancient Greek Sacrificial Ritual and Myth*, trans. Peter Bing (Berkeley, 1983), 56–57.

36. J. M. C. Toynbee, *Death and Burial in the Roman World* (Ithaca, 1971), 44.

37. *Romans and Barbarians*, exh. cat. of the Department of Classical Art, Museum of Fine Arts (Boston, 1976), 28.

38. Goodenough, "Crown of Victory," 151, with further citations of Roman sources.

39. The same metaphor is employed in Jewish sorces. Goodenough, "Crown of Victory," 154–158.

40. "Henceforth there is laid up for me the crown of righteousness, which the Lord, the righteous judge, will award to me on that Day, and not only to me but also to all who have loved his appearing" (2 Tim 4:8); "When the chief Shepherd is manifested you will obtain the unfading crown of glory" (1 Pt 5:4); "Blessed is the man who endures trial, for when he has stood the test he will receive the crown of life which God has promised to those who love him" (Jas 1:12); "Be faithful unto death, and I will give you the crown of life" (Rv 2:10; and further references elsewhere in Rv).

41. Wharton, "Ritual and Reconstructed Meaning," 374–75.

42. Ambrose, *De sacramentis*, I: 2, 4. Emphasis added.

43. Alfred C. Rush explores patristic sources on both the Christian rejection of funeral crowns and their rich use of the metaphor of a crown as the reward of life. *Death and Burial in Christian Antiquity* (Washington, 1941), 133–149.

44. Wharton's suggestion that the Apostles actually offer the crowns to the neophytes below is ingenious, but it does not fit parallel crown-offering processions at the Arian Baptistery and at the "new" Saint Apollinaris. Wharton, "Ritual and Reconstructed Meaning," 375.

45. John Wilkinson, trans. and ed., *Egeria's Travels to the Holy Land*, rev. ed. (Warminster, 1981).

46. John Baldovin, *The Urban Character of Christian Worship, The Origins, Development, and Meaning of Stational Liturgy*, Orientalia Christiana Analecta, vol. 228 (Rome, 1987), 39.

47. Ibid., 236.

48. Ibid., 184.

49. Chrysostom, *De s. hieromartyre Phoca*, PG 50:699; trans. in Baldovin, 183.

50. Ambrose, *Epistolae*, 40.

51. On the choice of saints, see Otto von Simson, *Sacred Fortress*, 81–88. The saints are sometimes said to reflect the manners of the imperial court; but their dress sets them dramatically apart from the imperial court shown in Saint Vitalis (fig. 117a&b). The enthroned Christ and the Adoration of the Magi have been heavily restored.

52. Richard Krautheimer, *Corpus Basilicarum Christianarum Romae*, I: 137–43; idem, *Rome, Profile of a City, 312–1308* (Princeton, 1980), 75. The building was a simple spacious hall, roughly 58 feet square, clothed with splendid marble revetment on all its walls. The mosaic was heavily reworked in the seventeenth century, the figures on the left suffering most. Marguerite van Berchem and Etienne Clouzot, *Mosaiques chrètiennes du IVme au Xme siècle* (Geneva, 1924), 119–24.

53. L'Orange imagined that Christ was not departing but arriving, appearing on the Last Day, in the guise of the emperor in his *adventus*. H. P. L'Orange and P. J. Nordhagen, *Mosaics*, trans. A. E. Keep (London, 1966), 19–20. But the eschatological imagery of the arch over the apse seems to be a later addition to the program. The style and the workmanship are quite diverse: the mosaic cubes in the arch are twice the size of those in the apse and the faces have been reduced to a Byzantine schematism in contrast to the vivid humanity of the saints in the apse. The apse image itself lacks eschatological symbols, and the hand of God holding a wreath above Christ's head implies that the direction of his movement is upward, to receive the crown that is offered. As at St. Pudenziana, Christ has no imperial attributes.

54. Christa Ihm puts the apse in the class of compositions of Christ appearing as "Emperor with Militia." *Die Programme des Apsismalerei*, 39–40. Theodoric is a Gothic name meaning "king," for which Theodore is the closest Christian equivalent.

55. The earliest document for reconstructing the external shape of the Roman liturgy is the seventh-century *Ordo Romanus I*. Mathews, "An Early Roman Chancel Arrangement and Its Liturgical Uses," *Rivista di Archeologia Christiana* 38 (1962): 73–95.

56. Otto von Simson, *Sacred Fortress*, 29–30. D. Stricevic, "Iconografia dei mosaici imperiali a S. Vitale," *Felix Ravenna* 80 (1959), 5–27; "Sur le problème de l'iconographie des mosaïques impériales de

Saint-Vital," ibid., 85 (1962): 80–100. Grabar, by contrast, ignored entirely the liturgical context of these representations in order to emphasize supposed parallels with other scenes of imperial donation. "Quel est le sens de l'offrande de Justinien et de Théodora sur les mosaïques de Saint-Vital?" *Felix Ravenna* 81 (1960): 63–77.

57. Kitzinger, prescinding from the rite represented, analyzes the panel in spatial terms and places the emperor at the head of a "v-shaped" procession. As he pursues this analysis, however, the "v-shape" gradually disintegrates, for he notices first that bishop Maximianus "appears to be standing in front" of the emperor and then that the censer-bearer at right overlaps the frame and hence is further in front. *Byzantine Art in the Making*, 87–88.

58. Mathews, *The Early Churches of Constantinople*, 138–47.

59. In his effort to put an imperial spin on the program, Maguire contends that the emperor and his court represent an earthly parallel to Christ and the twelve apostles. This is unconvincing. Besides Justinian's third place in the procession, the twelve-ness of his company is not very legible since some of the soldiers are hidden. Henry Maguire, *Earth and Ocean*, 76–80.

60. Von Simson, *Sacred Fortress*, 36; Ihm, *Die Programme der christlichen Apsismalerei*, 26–27; Beckwith, *Early Christian and Byzantine Art*, 50; Kitzinger, *Byzantine Art in the Making*, 85.

61. Christine Alexander, "A Lead Tablet of the Second Century A.D." *Metropolitan Museum of Art Bulletin* 26 (1931): 148–50. Stephen R. Zwirn, "Plaque with the Danubian Horsemen," in *Age of Spirituality* 196–97.

62. J. Godwin, *Mystery Religions in the Ancient World* (San Francisco, 1981), 157.

63. Ibid., 166.

64. Ibid., 155.

CHAPTER SEVEN

1. *Epist. ad Constantiam*, PG: 20, col. 1545, trans. Cyril Mango, *Art of the Byzantine Empire*, 17.

2. Eusebius, in Mango, *Art of the Byzantine Empire*, 18.

3. *Ecclesiastical History* VII: 18, 4, *Art of the Byzantine Empire*, 16.

4. Ernst Kitzinger presupposes that the rise of icon veneration developed in the opposite direction, from official acceptance in imperial circles to popularity in private domestic situations. Ernst Kitzinger, "The Cult of Images in the Age before Iconoclasm," *Dumbarton Oaks Papers* 8 (1954): 88–98, reprinted in Kitzinger, *The Art of Byzantium and the Medieval West: Selected Studies* (Bloomington, Indiana, 1976), 94–104.

5. Irenaeus of Lyons, *Against the Heresies*, I: 25, 6, trans. Dominic J. Unger and John J. Dillon (New York, 1972), p. 90. See P. Corby Finney, "Alcune note à proposito delle imagini Carpocraziane di Gesù," *RAC* 57 (1981): 35–41. Marcellina belonged to a gnostic sect called Carpocratians, and hers and the following instances of icon use are often dismissed as "heretical," and therefore not authentically Christian. But the term "heretical" pertains to the realm of doctrine, and icon use belongs to the realm of cult where it is pagan in manner but Christian in the persons being venerated. To find instances of icon use that are authentically Christian, that is, placed outside the realm of debate within the church, one would have to wait until the Second Council of Nicaea, 787.

6. Edgar Hennecke and Wilhelm Schneemelcher, *New Testament Apocrypha*, trans. R. McL. Wilson (Philadelphia,

1964), vol. 2, pp. 188–259. The editor K. Schäferdiek places the composition of the *Acts of John* in third-century Asia Minor. Ibid., 214–215.

7. *Acts of John*, chaps. 26–29, Hennecke and Schneemelcher, *New Testament Apocrypha*, vol. 2, pp. 220–221.

8. *Acts of John* 19–20; Hennecke and Schneemelcher, *New Testament Apocrypha*, vol. 2, 216.

9. "I tried to see him as he was, and I never saw his eyes closing but always open." *Acts of John*, 89, Hennecke and Schneemelcher, *New Testament Apocrypha*, 225.

10. *Acts of John*, 27–29, Hennecke and Schneemelcher, *New Testament Apocrypha*, 220–221.

11. For example, see the stories in Mango, *Art of the Byzantine Empire*, pp. 139, 222.

12. Pietro Amato, *De Vera Effigie Mariae, Antiche Icone Romane* (Rome 1988).

13. Cf. Marguerite Rassart-Debergh, "De l'icône païenne à l'icône chrétienne," *Le Monde Copte* 18 (1990): 39–70.

14. Kurt Weitzmann, *The Monastery of Saint Catherine at Mount Sinai, The Icons, Vol. I: From the Sixth to the Tenth Century* (Princeton, 1976), which largely supersedes G. and M. Soteriou, *Icônes du mont Sinaï*, 2 vols. (Athens, 1956–1958).

15. Euphrosyne Doxiadis, *The Mysterious Fayum Portraits: Faces from Ancient Egypt* (New York, 1995), 90–92; Robin Cormack, *Painting the Soul: Icons, Death Masks, and Shrouds* (London, 1997) 65–76. While the verist techniques involved in the mummy portraits carry over into a few Early Christian icons (see Mathews, *Byzantium from Antiquity to the Renaissance*, New York, 1998, 47–52), they were basically a different kind of object.

Icons are framed paintings, generally of full- or half-length figures; the mummy portraits are unframed paintings of head and neck, left unfinished in the lower part to be covered with mummy wrappings. They were part of the undertaker's trade, never seen except in the tomb.

16. Hans Belting repeats the traditional view in his wide-ranging study of icons, *Likeness and Presence: A History of the Image before the Era of Art*, trans. Edmond Jephcott (Chicago, 1994); but Ernst Kitzinger pioneered the theory in his "The Cult of Images in the Age before Iconoclasm," *Dumbarton Oaks Papers* 8 (1954) 83–150, reprinted in Kitzinger, *The Art of Byzantium and the Medieval West: Selected Studies* (Bloomington, Indiana, 1976) 90–156. Most of the texts were collected already by E. von Dobschütz, *Christusbilder (= Texte und Untersuchungen zur Geschichte der altchristlichen Literatur*, Neue Folge, III) (Leipzig, 1899). See also André Grabar, *L'iconoclasme byzantin, Dossier archéologique* (Paris, 1957). Peter Brown's position stands somewhat apart in proposing an origin in the cult of the rural "holy man" for whom they were a substitute, "A Dark-Age Crisis: Aspects of the Iconoclastic Controversy," *The English Historical Review* 346 (January 1973), 1–34. But this is hardly consistent with the fact that very few of the early icons represent such ascetics. See also the criticism of Stephen Gero, "Notes on Byzantine Iconoclasm in the Eighth Century," *Byzantion* 44 (1974): 38–42.

17. Thomas F. Mathews, "The Corpus of Late Antique Icons and their Relevance to the Origins of Christian Icons," paper presented at the symposium "From the Fayum Portraits to Early Byzantine Icon Painting," the Vikelaia Municipal Library, Herakleion, Crete, 22–24 May 1998. A checklist of the corpus of Late Antique icons follows:

a) Berkeley, Phoebe Hearst Museum of Anthropology, no. 6.21384, Military God. David L.

Thompson, "A Painted Triptych from Roman Egypt," *The J. Paul Getty Museum Journal*, 6–7 (1978–79): 185–192.

b) Berkeley, Phoebe Hearst Museum of Anthropology, no. 6.21385, Military God. Ibid.

c) Berkeley, Phoebe Hearst Museum of Anthropology, no. 6.21386, Enthroned God. Unpublished.

d) Berkeley, Phoebe Hearst Museum of Anthropology, no. 6.21387, Priest and Donor (Sobek). Unpublished.

e) Berlin, Staatliche Museen, Ägyptisches Museum, no. 15979, Military God with Medusa Head. Otto Rubensohn, "Aus Griechische-Römische Häusern des Fayum," *Archäologischer Anzeiger* 20 (1905): 1–25.

f) Berlin, Staatliche Museen, Ägyptisches Museum, no. 15978, Isis, Suchos, and Harpocrates Enthroned [destroyed]. Ibid.

g,h) Berlin, Staatliche Museen, Ägyptisches Museum, no. 17957, two triptych wings with divinities in two registers. Rudolph Pagenstecher, "Klapptafelbild, Votivtriptychon und Flügelaltar," *Archäologischer Anzeiger* 34 (1919): 9–25.

i) Berlin, Staatliche Museen, Antiquarium, no. 3129, Septimius Severus and Family. Heinz Heinen, "Herrscherkult im römischen Ägypten und Damnatio Memoriae Getas: Überlegungen zum Berliner Severtondo und zu Papyrus Oxyrhynchus XII 1449," MDAI (R) 98 (1991): 263–298.

j) Brussels, Musées Royaux d'Art et d'Histoire, no. E-7409, Pair of Military Gods (Heron?). Franz

Cumont, "Un dieu supposé Syrien, associé a Hérôn en Égypte," *Mélanges Syriens offert a René Dussaud*, vol. 1 (Paris, 1939): 1–9.

k) Cairo, Egyptian Museum, no. J. 31568, Horos/Harpocrates. Rubensohn.

l) Cairo, Egyptian Museum, no. JE. 87191, Equestrian God. Étienne Drioton, "Objets de culte domestique provenant de Médinet-Qoûta," *Annales du Service des Antiquités* 40 (1940–41): 923–935.

m) Dakhleh Oasis, Egypt, Isis. Colin Hope, "Excavations at Ismant el-Kharab in the Dakhleh Oasis," *Egyptian Archaeology*, 5 (1994): 17–18.

n) Étampes, France, Private Collection, Pair of Military Gods (Heron?) Maggy [Marguerite] Rassart-Debergh, "Plaquettes peintes d'époque romaine," *Bulletin de la Société d'Archéologie Copte* 30 (1991): 43–47.

o) Hartford, Wadsworth Atheneum, no. 1934.6, Mounted Equestrian God (Heron?) David L. Thompson, "The Hartford Horseman," *Chronique d'Égypte*, 50, no. 99–100 (1975): 321–325.

p) Malibu, J. Paul Getty Museum, no. 74.AP.21, Serapis. David L. Thompson, "A Painted Triptych from Roman Egypt," *The J. Paul Getty Museum Journal*, 6–7 (1978–79): 185–192.

q) Malibu, J. Paul Getty Museum, no. 74.AP.22, Isis. Ibid.

r) Moscow, Pushkin Museum, no. 4233/I Ia 5786, Ares and Aphrodite. K. Parlasca, *Mumienporträts und verwandte Denkmäler* (Weisbaden, 1996): 72–73.

s) Paris, Louvre, no. P207, Eques-

trian God. K. Parlasca, *Mumien-porträts*, 60.

t) Paris, Louvre, no. AF 10878-AF 10879, the Tyche of Constantinople. Marie-Hélène Rutschowscaya in Guillemette Andreu, M.-H. Rutschowscaya and Christiane Ziegler, *L'Égypte ancienne au Louvre* (Paris, 1997): 147–148.

u) Providence, Rhode Island School of Design Museum, no. 59.030, Military God (Heron?) George Nachtergael, "Trois dédicaces au dieu Hérôn," *Chronique d'Égypte*, 71 (1996): fasc. 141, 138–142.

v) Tebtunis Excavation in progress, Egypt. Military God. Unpublished.

18. Pliny, *Natural History*, XXXV, xxxvi: 69 and 71, trans. H. Rackham, Loeb Classical Library (London, 1952), 312 and 314.

19. Pliny, *Natural History*, XXXV, xxxvi: 63, 109, 131; in Rackham: 308, 340, 356.

20. "Huius erat Minerva spectantem spectans, quacumque aspiceretur." Pliny, *Natural History* XXXV, xxxvi: 120; in Rackham: 348.

21. Pliny, *Natural History*, XXXV, xxxvi: 2, 5, in Rackham: 262.

22. On the checklist in note 17, *e, f, l* and *t* are from domestic sites; *m* from a temple.

23. Clement of Alexandria, *The Exhortation to the Greeks*, chap. IV, trans. G. W. Butterworth, Loeb Classical Library (London, 1953), 138–141.

24. See checklist in note 17, *r*.

25. George K. Boyce, *Corpus of the Lararia of Pompeii* (Rome, 1939); David G. Orr, "Roman Domestic Religion," University of Maryland diss., 1972.

26. See checklist in note 17, *e* and *f*.

27. Weitzmann, *The Monastery of St. Catherine at Mount Sinai, The Icons*, 31, 38, 56.

28. See checklist in note 17, *p* and *q*. Published again by David L. Thompson in *Mummy Portraits in the J. Paul Getty Museum* (Malibu, 1979), 24, 46–51; and in Susan

Walker and Morris Bierbrier, *Ancient Faces: Mummy Portraits from Roman Egypt* (London, 1997), 1223–1224. The Getty Museum's association of these two panels with a central panel depicting a bearded man is certainly wrong. In the first place, the dimensions are wrong; in order for the pintles to fit into the frame of the center panel, the wing panels should be shorter than the center panel, but they are in fact 4 cm. taller. Second, placing the gods in the wings makes them subordinate to the mortal in the center panel, which is unthinkable for gods of this rank. When mortals enter Late Antique religious panels, it is on a reduced scale behind the gods. (Cf. checklist in note 17, *a, j, n, u.*) Third, the painting style of the wings is very different from that of the portrait and includes heavy black borders above and below that correspond to nothing in the portrait.

28a. See checklist in note 17, *c*.

29. A. E. R. Boak and E. E. Peterson, *Karanis: Topographical and Architectural Report of Excavations during the Seasons 1924–31* (University of Michigan Studies, Humanistic Series XXX, Ann Arbor, 1933), 34; Elaine K. Gazda, *Karanis: An Egyptian Town in Roman Times* (Ann Arbor, 1983), 39–40.

30. Weitzmann, *The Monastery of St. Catherine at Mount Sinai: The Icons*, 77–78. Weitzmann opts for an eighth-century date, although all the parallels he cites in style and imagery are sixth and seventh. For the other enthroned Virgins, see Weitzmann, ibid. 18–21, and Amato, *De Vera Effigie*, 26–32.

31. See checklist in note 17, *j* and *q*.

32. Peter Brown, *The Body and Society: Men, Women and Sexual Renunciation in Early Christianity* (New York, 1988).

33. *Acts of John*, chap. 29, Hennecke and Schneemelcher, 176.

34. Weitzmann, *The Monastery of St. Catherine at Mount Sinai: The Icons*, 26–27,

41–42, and 13–15, respectively. Properly speaking, this icon should not be called the "Pantocrator," which is a name not employed for images of Christ until the ninth century. Jane Timken Matthews, "The Pantocrator: Title and Image," New York University diss., 1976.

35. See checklist in note 17, *p*; also note 28 above.

36. Rufinus, *Historia ecclesiastical*, II: 23, PL 21, 532.

37. Theodore the Lector, *Historia ecclesiastical* I: 15, trans. Mango, *Art of the Byzantine Empire*, 40.

38. See checklist in note 17, *l* and *s*.

39. Weitzmann, *The Monastery of St. Catherine at Mount Sinai: The Icons*, 36–37.

40. See checklist in note 17, *a, n,* and *u*.

41. Weitzmann, *The Monastery of St. Catherine at Mount Sinai, The Icons*, 37–38, 41–42, 48; to these might be added the inscription of Nikolaos Sabatianos, who appears in miniature beneath the St. Irene in an icon of the eighth or ninth century, Weitzmann, ibid. 66–67.

42. See checklist in note 17, *t*.

43. Frank Trombley, *Hellenistic Religion and Christianization c. 370–529* (Leiden, 1993).

44. John Malalas, *Chronicle*, XVIII: 136, trans. Elizabeth Jeffreys, Michael Jeffreys and Roger Scott (Melbourne, 1986), 300.

45. St. John of Damascus, *On the Divine Images*, I: 24, trans. David Anderson (Crestwood, New York, 1980), 32. Cf. PG: 94, 1256–1257. Anderson translates the present tenses as past, which I have corrected. This whole passage is repeated almost verbatim in II, 17 (Anderson, 63).

46. John of Damascus, *On the Divine Images*, II: 11, in Anderson: 58.

47. See note 16.

48. Leontius of Neapolis, *Sermo contra Iudaeos*, PG: 93, 1604C, trans. Norman H. Baynes, *Byzantine Studies and Other Essays* (London, 1960), 235.

49. J. D. Mansi, *Sacrorum conciliorum nova et amplissima collectio* (Florence, 1759–98), vol. 12, 1013.

50. Julian, "Letter to a Priest," in *Works*, trans. Wilmer C. Wright, Loeb Classical Library (London 1913), vol 2, 308–310, discussed in Baynes, *Byzantine Studies*, 130.

51. Zacharias the Rhetor, *Ecclesiastical History*, XII: 4, trans. Mango, *Art of the Byzantine Empire*, 114–115.

52. Kitzinger, "Cult of Images," 100; *Art of Byzantium*, 106.

53. Hans Belting, *Likeness*, 53.

54. M. P. Nilsson, "Procession," in *Oxford Classical Dictionary*, 2d ed., 880; Ptolemy II's extravagant procession of Dionysiac statues and related objects in Alexandria is described in Athenaeus, *The Diepnosophists*, V: 196–203, ed. Charles B. Gulick, Loeb Classical Library (London, 1928), vol. 2, 386–418.

55. The key role of women in icon cult was explored by Judith Herrin, "Women and the Faith in Icons in Early Christianity," in *Culture, Ideology and Politics: Essays for Eric Hobsbawm*, ed. R. Samuel and G. S. Jones (London, 1982), 56–83.

56. Belting, *Likeness and Presence*, 102–114. Consular diptychs are also invoked in this connection, but their greeting-card format, with images outside and message within, is without parallel in Christian icons.

57. Kitzinger, "Some Reflections on Portraiture in Byzantine Art," *Zbornik radova*, 8/1 (1963): 185–193, reprinted in *The Art of Byzantium*, 256–269; Belting, *Likeness and Image*, 134–139.

58. Julian, "Letter to a Priest," 294D, in Wright, *Works*, II: 310, emphasis added.

59. Mango, *Art of the Byzantine Empire*, 115, emphasis added; see alternate translation of the last line in W. R. Paton, *The Greek Anthology*, I: 36 (London, 1960), 23.

LIST OF FIGURES

INDEX

DATE DUE

JAN 0 4 2000

APR 2 5 2000

MAY 0 6 2003

JUL 0 1 2014

DEMCO, INC. 38-2931